# SELECTED WRITINGS
## OF
# GUILLAUME APOLLINAIRE

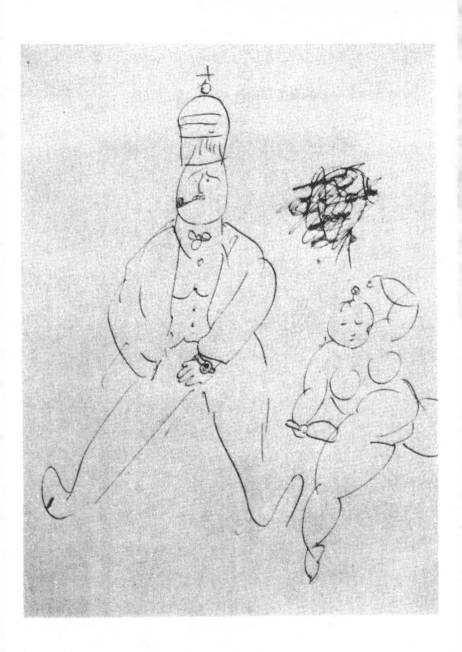

DRAWING BY PICASSO

SELECTED WRITINGS OF

# GUILLAUME
# APOLLINAIRE

TRANSLATED

WITH A CRITICAL INTRODUCTION

BY

ROGER SHATTUCK

A NEW DIRECTIONS BOOK

Library of Congress Catalog Card Number: 72-145928

ISBN 978-0-8112-0003-5

Published by arrangement with Librairie Gallimard, Paris

Manufactured in the United States of America
First published as New Directions Paperbook 310 in 1971
Published simultaneously in Canada by Penguin Books Canada Limited

New Directions Books are published for James Laughlin
by New Directions Publishing Corporation,
80 Eighth Avenue, New York 10011

FIFTEENTH PRINTING

# TRANSLATOR'S NOTES

Because of its length, one important critical work has been omitted from this selection: *Les Peintres Cubistes* (The Cubist Painters). There is, however, a translation of it by Lionel Abel still in print at this time, published by Wittenborn & Co., New York.

The verse translations herein should be able to stand alone as poems in the English language. However, they must serve the equally important purpose of helping the reader whose French is uncertain to follow the original text—or rather, of *forcing* him to refer to the left-hand page out of a natural dissatisfaction with what is on the right-hand page. By the curiosity and exasperation they provoke, verse translations make us aware of the contents of the two languages involved and oblige us to acknowledge what is untranslatable in poetry.

I wish to acknowledge with gratitude the assistance in the preparation of this volume of Professor Wallace Fowlie, who helped me in all stages of the work, Professor Henri Peyre, Mr. T. Weiss, Mlle Nadine Chauveau, and Madame Apollinaire, the widow of the poet, who received me with hospitality and gave me access to his manuscripts and his library.

These translations are lovingly dedicated to my Mother.

R.S.
Paris
*October* 1948

For this new impression, I have been able to make only essential corrections. Much has happened in twenty-two years to reveal new aspects of Apollinaire and to shift my own critical attitudes. However, I believe the Introduction still serves its purpose in spite of its age. I should have liked to make extensive changes in the selections of Apollinaire's work. It was possible only to add a few short poems. The bibliography has been revised and brought up to date.

Austin, Texas
*August* 1970

# CONTENTS

# ILLUSTRATIONS

# INTRODUCTION

# APOLLINAIRE, HERO-POET

## I

In his story, "The Heretic", Guillaume Apollinaire invented an ingenious heresy of a triple incarnation called "The Three Lives". Among the eccentricities, the argument for the earthly life of all three persons of the Trinity is surprisingly convincing. There is, however, a far more dangerous heresy of a literary nature which Apollinaire did not write about, but which could bear the same title. It is unfortunate that he did not expose this doctrine, for he is one of the figures who has suffered most from its distortions. The heresy is that of the separation of the three lives or persons of the poet: his biography, his myth, and his verse. Ever since the assertion of individual personality during the Renaissance and Romantic periods, the designation, "poet", has been applied to a loose combination of the first two of these elements. The work of a poet has too often been set aside as nothing more than a kind of evidence pointing back to his life. The true nature of Apollinaire, the poet, has undergone just such a division at the hands of some of his most ardent admirers, and his name is in need of repair.

These three lives could be represented by three partially congruent circles; where they all coincide is the area which we can most unmistakably identify as the poet. The portion of each circle which lies outside this overlapping is not extraneous, but it cannot be taken alone as a basis for evaluation. In the case of Apollinaire, the myth of an erratic and irrepressible personality, the leader of the Paris avant-garde, has swelled one of the circles to huge proportions. The other aspects of the man have been overshadowed by his fable, related in numberless anecdotes whose fascination is undeniable. It seems suitable to begin this introduction with some of this very extravagance—in the knowledge, however, that the true poet is behind it, beyond it.

Picabia, the painter, tells the story of how he came to get Apollinaire one evening before a formal dinner and found him in full dress except

for his black tie. This essential item seemed to be lost. Together they searched the apartment into which Apollinaire had recently moved and they finally discovered all of his neckties collected inside a bottle. Apparently he had put them there to keep them together during the move. The bottle was a valuable curio however, and Apollinaire could not bring himself to break it. Therefore they tried with various implements, including a botton hook, to rescue the ties through the neck of the bottle. All efforts were unsuccessful. Finally, since it was getting late, a brilliant solution was reached. Picabia, using China ink, painted the missing tie on Apollinaire's shirt-front, and the poet, immensely satisfied with the substitute, attended the dinner fully dressed. Many a friend has described Apollinaire's unpredictable manner of walking through the streets of Paris. As if it were his profession, he would carefully appraise and quote a precise figure in francs on the value of doorways or of ugly public monuments. He would turn around to follow people whose appearance interested him, expounding seriously upon their occupation and character. In the most unlikely places, his friends would see him shake hands with the proprietor of a store or restaurant as if he were an old acquaintance—and the truth could never be known. He one day bought a large, over-decorated inkwell at the bazaar of the Hôtel-de-Ville and carried it about with him as an object of beauty. This kind of gesture in defiance of " good taste " was certainly not just whim or perverseness. The most obscure of his deeds had a purpose.

But there are anecdotes which permit a clearer view of the poet. André Billy in his book, *Apollinaire Vivant*, relates one of the best. Billy and Apollinaire, both of whom had been roaming about the Left Bank for some time unable to get down to work, decided one day to help each other to write every morning. The following day at nine, Billy arrived at Apollinaire's attic apartment in the Boulevard Saint-Germain and got him out of bed. Tremendously amused, they spent the first morning arranging the furniture to suit their plan. The second morning when they had settled down facing one another inexorably across a writing table, Apollinaire casually told Billy to go to it. Billy objected that they both had to write, but Apollinaire replied easily that he had some letters to sort out first. For four or five days he occupied himself with his huge and unattended correspondence. Finally however he reached the bottom of the

4

piles of letters and he could procrastinate no longer. Resolutely he took up his pen and wrestled in visible discomfort with the emptiness of his mind. Then suddenly he started humming to himself as was his habit, and his pen moved rapidly across the paper in front of him. He began what he intended to be a story for the magazine, *Excelsior*. Reaching a pause in its flow, the prose modulated irresistibly into poetry, and Apollinaire went on to write the first version of one of his loveliest poems, " Un Fantôme de Nuées ". Out of this ludicrous game played as a joke with Billy had come a moment of inspiration which turned the literary buffoon into a lyric poet. Here then was a point of congruence where the man and the myth and the poet coincided.

It is to be regretted that the mass of material that has been written on Apollinaire—*hommages, témoignages, portraits, testaments, souvenirs,* etc.—has now almost obscured him behind an unreliable blend of fact and invention. Too many of his acquaintances who were charmed by the qualities of his personality have wanted to set down their version of it. They point to his verse as a sort of astonishing and corroborating excrescence of his life. The glee with which Apollinaire cultivated his own myth and his own mystery has not made the critic's job any easier. The true poet is there, however, even if he keeps himself in shadow. He can be found best by a direct and sustained attention to his verse and a critical eye on the enchantments of his life.

Apollinaire, in his verse and in his life, was successively a clown, a scholar, a drunkard, a gourmet, a lover, a criminal, a devout Catholic, a wandering Jew, a soldier, a good husband. These are partial revelations he made of himself. They resolve into two distinct themes: a huge gaiety and vitality which carried him through life with apparent assurance, and an equally strong but slightly muted note of tragedy and despair which was the reverse side of the same life. Referring to one of the less successful of Apollinaire's works, André Breton writes: " Je sais qu'Apollinaire tient le secret d'une gaieté moderne, à la fois plus profonde et plus tragique et que c'est volontairement qu'il ne l'a pas engendrée." But this distinguishing of two contrasting tones in Apollinaire's work is by no means a complete analysis. It is the manner in which he embraced and rose above this division that wins him the title I have used of " hero-poet ".

I shall have to put off until later a full discussion of this heroism. It can

be said here briefly that it takes courage to affirm together, as Apollinaire did without any sophistry of reconcilement, two conflicting tendencies in one's deepest being. This courage is the index of his heroism. His boldest acts and his boldest works display a desire to touch simultaneously the extremes of tragic despair and of exultant gaiety. Today we have given to the products of this boldness the name "surrealism", or rather we have accepted the name from Apollinaire himself. Yet it is easy to forget the heroism which marks the origin of such a new attack upon the frontiers of life. Voyages of discovery require a shunning of the ordinary standards of safety and danger. What Apollinaire did in his life and work endangered his position in normal society and the security of his daily life. Yet he lived to surpass at moments this ordinary conception of danger and to find a new and rewarding safety which was the goal of his search.

One of the principal resources of surrealist literature is "automatic writing". Its purpose is to turn over the ground of the unconscious personality and to bring up the deep-lying soil whose values are otherwise little used. As an art form in itself, it is unsatisfactory, but there is no doubt of the value of the material it furnishes. Apollinaire, I am ready to say, exceeded even the resources of this literary device. He came close to attaining what could be called the "automatic life". He lived and acted out of recesses deeper in himself than most people ever become conscious of, and his heroism consisted in sustaining this way of life. The biography, the myth, and the work show little disparity in the light of the courage with which he asserted his rich imagination.

II

Guillaume Apollinaire Kostrowitzky was born near Rome on the 26th of August, 1880. His mother, Mme. Angelica de Kostrowitzky, was a Polish lady whose father had been a colonel in the Papal guard. She was unmarried and had two illegitimate sons, Guillaume and Albert. Throughout Apollinaire's life and as late as 1950 it was thought that the father of this family was a prelate of high standing in the Roman church, possibly a Cardinal—even, some liked to hint, the Pope himself. However, it is established in some recent biographies that the father was

probably a high-living Italian officer, Francesco Flugi d'Aspermont. After a nomadic existence with their mother the boys were sent to the Riviera for a Catholic schooling at Monaco, Cannes and Nice. During these years Apollinaire made his early and lasting friendships with Toussaint Luca, René Dalize, Louis de Gonzague-Frick—three poets. He and his brother lived apart from their mother in complete freedom. With his classmates in school Apollinaire read Mallarmé, de Regnier, Racine, Corneille, de Gourmont, Verlaine, Nerval and a number of other poets. Already they were steeped in literature. At eighteen Apollinaire was told by his mother to make his own living, and he found himself a position as tutor for the daughter of a German viscountess. This job gave him the opportunity to travel extensively about Europe under agreeable conditions. At intervals during the short year that he held this position, he accomplished a great amount of reading, much of it abstruse and scholarly.

In 1902 he settled in Paris, worked in a bank, and lived with his mother. He wrote in his free time and formed a wide acquaintance in literary circles. He spent most of his time with other young artists and writers such as Picasso, Paul Fort, Vlaminck, Max Jacob, Marie Laurencin, Alfred Jarry, and many others whose names are now familiar. By this time he had adopted the name Guillaume Apollinaire. In 1903 he founded and directed a literary review, *Le Festin d'Esope*, which appeared for more than a year, and his activity in the literary world of Paris became immense. He wrote widely: poems, articles, stories, translations, theses for university students, introductions to *de luxe* editions of erotic literature, children's books, and columns in the daily newspapers. His first important book was a collection of stories, *L'Hérésiarque et Cie*, which was published in 1910. In 1911 his first poems appeared in book form in *Le Bestiaire* (illustrated with woodcuts by Raoul Dufy). These works established his position as an important young author of marked originality.

A distressing event soon added to the unique quality of his fame. A few days after the sensational theft of the Mona Lisa from the Louvre in September, 1911, Apollinaire was arrested and held in prison. Six days later he was released. A casual friend of his had stolen some statuettes from the Louvre. But Apollinaire never touched the Mona Lisa. The ex-

7

perience of this imprisonment was profoundly disturbing to Apollinaire, as his work reveals in several places, and the publicity he gained thereby was entirely repugnant to him. In order to bolster his spirits and his reputation, his friends helped him to start another review, *Les Soirées de Paris*, which was a considerable success and appeared until 1914.

In 1913 *Les Peintres Cubistes* was published, the fruit of long collaboration and discussion of art with Picasso, Braque, Gris, Marie Laurencin, Picabia, Metzinger, Léger, Marcoussis, and many others. The cubist style had evolved principally in the work of the first three artists in their progress away from impressionism, but it was Apollinaire who explained the new esthetic, defended it, praised it, and encouraged it. Several years earlier, Alfred Jarry and he discovered Henri Rousseau, " Le Douanier ", and launched his career as a painter. In 1913, *L'Antitradition Futuriste*, a futurist manifesto by Apollinaire, appeared in Milan. The same year *Alcools*, the first of his two important volumes of verse, was published by the *Mercure de France*. Thus in 1914 Apollinaire was at the peak of his career—the man who had led Bohemian Paris from the Montmartre to the Montparnasse and who directed the movements of the avant-garde. When the war broke out, he could as an Italian citizen have continued his work undisturbed. However, he decided to become a French citizen and he volunteered for service as soon as possible.

During the war, Apollinaire trained and fought with the enthusiasm of a convert and with his own natural ability to enjoy any rôle in life. He began in the artillery and two years later he became, upon his own request, a lieutenant with the infantry at the front. During all this period he continued to write, reproducing on gelatine a sheaf of verse while he was still in the trenches. In March, 1916, he was wounded in the head by a shell fragment while reading a new issue of the *Mercure de France*. Two operations on his skull were required to return to him the full use of his limbs, but he recovered soon and was proud of the impressive bandage around his head. Unfit for active service, he took a job in Paris in the Bureau of Censorship and revived his literary work. He assembled his second important volume of verse, *Calligrammes*, and completed his " surrealist " play, *Les Mamelles de Tirésias*.

Through all these years the profound affection and love of which Apollinaire was capable expressed itself partially in his warm friendships

for the men who surrounded him. However, his deep love of a few women played a far more important part in his emotional life. His first love, Annie, was an English governess whom he knew during his days as a tutor. There followed Marie Laurencin, whose loss crushed him almost as much as Annie's; Lou, a young woman he met while training at Nîmes; and Madeleine, a schoolteacher in Marseilles whom he met òn a train and to whom he addressed a vast amount of verse and correspondence as he had to Lou. All these attachments were fertile sources of inspiration for him—he knew nothing more natural than to celebrate his love in verse. Finally, while recovering from his wound, he met Jacqueline Kolb, " la jolie rousse ", whose beauty and sympathy pleased him immediately. They were married in May, 1918 at a very small ceremony. For the next few months they were extremely happy, living in Apollinaire's celebrated " pigeonnier " on the Boulevard Saint-Germain. But his health had been undermined by his wound and the subsequent operations, and on November 9 he died, after a brief illness, of the Spanish grippe. Paris was at the time celebrating the approaching Armistice, and two days later his friends followed his remains to the cemetery of Père Lachaise through a city decked out in flags. They were all certain that he would have been delighted with such a funeral.

These are the bare facts of Apollinaire's life—and we can now be fairly sure of them. Any accurate knowledge we have, however, is quickly confused by the mystery which arises when an elaboration of these facts is attempted. During his life Apollinaire did nothing to illuminate his past, relating extravagant and contradictory stories about it with great relish. He appeared to approve of the general belief that his father was a member of the church hierarchy. This mystery is one factor which allowed the myth of the poet to form. A full biographical treatment of Apollinaire, although it may have a wealth of material to draw upon, faces the task of resolving endless conflicts.

The personality which gradually emerges from the confusing evidence has one unequivocal characteristic: enthusiasm. He was endowed with a physical and mental robustness which transmitted itself to his work and into his social relationships. It was the basis of his bold imagination and his strong qualities of leadership. Probably the most startling

9

and immediate evidence of his enthusiasm was his appetite; he was a prodigious eater. He took his friends on culinary tours of Paris during which each course of a dinner was eaten in a different restaurant specializing in one dish. Francis Carco offers a graphic description of his love of a good meal.

> Gourmand, énorme, appétissant à voir, il brisait entre ses machoires les os qu'on lui servait, les suçait, se barbouillait de graisse et, contant quelqu'histoire de peintre, faisait péter sous lui sa chaise sans s'occuper des frais. Qu'avait-il donc à craindre? Il ressemblait à quelque dieu hilaire...

This gustatory energy had its counterparts in all of his sensibilities. He enjoyed walking, riding in cars, and travelling in any way. Later in life he took up drawing when confinement in the hospital forced him to be inactive. He talked endlessly in a flexible, melodic voice, charming any company with the amusing fantasy of his remarks. He sang and gestured and performed with a liberty that endeared him to all.

His physical robustness enabled him to work immensely without strain. Never does he display that terror of the inability to write which plagued the talents of Baudelaire and Mallarmé. He wrote on all subjects, in all forms, and for all purposes. For him there was no separation of art and action; they were identical. With complete spontaneity he wrote verses on matchboxes and postcards to send to his friends. Being a poet was not work to him, but rather the natural way of living and manifesting the great love he felt for people and for things. The characteristics of his mind were also principally those of a vital enthusiasm toward life: boldness, iconoclasm, buffoonery, curiosity, sentimentality, assertive leadership, shamelessness. The true nature of this mind, however, is best illuminated by the glow and sparkle of the verse it produced.

In order to better understand the verse, a few significant elements can be distilled from the bulk of anecdote and emerging fact which surround his life. Their enumeration here is in danger of being an oversimplification, but certain points must be stressed in this fashion. Apollinaire was an illegitimate child who never had any relationship with his father and very probably never knew his identity. No social stigma ever resulted from this unorthodox birth as far as one can discover, but it led to the almost complete freedom in which Apollinaire spent his childhood. This lack of a father found partial compensation in his close relationship with his

mother to the end of his life. He treated her with respect and tenderness, taking his most intimate friends to see her but keeping her apart from his far from ordinary life in Paris. She treated him always as a little boy, but made no attempt to interfere in his life. The only one of his works she ever read was the volume of stories, *L'Hérésiarque et Cie*, which she bought for herself and found " idiotic ". Apollinaire was fatherless in the fullest sense, and his mother, unwilling to recognize her own age, never acknowledged his manhood.

Another element is the rootlessness of the first twenty years of his life. Born in Italy and schooled in southern France, he immediately set out upon travels which took him to all parts of the continent. He literally had no home, no country. Travel made him a cosmopolitan of the truest type, and he never ceased to think in terms of the wealth of lands he had lived in and visited. In a like manner his spasmodically intense but unsystematic studies had filled his mind with a body of knowledge that was of no single country, no one tradition. In the end he became essentially French, but German culture was an important influence on his development as well as Italian and Slav cultures. His natural curiosity of mind took him far afield into ancient history, magical lore, and erotic literature. The same inclination to investigate new territory led to his familiarity with the arts outside of literature and to his contributions to them. Painting and, less intensely, music, absorbed him to the extent of influencing his own writings.

Through all these various manifestations of quest and search, one force remained paradoxically strong for so independent a personality as Apollinaire—the Catholic Church. We know that he was baptized and had a Catholic schooling; later in life he maintained no regular connection with the Church. Yet this early training left its mark on him in two ways: a mocking fascination with the meaning of Catholic dogma, and a recurring feeling for the cadences of the liturgy, especially those of the litany. The former was to be the origin both of his burlesques of the Church and of his devious acknowledgements of its strength; the latter was to influence the actual composition of his verse. Whatever his attitude toward the Christian God, faith in a deity was never entirely absent from his consciousness. The symbol was too convenient, too necessary. He never truly wrestled with problems of faith, but they were

unavoidable. They occur in his work satirically and indeed grossly as in parts of *L'Hérésiarque et Cie*, or sentimentally and nostalgically as in the poem, " Zone ".

These elements of Apollinaire's early life prepared the ground for the last two I shall mention. In a life that lacked so many of the normal factors of stability—home, family, country, and religious faith—there were two principal actions outside of literature into which he threw himself with sustained devotion. The first was the Bohemian life of Paris. As long as France has been a nation, Paris has been its capital culturally and artistically as well as politically. Villon wrote of it in the fifteenth century, and Apollinaire is in many ways the Villon of the twentieth century. Such romantic works as Puccini's *La Bohème*, Rostand's *Cyrano de Bergerac*, and Murger's *Scènes de la Vie de Bohème* have glorified the artist's life in Paris with a touching sentimentality that borders always on insipidity. The Bohemianism of the early twentieth century, led to a great extent by Apollinaire, rejected this soft romanticism for something more violent and bold. Francis Carco is again the chronicler of the movement, the pilgrimage described in his book, *De Montmartre au Quartier Latin*.

> Montparnasse est né d'Apollinaire qui, le premier, nous entraînait chez Baty, se vit partout fêté. Sa présence en ces lieux où le mélange des races provoque un inquiétant remous, créait comme une union sacrée des arts, la fixait, la cristalli-sait... il pintait très fort, peu s'en fallait qu'à n'importe quelle époque de l'année, sa troupe et les poésies d'alentour ne s'écriassent: " Le Roi boit! Le Roi boit!" en approchant leurs verres pour trinquer avec lui.

Apollinaire's own work is in many places a record of this Paris scene, and his exuberance toward art and life was instrumental in moulding its Bohemianism into a spirit which was creatively iconoclastic.

The second activity which absorbed the latter part of his life was a military career in the war. He espoused the cause of France with a fervour that combined with his assertive personality to make him extremely ambitious. Yet it was not pride alone that made him fight; it was his never satisfied appetite for new experience. When finally he was given a commission in the infantry, he was intensely proud. Later, his bandaged head was his badge of devotion and sacrifice. A uniform gave him an almost childish pleasure, and in every respect he found it

rewarding to participate in the mighty effort of war. His poems and letters of this period do not complain of any hardships or privations. He found beauty in the spectacle of war, admiration for the ingenuity of its methods, and security in the human companionship it offered. Apollinaire appreciated the army as he did the streets and bars of Paris. For a person of his erratic youth and education, neither was a random diversion. He found in both cases a place in life, a cause, and a loyalty which absorbed his swelling vitality.

<center>III</center>

In *Anecdotiques* Apollinaire writes: " Certains poètes ont le droit de rester inexplicable, et, à vrai dire, ceux qui paraissent si clairs ne seraient pas toujours les moins obscurs, si l'on voulait débrouiller le sens véritable de leurs poèmes." This is as apt a generality as can be made about his own work, for his verse hovers somewhere between lucidity and obscurity in a manner which can be satisfying when a careful balance is retained, or outrageously exasperating when it becomes lost to one tendency or the other. A work of art must be at the same time clear and mysterious (or simple and inexhaustible, available and inaccessible). In this tension a poem exists as a unity. Any division of the poem that is made for the purpose of criticism, any isolation of a single characteristic in order to evaluate its function more precisely, is provisional and does not exist in the poem itself. A breakdown of the total experience of a poem is useful only if it is known that a poem is a single unit of language which is therefore only understood when it is reconstructed and again set in motion. It is principally by these standards of balance and unity that I would evaluate first Apollinaire's prose and then, in far greater detail, his verse.

Two novels, *Le Poète Assassiné* and *La Femme Assise*, and a volume of stories, *L'Hérésiarque et Cie*, comprise his principal works of fiction. The most successful of these is the volume of stories, which draw chiefly upon his experiences as a European traveller and were well received at the time of their publication. They treat exotic and bizarre themes: the wandering Jew; a Pope asking *ex cathedra* for the dissolution of the Church; the death of Salome; the fantastic, partly true adventures of a

<center>13</center>

certain Baron Ormesan; and the esoteric heresy of the triple incarnation which has already been mentioned. The direct narrative style, adorned only with dialect and obscure place names, carries a strange blend of irony and credulity as if the author himself partially believed his tales. The book merits comparison with Rabelais, Swift, and Boccacio. Apollinaire is in reality dealing with a Europe we know only in legend, both secular and religious. The dogma of the Church of Rome is treated on a par with the extravagant tales of a sailor from Amsterdam.

The two novels, because they are fragmentary and formless, fall far below the merits of *L'Hérésiarque et Cie*. *Le Poète Assassiné* is a twistedly autobiographical tale of the poet, Croniamantal, who proclaims the freedom of poetry, is persecuted mercilessly as betraying life, and replies to the masses, " Your hero is boredom bringing misery". It is little more than a succession of incidents salted with an occasional vivid passage and written with humour and a keen sense of the ridiculous. The second novel, assembled at the end of his life from various pieces of disconnected writing, is even more uneven than the first although more brilliant in spots. Adventures in Europe are again a part of the book, but this time Apollinaire transfers a great deal of his interest to the Mormons of the western United States and their customs of polygamy.

Two anecdotal works, *Anecdotiques* and *Le Flâneur de Deux Rives*, were published after his death. The former is the better of the two, a collection of brief articles which appeared in the *Mercure de France*. Unfortunately few of the ideas are developed. Such interesting subjects are broached as the language of soldiers, a tactile art, the future of drama, the supposed story of Whitman's funeral, and the contemporary confusion of the idea of speed with the idea of progress. Besides these, there are three more or less dramatic works: *L'Enchanteur Pourrissant*, *Les Mamelles de Tirésias*, and *Couleur du Temps* (in verse). *L'Enchanteur* was his first published book, a strange primitive conglomeration of mythical characters. The enchanter in his tomb speaks with all the figures who pass, and a grotesque picture of the world emerges. The work is important as startling evidence of the orphic power which was later to permeate his writing. *Les Mamelles* is widely known as the first surrealist work. Drawing heavily on the buffoonery and vulgarity of Alfred Jarry in *Ubu Roi*, this play was received with violent demonstrations at its

première in 1917. With a ridiculously didactic theme, it flouts the formal traditions of the stage in a kind of farcical improvisation. Poulenc's score for it as a comic opera has given it a lyric beauty and balance that does not arise out of the text alone. *Couleur du Temps* is as close as Apollinaire came to symbolism. The airplane which carries the characters from place to place in their vain quest for peace, is life itself with its endless combats. Even though there are some powerful speeches by the passengers looking down at the earth and commenting on it with new perspective, there is no convincing drama or conflict in the play.

Although smaller in bulk than the fiction and the drama, Apollinaire's critical work is far more significant than either of them. As a critic he was rash, imaginative, perceptive, sympathetic, and in most respects far ahead of his time. He applied his talents to criticism of both literature and painting, and it is to be regretted that most of these works had to wait over thirty years before being widely recognized and re-edited.

In a brief introduction to a *de luxe* edition of the poetry of Baudelaire, he writes: " C'est à partir de Baudelaire que quelque chose est né qui n'a fait que végéter tandis que naturalistes, parnassiens, symbolistes, passaient auprès sans rien voir . . . " This essay is important in that it launched the now established critical opinion that Baudelaire was in some ways the " first modern." Up to this time, Baudelaire had been classified primarily as a decadent. Apollinaire, although censuring the morbid extravagances in his work, affirmed and lauded Baudelaire's courage in subjecting all of life, even its more shameful aspects, to a careful scrutiny. These two poets, in fact, had much in common. Both pioneered new territory for poetry; both applied their talents to criticism of contemporary painting.

In the manifesto, *L'Antitradition Futuriste*, Apollinaire made an exaggeratedly destructive declaration of his position. It is virtually a rejection of the restraints of tradition and an affirmation of complete liberty. The manifesto is shrill and ineffective compared to his one real work of literary criticism, *L'Esprit Nouveau et les Poètes*. It is an article written shortly before his death, and since it is a final statement of faith, it merits close study. He touches on certain futurist ideas about the importance of mechanical devices in the arts, namely the phonograph and the cinema. Most important, he makes a clear explanation of how the new spirit,

consisting principally of *surprise*, is not a shattering of tradition but a careful selection of the best of traditional elements. " Order " is a necessity, but " liberty " to choose contemporary subject matter and new verse forms is equally essential. Imitation is rejected in favour of the discovery of a " new order " which will serve to capture contemporary life in terms adapted to it. The poet must be bold in investigating new means whereby experience can be organized, and surprise is the effect that these findings should carry. Certainly Apollinaire himself displayed this insatiability for life and its full perception.

> C'est pourquoi le poète aujourd'hui ne méprise aucun mouvement de la nature, et son esprit poursuit la découverte aussi bien dans les synthèses les plus vastes et les plus insaisissables. . . Les poètes ne sont pas seulement les hommes du beau. Ils sont encore et surtout les hommes du vrai.

This is a dangerous position for an artist—the assertion of " truth ". Apollinaire does not elaborate his meaning, but it is clear enough that beauty in the romantic sense has given way to the search for a new order of truth. The nature of this search is defined more clearly for us in his more thorough criticisms of the plastic arts.

Cubism as a discernible movement in art arose between 1906 and 1908 and was named by Matisse and Apollinaire. The first group exhibition of the cubists took place in 1911, and within a short time the name included such important figures as Braque, Picasso, Metzinger, Gleizes, Gris, Léger, Duchamp, and Duchamp-Villon. In 1913, Apollinaire issued his *Les Peintres Cubistes*, subtitled " Méditations Esthétiques ". In estimating this work of criticism we must remember that it was the first such attempt and that to a great extent Apollinaire was obliged to work out the vocabulary to apply to the new art; indeed Apollinaire was to Picasso and the cubists what Duret had been to Manet and the impressionists. But whereas Duret was concerned principally with the historical events, Apollinaire devoted himself to commenting on and evaluating the esthetic principles and the actual painting of these men. In the new art of cubism (the counterpart of the " new spirit " in poetry) he immediately detected the two principal currents: the analytic tendency which reconstructed the world of nature according to rigid rules of geometry, and the synthetic tendency which stressed creation, surprise, and spontaniety. These currents corresponded roughly to the national

backgrounds of the painters: French (Braque, Gleizes, Metzinger) and Spanish (Picasso, Gris, Picabia). Apollinaire's sympathies lay with both groups. He perceived how valuable for painting even a dry discipline of analytic cubism could be toward breaking new ground; and at the same time he understood the almost violently creative art of Picasso. His category of " scientific cubism " is confused, for it includes both Picasso and Metzinger, and his other classifications of " physical, orphic and instinctive cubism " are not well defined. But the lyric sentences Apollinaire has written seem almost to breathe the spirit of the new art. Of Picasso he says:

> A new man, the world is his new representation. He enumerates the elements, the details, with a brutality which is also able to be gracious. New-born, he orders the universe in accordance with his personal requirements, and so as to facilitate his relations with his fellows. The enumeration has epic grandeur, and, when ordered, will burst into a drama. One disagrees about a system, an idea, a date, a resemblance, but I do not see how anyone could fail to accept the simple act of enumerating.

This is as illuminating a passage as has been written on the artist, and the concept of " enumeration " is especially helpful in understanding the *collage* mode of cubism.

After treating Picasso thoroughly, Apollinaire comments on the revolutionary nature of Seurat's pictures and their kinship to scientific cubism, on the logic of Metzinger's art, and on the precise generalization of Gleizes. The sentimentality of Rousseau is cited and censured, yet this strange painter's trust in his own imagination and his unshakable will to embody it are justly praised. Apollinaire gives a poor and excessively harsh judgment of Gris, for this painter's compositions have a vitality which is logically and sensuously satisfying. One of the most significant paragraphs is that which suggests a correspondence between the organic titles of Picabia's paintings, the clippings and real objects in Braque's and Picasso's works, the linear arabesques in Marie Laurencin's backgrounds, and Léger's recurrent bubble-like shapes. They all serve as " inner frames " with the intuitively pictorial purpose of providing a fixed point of reality within the picture as well as around it.

Throughout this work Apollinaire puts an unexpected stress on light and colour. These elements were at first deliberately reduced in cubist art in favour of geometric arrangement and a formal analysis of

17

appearance. It was well for him to recall the attention of the artists to these essential qualities, but he occasionally spoke favourably of light where it had been used very weakly. Apollinaire, a non-painter, was entering territory where he could speak without restraint or prejudice. He called for the abandonment of verisimilitude as a standard. Above all, in keeping with the force of his own character, he demanded that the new cubist art be unafraid and inhuman, "the painter contemplating his own divinity". Some of his statements, it is true, stagger a little under the weight of their own magnificence, but his very lack of inhibition produced a book which has been superseded in substance but not in spirit. *Cubism*, by Gleizes and Metzinger, which appeared the year after Apollinaire's book, is a rigid codification of practices which the cubists had followed, but there is little imaginative power in its categorical statements. The only subsequent work that has tried to reach the core of cubist art is Henry Kahnweiler's recent work, *Juan Gris*. The care with which certain distinctions are made—especially those between expressionist and constructivist deformation and between the concretion of cubism and the abstraction of other styles—makes this an important document for cubism, approached through one of its greatest exponents.

The significance of Apollinaire's critical work is considerable and as yet little documented. *L'Esprit Nouveau et les Poètes* made a forceful impression upon the generation of writers who were looking for new loyalties immediately after the first war. Dada and surrealism drew upon the abundance of his ideas. His criticism was never destructive but was rather a strong germinating force which produced further growth in the subjects it treated. There were many unbalanced individual judgments, but the final effect was always one of stimulus.

## IV

Poetry as usually read today, silently and from a monotonously printed text, fails to exploit its two principal sensuous aspects, its shape and its sound. If for nothing else, Apollinaire will be remembered as the poet who did not allow either of these elements to be passed over. Had it been feasable, he would undoubtedly have explored gustatory, olfac-

tory, and tactile sensations in verse, for he wrote of such possibilities. The physical properties of a book, however, restricted him.

The first experience in reading a poem is visual: a perception of dark figures arranged on a light surface (or *vice versa*). Although we are not usually conscious of this visual experience, we do occasionally react to this first impression. Small type without paragraphs discourages us; the imposing, unvarying march down the page of Milton's pentameter suggests the ponderousness and profundity of his thought; the familiar form of a sonnet, an almost universally recognized geometry, prepares us subtly for the concentrated organization of thought which constitutes this verse form. Seldom do we make any further use of the visual experience. Only when the element of surprise halts our customary reading do we pay close attention to the shape of a poem.

In the past there have been efforts to make a poem a distinct visual object. These efforts have usually relied on the principle of the ideogram, a representation of the object described by an arrangement of normal calligraphy. A few classic poets explored this type of writing; later, Panard, a French poet of the eighteenth century, and George Herbert in England produced a few examples. The majority of Apollinaire's poems are of normal shape, but in *Calligrammes*, as the title indicates, he attempted visual as well as verbal composition. One of the titles originally intended for a section of this volume was "Moi aussi je suis peintre". Twenty-eight of the poems in the volume are visually manipulated. He uses this plastic arrangement of words in three different fashions: to represent the objects being described; to represent a total conception of the order of the world or of the universe; and to express a movement of thought within the poem.

Examples of the first usage are numerous and they are not disturbing in that they almost seem to be excrescences of an imagist theory of poetry. "Paysage", "La Cravate et la Montre", and "Il Pleut" are poems in which the words themselves form the objects. They are amusing, unpretentious poems in which the text itself is usually meagre and shallow enough to gain from this visual addition. An illustration of the second type of calligram is "Lettre d'Océan" in which a representation of a full cosmology is the intention. The words are arranged in a very complicated fashion—around central points, running up and down the

page, broken into separate syllables or letters, and in many sizes of type. From this poem one does receive a certain impression of the distribution of the world in space, of distances which at the same time separate and link together remote places. But the lines are unreadable; thus sprinkled about the page, it is not a poem.

The third way of using words plastically is illustrated by " Visée " where the variations in position of the lines correspond to the shifting attitude of the poet. Of the eleven lines, the first makes a slight angle with the horizontal, an angle which is progressively increased until the concluding words climb vertically toward the top of the page. This gradual transition is very similar to the sensibility Apollinaire generally displayed, slowly turning his attention across the world and speaking of each object as it enters his field of vision. Thus in " Visée " the reader journeys through the various scenes described, understanding that the connection between lines is not one of logical sequence and that they are somehow related by the central theme of the impact of war. The other poems of this type are far less successful.

This third manner of writing for the eye corresponds very closely to what Mallarmé undertook in *Un Coup de Dés*. In this work the spaces in the page amount to silences—" subdivisions prismatiques de l'Idée ", and a " vision simultanée de la Page ". In Mallarmé, the page becomes a literary score in which the interrelationships of the phrases are expressed by rests and notations of value. Ezra Pound, E. E. Cummings, and Dylan Thomas have all paid some attention to the visual side of their verse. However, I can see only one instance in which the plastic manipulation of a poem is always advantageous. It is when the poet wishes the reader's entry into the poem to be not linear—as one reads lines of prose, that is—but gradual, simultaneous, and total—an experience that has neither bottom nor top nor left nor right. By choosing and arranging the size of the print, the skeleton of the poem can be made to stand out visibly from the lesser members and from the burden of verbal flesh. The fundamental shape of the poem can be immediately detected. We see a picture in this fashion, and verse does not have to be a highway of words followed inexorably across and down the page. Apollinaire wrote many useless bits of prettiness among his calligrammes, but he was exploring far more than simply a trick style. His own statement on his use of visual

effects is conclusive in the very rashness of its prediction. "Quant aux Calligrammes, ils sont une idéalisation de la poésie verslibriste et une précision typographique à l'époque où la typographie termine brillamment sa carrière à l'aurore des moyens nouveaux de reproduction qui sont le cinéma et le phonograph."

In the order of their occurrence to the reader, the second sensuous element of poetry is aural: the sound of the words in combination. Although Apollinaire made plastic objects out of several of his poems, his concern with sound was more profound and sustained than with appearance. It is the foundation of all his lyric work, and when the aural elements fail, the poem as a whole seldom holds up. In composing verse, he seems to have had two methods between which his work is polarized, and they explain to some extent the aural effects of his poetry. One method was to write while humming a tune to whose rhythm he could fit words. It seems to have been almost a mechanical means of keeping track of the meter, for Apollinaire was not musical. The other method was that of combining almost at random the odd sentences and phrases that occurred to him or that he overheard. "Poèmes conversations" he called these last. The degrees of tightness and looseness in Apollinaire's rhythms are defined by these two manners of composition. Several of the lyric poems in his work seem to be almost pure sound, whose exploration of vowel qualities, of alliteration, and of rime is simple and pleasing. One of his very early poems, "Voyage à Paris", is of such a nature.

> Ah la charmante chose
> Quitter un pays morose
> Pour Paris
> Qu'un jour
> Dut créer l'Amour
> Ah la charmante chose
> Quitter un pays morose
> Pour Paris                    [P. 200]

This work has been effectively set to music, and there is little more to it than the joyous modulation of sound around a few evocative words whose rime is almost the essence of the poem. A more striking example is the later poem, "Saltimbanques", of which I omit the first stanza.

Et les enfants s'en vont devant
Les autres suivent en rêvant
Chaque arbre fruitier se résigne
Quand de très loin ils lui font signe

Ils ont des poids ronds ou carrés
Des tambours des cerceaux dorés
L'ours et le singe animaux sages
Quêtent des sous sur leur passage          [P. 86]

The five nearly identical vowel sounds in the first line are startling and unforgettable, and the continuation of this hollow, deep nasal gives the haunting tone to both stanzas. The dreamlike atmosphere in which these ancient jugglers traverse the countryside emerges from the sounds themselves. Apollinaire was capable of this purity of sound from his earliest poems in *Le Bestiaire* to the last verse that he wrote, and it has kept him always a popular poet.

It is where Apollinaire combines his sensitivity to pure sound with the discipline of a consistently followed stanza form that his rhythms are the most successful. His two longest poems, " La Chanson du Mal-Aimé " and " Les Collines ", both use throughout a five line stanza and a line of eight syllables. The former is a work of about 1903, the latter of 1917, and their comparison is revealing. I quote a short section from each.

Beaucoup de ces dieux ont péri
C'est pour eux que pleurent les saules
Le grand Pan l'amour Jésus-Christ
Sont morts et les chats miaulent
Dans la cour je pleure à Paris

Moi qui sais des lais pour les reines
Les complaintes de mes années
Des hymnes d'esclaves aux murènes
La romance du mal-aimé
Et des chansons pour les sirènes

L'amour est mort j'en suis tremblant
J'adore des belles idoles
Les souvenirs lui ressemblant
Comme la femme de Mausole
Je reste fidèle et dolent          [P. 100]

\*   \*   \*

Jeunesse adieu jasmin du temps
J'ai respiré ton frais parfum
A Rome sur les chars fleuris
Chargés de masques de guirlandes
Et des grelots du carnaval

Adieu jeunesse blanc Noël
Quand la vie n'était qu'une étoile
Dont je contemplais le reflet
Dans la mer Méditerranée
Plus nacrée que les météores                    [P. 144]

It should be noted that outside of his free verse, Apollinaire seldom used
a line of more than eight syllables. He avoided, as in these two poems,
the dramatic cadences inherent in the Alexandrine, and there is seldom a
tendency in his verse to be declamatory. He was distinctly not a dramatic
poet, and his few attempts to write in that style, all in *Alcools*, are unsuc-
cessful. The lines quoted here are all sufficiently end-stopped to make
them recognizable as units. Within this unit there is no regular division
but a freely shifting caesura which is not emphasized. A line which
contains several pronounced breaks—periods, semicolons, or other
halting punctuation—tends to lose its identity as a line and becomes a
series of separate phrases. Apollinaire likewise treats all of the quoted
stanzas as units, completing the development of a thought within each
one and giving the space between stanzas logical as well as formal
significance.

The use of rime in these two poems is not similar, however, as is their
articulation of rime and stanza. It differs both in its scheme and in the
nature of the rimes employed. We can trace here the lines along which
Apollinaire's verse developed technically. "La Chanson" follows
throughout a semi-regular rime scheme of ABABA (compare Valéry's
AABCCB in his long reflective poem "Le Cimetière marin"). "Les
Collines" has no regular pattern but seems to rime at random—at times
a fully rimed stanza, at times a stanza neglecting rime entirely. In the
selection of the words composing the rimes, Apollinaire shows a similar
development toward liberty. His very early work in *Le Bestiaire* follows
the academic rules which prescribe that riming vowels or diphthongs be
orthographically identical. In the three stanzas above from "La Chan-

son " he is still riming regularly, although the rimes themselves often depart radically from the rules. By the time he wrote " Les Collines ", and before, Apollinaire was making his own rules. In the two stanzas quoted here, he uses the off rime, " Noël/étoile", and the loose combination, " reflet/Méditerranée ". In other sections he rimes singulars with plurals, stems with composite forms, words with themselves, and simple consonant sounds with any vaguely similar sound. Baudelaire, Rimbaud, and Hugo had previously broken the rules of rime, but never with this easy audacity. Louis Aragon, whose work is technically and thematically derivative from Apollinaire's, points out how his predecessor could be said to have redefined the way in which rimes are masculine or feminine. He treated all words ending in a consonant sound as feminine and those ending in a vowel or nasal sound as masculine. This new definition, applied to the academic rules, produced a whole new range of versification which poets are still exploring in French today. Apollinaire's development toward an almost totally unfettered versification still within the traditional forms aided the spread of these technical innovations.

Apart from the five line stanza, a ballad form in his hands, Apollinaire used many other fundamentally lyric forms. " A la Santé ", a work of great delicacy, is composed of six short songs, each of a slightly different form. They recall several of the influences upon his style. The sensitive lyricism of Heine and Nerval is clearly felt, as are certain Rennaissance and Provençal forms such as the rondel. When one adds the further haunting presence of liturgical rhythms, the similarity to Villon is apparent. There is little doubt that in certain poems Apollinaire had the work of Villon in mind. " Vendémiaire " begins: " Hommes de l'avenir souvenez-vous de moi". Both these men were troubadours, inspired by Paris, by a haunting sense of religious mystery, and by the wonder of the very words they were using.

The other general category of versification into which Apollinaire's poetry falls is free verse, including its extreme manifestations in his " poèmes conversations". Although he wrote increasingly in this form, he never found it suitable for all his expressions. No accurate statement can be made on the difference in content between the two styles; there would be too many exceptions to any such generality. Each poem is an

24

individual case, and Apollinaire can be just as disturbingly and painfully personal in a short lyric like " La Tzigane " as he can in a long, freely constructed poem like " Zone ". The only way to come to any critical conclusions about this free verse is to study closely the rhythms of the text itself. Here are seven lines from " Il y a ", each of them a separate sentence.

> Il y a un vaisseau qui a emporté ma bien-aimée
> Il y a dans le ciel six saucisses et la nuit venant on
>       dirait des asticots dont naîtraient les étoiles
> Il y a un sous-marin ennemi qui en voulait à mon amour
> Il y a mille petits sapins brisés par les éclats d'obus
>       autour de moi
>
>     . . . . . .
>
> Il y a le vaguemestre qui arrive au trot par le chemin de
>       l'Arbre isolé
> Il y a dit-on un espion qui rôde par ici invisible comme
>       l'horizon dont il s'est indignement revêtu et avec quoi
>       il se confond
> Il y a dressé comme un lys le buste de mon amour

In all these lines the expression of the thought is direct; there is no interference caused by twisting a natural word order so as to fit it into a stanza form. The statement of the first line is short and clear. The second line, however, is longer, and since the syntax is a little confused, the line is less effective than the first in spite of its imagery. The third line, like the first, reads with an easy rhythm; the word order defies change. The fourth line, since it ends with three short prepositional phrases, seems to trail off weakly. The order of the sentence could be changed to advantage by putting the anticlimactic " autour de moi " after the " Il y a ". This same criticism applies to the fifth line, a similar, unemphatic *mélange* of short phrases. The last two lines quoted illustrate a different point. Here the slow and complicated movements of the long line absorb the interest in a way which contrasts sharply with the harsh impact of the short line which follows. The surprise which the second of these two lines carries lies partially in the imagery and partially in the brevity of statement. This quotation is a random sample, and on the whole

Apollinaire shows a grasp of the technique of free verse. The most successful poems in this style are " Zone ", " Cortège ", " Les Fenêtres ", and " Un Fantôme de Nuées ".

This consideration of the sensuous side of Apollinaire's poetry permits only a restricted general statement. What appears to characterize all his verse, both the lyrics and the free verse, is an integrity of line, a desire to make each line a partially self-sufficient unit which does not depend too greatly upon the succeeding line. This integrity of line extends to an integrity of stanza and of the poem itself, and thus we arrive at the secret of his composition at its most successful. Each line is like a brick in a wall and is an essential part of the structure; yet each is still clearly defined and distinguishable within its setting. His lines are highly articulated syntactically and rhythmically. This composition testifies to an intrinsic logic in Apollinaire's vision, to a desire to avoid unnecessary complexities, and to a keen feeling for unity in his verse.

As evidence of the soundness of this construction, there is the fact of the total absence of punctuation from all Apollinaire's verse beginning with *Alcools*. Mme. Faure-Favier tells how he was so exasperated by the number of mistakes in the proofs of this volume that he inscribed on them one magnificent *delete* for all the punctuation. He then defended his position before his editor, Alfred Vallette, and several other poets. " La ponctuation n'est pas indispensable en poésie. . . Son rythme et sa cadence sont là dans ce but, lorsqu'elle est bien conçue par un vrai poète." In the same year he proclaimed the " suppression of punctuation " in his flamboyant Futurist Manifesto. That his poems stand as firmly without the assistance of punctuation can be demonstrated without great difficulty. For the most part his lines are sufficiently end-stopped to make each a unit—what I called above " integrity of line ". Passages where the divisions of thought fall regularly at the end of each line are easy to find; here, as a test, is a more difficult section from " L'Espionne ".

> Pâle espionne de l'Amour
> Ma mémoire à peine fidèle
> N'eut pour observer cette belle
> Forteresse qu'une heure un jour

The punctuation is not missed, for the sound carries one over the only

divided phrase, " cette belle/Forteresse ". Thus in the regular verse forms this gentle end-stopping makes the poems exceptionally lyric and well adapted to actual vocal rendition.* In the free verse poems, their near conversational tone means that the lines are broken where there is a natural pause. It is only rarely that a long, confusing, appositive clause or a suspended verb makes one feel the lack of commas. Along with the end-stopping of his lines, the simplicity of his syntax enabled him to dispense with punctuation. Apollinaire never allowed his style to become involved in the complexities which are both a merit and a weakness of Mallarmé's and Valéry's verse. It is the grammar of ordinary speech he writes, direct and unadorned.

The fundamental question in regard to Apollinaire's punctutation is whether he was justified in abolishing it entirely or whether he should simply have reduced it to a minimum, using it only where it could clarify the sense or the rhythm. I find that the cases of confusion caused by the absence of punctuation are so few and that its function in the poems before 1913 is so minor that his apparently defiant act of deletion was in reality a very reasonable correction. Poetry does gain a kind of purity on the page when it is not interrupted by the recurrence of black dots, and punctuation is a convenience more necessary to the typography of prose than that of poetry. Mallarmé preceded Apollinaire in this elimination of what was an increasingly superfluous element in the verse of both men. In recent poetry, especially French poetry, punctuation has been frequently supressed in this manner, or else carefully used only for rhythm and stress and not simply according to the rules of grammar.

The logic with which Apollinare composed his verse technically does not extend in the same manner to his vocabulary. Here he begins to show the more erratic side of his character, the desire to mix anomalous components. For the most part he clung to a simple language. The words which emerge like islands after several readings of his verse are resonant and clear:' rose, obus, ombre, couleur, souffler, flamboyer, danser, gaz, crépuscule, aube. He also uses distinctly common words which

* A considerable number of musicians have set Apollinaire's verse to music, among them Honegger, Rivier, Duret, and Poulenc. Besides Les Mamelles de Tirésias, already a part of the repertory of the Opéra Comique with lovely music by Poulenc, there is the opera, Casanova, not yet set to music.

frequently border on the vulgar: *pisser, cadavre, voyou, quémander, ventre, cul,* etc. Whatever convention tends to keep apart these two categories of words is non-existent in Apollinaire's verse. They are interspersed, not indiscriminately, but with calculated effect so that elements of lyric beauty, burlesque, and tragedy are all present. One of these elements may predominate, but the other two, hovering in the recesses of the words, prevent the poem from being in turn purely romantic, comic, or depressing. There is almost a dimensionality to every feeling through this admixture of vocabulary. Apollinaire's interest in words as such and in linguistics is apparent in many of his prose writings. In *La Femme Assise,* he devotes several pages to a study of the number of synonyms in general usage among soldiers for everyday objects. To him language was an organism whose life he could feel and influence. In order to create certain effects, he made unhesitating use of pedanticisms and exotic words. Greek and Oriental expressions appear as morsels to be relished by the tongue and the mind together: *cinyre, satyres, pyraustes, sphynx, cosaques, zaporogues,* and the like. Occasionally he chose a rare word or an archaic word, but neologisms are few. He was content with the already existing treasures of the language. Interjections, curses, onomatopoeia, slang, and barbarism all find a place in his work. He uses popular words not by writing dialect poems—a realist practice which would have had little interest for him—but by never hesitating to use the most apt and specific word, whatever its origin and usage. His vocabulary, therefore, in its deliberate combining of argot and pedantry with a choice of simple words, anticipates several of the paradoxical aspects of his character which will be elaborated later.

The punctuation and syntax of Apollinaire's verse, however, together with its aural and visual aspects are all by their very simplicity elements of clarity. I spoke at the start of a criterion applicable to all art: that it should present both clarity and mystery. These terms and the evaluations they permit can now be elucidated. The clarity of a literary work of art lies in its reference to experiences already familiar and available to the reader, which allow him to orient himself within this territory called art. The mystery points toward experience not yet known, to an extension of the consciousness. The tension between the two is essential in that neither is satisfying alone and that mystery must always be composed

partly of elements of clarity and of the familiar. The sensuous aspects of Apollinaire's verse depend principally upon simple, familiar sensations of the eye and of the ear. The aural rhythms are those of conversation and of song. The occasional visual manipulation is often successful in its attempt to be a representation of a common visual experience. When the plastic nature of the poem is not easily understood, it usually becomes an element not of mystery but of pure confusion. In the cadences and appearance of poetry as written by Apollinaire, there is always a framework of familiar sensations which afford that clarity which is half of art. To say that this sensuous side of his verse is without any effects of mystery would be innacurate, for at times a combination of sounds, by its insistent sonority or by its suprising ellipsis, can suggest or anticipate new experience. Nevertheless, Apollinaire showed an intuitive poetic talent in making the mechanics of his verse very simple. The lack of punctuation emphasizes rather than detracts from the limpidity and transparence of his surface. It is in Apollinaire's imagery and in the ideas which occupied him that we shall find the elements of mystery which he has kept out of the sensuous surface of his verse.*

<center>V</center>

The imagery Apollinaire uses is refreshing, often to the point of being disconcerting. Where the grammar of his sentence structure is at its simplest, he will often employ a " grammar " of the imagination which

---

* A brief, undeveloped statement by Jean Royère points up my contention here: " Son art est souvent une sorte de Mallarméisme renversé ". (" Sur Guillaume Apollinaire ", *Mercure de France*, Nov. and Dec., 1923). The characteristic difficulty of Mallarmé's work is that the mystery is on the surface—in the syntax, the vocabulary, and the symbols themselves. (Not however the versification.) The meaning, if one can with impunity separate that component, is often very simple but hidden behind a mask of complicated language and obscure references. This is not to say that Mallarmé is shallow. It rather means that his poems become more clear and precise as one pierces beyond the surface. In Apollinaire's verse on the other hand, the meaning tends to widen out to infinite proportions behind the surface which is transparent and offers no resistance to the understanding. Behind a poem of Mallarmé there is a convergence of ideas, whereas behind a poem of Apollinaire there is a divergence or radiation of ideas. It is in this sense of the movement of his meaning that Apollinaire is the inverse of Mallarmé.

is striking and highly compressed. Because of the audacity and control he showed in using such imagery, he has sometimes been called a "cubist" poet. The term is misleading, however, and we must examine his work before any such classification.

1/ Et les obus en tombant sont des chiens qui jettent de la terre
   avec leurs pattes après avoir fait leur besoins
2/ Les siphons enrhumés
3/ Cette dame a le nez comme un ver solitaire
4/ La forêt fuit au loin comme une armée antique
5/ Les bulles de niveaux qui remuent comme les yeux des chevaux
6/ Le troupeau de ponts bêle ce matin
7/ Les raisins de nos vignes . . .
   Ont la saveur du sang de la terre et du sel
8/ L'amour a remué ma vie comme on remue la terre dans la zone
   des armées

These selections show the range of Apollinaire's imagery both in tone and in the senses relied upon. There is humour (1, 2, 3, and 5) and a subtle melancholy (4, 5, and 8). He uses the sense of sight (1, 3, 4, and 5), hearing (2 and 6), and taste (7). The last (8) is a powerful kinesthetic image which affects all the senses. The trembling of the earth leaves no nerve intact. The variety of this quoted imagery typifies the variety in the whole of his verse, which therefore cannot be classified by its dependence upon a restricted sense perception. Blake, in this way, was "visual"; Joyce was "aural". Apollinaire made full use of all his senses and was subject to no natural or imposed restrictions.

A few sentences from Apollinaire's poetic doctrine should be of assistance in evaluating his imagery. They are from his critical statement, *L'Esprit Nouveau et les Poètes*.

Il y a mille combinaisons naturelles qui n'ont jamais été composées. Ils les imaginent et les mènent à bien, composant ainsi avec la nature cet art suprême qu'est la vie. . . Mais le nouveau existe bien sans être un progrès. Il est tout dans la surprise. L'esprit nouveau est également dans la surprise. C'est ce qu'il y a en lui de plus vivant, de plus neuf. *La surprise est le plus grand ressort nouveau. . .*

Le moindre fait est pour le poète le postulat, le point de départ d'une immensité inconnue où flambent les feux de joie de significations multiples.

C'est pourquoi le poète d'aujourd'hui ne méprise aucun mouvement de la nature.

We know from this same article that the new spirit is not a shattering of
all tradition, an indiscriminate departure from every manifestation of the
past. It is rather an assertion of certain principles whose observance will
lead to a continual extension of the poet's sensibility. This very insistence
upon advance becomes itself a tradition.

I should like to consider what Apollinaire has said about surprise and
about the poetic fact which is the point of departure for the poet, in
connection with *poetic transformation*. It is possible to distinguish two
uses of imagery: that of illustration and that of transformation. The
former employs a figure in order to bring out a certain aspect or meaning
of the object. In this process the object is never lost sight of, but is seen
in a new light or a new focus. The latter function, transformation, is
the use of a figure whose reality is made to be more forceful than that of
the object; the resulting new reality obliterates and is substituted for the
original. All this is not simply a circumlocution for the terms " simile "
and " metaphor ". These two words partially indicate the distinction I
am trying to make but they are not accurate. A simile, although it
usually only illuminates, can at times transform if its content is sufficiently
vivid. Surprise is the element of this vividness which Apollinaire stressed
to good purpose, for surprise obliges one to use all the faculties of the
imagination. Likewise a metaphor, although syntactically it does imply
a transformation, may be strong enough only to illustrate. Furthermore,
the terms transformation and illustration are applicable not only to single
figures but also to whole poems—ultimately to the entire work of a poet.
The attainment of a truly great poet lies not in how he illustrates the
world but how he transforms it to create a new reality.

The possibility of total transformation can be demonstrated by com-
paring the first and last sections of Apollinaire's poem, " Chevaux de
Frise ".

> Pendant le blanc et nocturne novembre
> Alors que les arbres déchiquetés par l'artillerie
> Vieillissaient encore sous la neige
> Et semblaient à peine des chevaux de frise

Entourés de vagues de fils de fer
Mon coeur renaissait comme un arbre au printemps
Un arbre fruitier sur lequel s'épanouissent
    Les fleurs de l'amour

    . . . . . .

Ton visage est un bouquet de fleurs
    Aujourd'hui je te vois non Panthère
      Mais Toutefleur
Et je te respire ô ma Toutefleur
Tous les lys montent en toi comme des cantiques
    d'amour et d'allégresse
Et ces chants qui s'envolent vers toi
     M'emportent à ton côté
    Dans ton bel Orient où les lys
Se changent en palmiers qui de leurs belles mains
Me font signe de venir

    . . . . . .

Et je t'aime comme tu m'aimes
    Madeleine                       [P. 188]

With a beautifully smooth movement the literal scene described in the
opening lines is transformed into a magical panorama of an entirely
different nature. The charm of love changes the depressing circumstances
of the snow in November, the artillery, and the cold night into " ton bel
Orient ". In the lines omitted, the scene slowly comes to life as is
anticipated by the figure of the fruit tree in the first stanza. There is a
crescendo of fertile imagery which finally reaches its peak in the word,
" Orient ", and then in a subordinate movement the transformation
subsides to what should be the literal level again with the final word,
" Madeleine ". But Madeleine is no longer simply a name; it is laden
with all the pageantry of the East and with all the passion of a soldier's
love. This poem has thus reached out toward a new reality not in the
spark of its figures alone but even more profoundly in its total move-
ment. It moves in a manner which is both surprising and inevitable.

The extent of this surprise is determined by the distance of the associa-
tive leap involved in the figure—that is, by the " courage of the imagina-

32

tion"* in connecting what are normally unrelated objects. Coleridge's definition of the imagination, " the reconciliation of discordant qualities ", is very close to this conception of surprise. The organization of the artist's mind in such a way that his experience is readily available to him to use in making significant associations is the essence of his creative originality. The sustaining of this organization is an act of courage. To go deeper than this into the problem is to become involved in a psychological study of the creative mind.

In this consideration of the function of the imagination there is contained a method of classifying imagery: according to the distance of the associative leap. The distance can be reckoned only in the nebulous terms of " normal " association, but most images do seem to fall easily into place somewhere along this scale. *It is not, however, a scale of value.* The biggest leap of the poet does not necessarily produce the best image (the chronic error of the avant-garde), for the gap may not be bridged by the mind of a careful and sensitive reader. Value is rather a matter of the extent to which the reader is compelled to make the desired association and the rôle it can play in extending his perception of the world. In this provisional scale of association, there are at one end the undemanding images of *cliché* poetry which call upon only those reactions close to the surface of the reader's mind; and at the other end are the extreme images, as of dada and surrealism, where the leap is often too great to allow any but a private span to be built from term to term. Upon this scale, Apollinaire's images are thickly scattered between the centre and the end on which only those images fall which spring from a violent exertion of the imagination.

Examples of imagery in which Apollinaire commits no outrage upon the sensibilities of the reader are most abundant in his early work. Many are extremely expressive without straining the element of surprise.

> Incertitude, ô mes délices
> Vous et moi nous nous en allons
> Comme s'en vont les écrevisses,
> A reculons, à reculons.                 [P. 58]

* I have borrowed this term from a short essay on Apollinaire and others by Wallace Fowlie, " Les Masques du Héros Littéraire," *Les Oeuvres Nouvelles,* 1944. " Le courage de son imagination est la mesure temporelle et spirituelle de tout artiste." p. 60.

This vivid quatrain from *Le Bestiaire* is both humorous and profound. The movement of a crayfish is familiar to most of us, and once the relationship has been pointed out to us between the tentative gestures of human uncertainty and the backward motion of a crayfish, we rejoice in the felicity of the association. Another very graphic simile, this one concerning the movement of pursuit, is found in " La Chanson du Mal-Aimé ", also an early work.

> Nous semblions entre les maisons
> Onde ouverte de la mer Rouge
> Lui les Hébreux moi Pharaon. . . [P. 94]

The Biblical story recalled is as available and as immediately applicable as the backward movement of a crayfish. Furthermore this conjuring up of characters from so distant a past that they are almost legendary lends a note of universality to the poem. The pursuit of the lover becomes a kind of eternal action in being associated with another pursuit of such ancient fame. At times however the simplicity of Apollinaire's imagery did fall into insipidity, a fault he was aware of in reworking his poems, as can be seen from his manuscripts. *Ombre de mon Amour*, a volume of the poems he sent as letters to Lou, is the best example of this weakness. Never corrected and not intended for publication in this form, these poems show the flaws of flatness and uninspired riming that are less frequent in the rest of his work. Behind all of his best lines one can feel the pressure of creation.

But it is not characteristic of Apollinaire's imagery to be restrained. In his later work he shows an increasing tendency to use images of disturbing vividness. These figures hover somewhere between gross humour and astonishing effectiveness; the range of experience they embrace is tremendous. Here are two in which he depicts the force with which love ravishes his passions (the combination of sounds in the second is brilliant).

> Et moi j'ai le coeur aussi gros
> Qu'un cul de dame damascène. . .
>
> L'amour lourd comme un ours privé
> Dansa debout quand nous voulûmes

Apollinaire could plunge even more deeply and more sustainedly into the labyrinths of free association and stride across vast territories of perception. At these moments he is most obviously the forerunner of the surrealists, employing one of two techniques: the erratic but often comprehensible gush of automatic writing, and the arbitrary and incoherent construction of the " poèmes conversations ". At the close of " Les Collines ", a long poem of uneven texture, the transition to unorthodox writing is made clear. He prepares us in one stanza for the sequences of surrealistic figures to follow and then at the end of the passage directs us to look back over the five stanzas of difficult imagery.

Maintenant je suis à ma table
J'écris ce que j'ai ressenti
Et ce que j'ai chanté là-haut
Un arbre élancé que balance
Le vert dont les cheveux s'envolent

Un chapeau haut de forme est sur
Une table chargée de fruits
Les gants sont morts près d'une pomme
Une dame se tord le cou
Auprès d'un monsieur qui s'avale

Le bal tournoie au fond du temps
J'ai tué le beau chef d'orchestre
Et je pèle pour mes amis
L'orange dont la saveur est
Un merveilleux feu d'artifice

Tous sont morts le maître d'hôtel
Leur verse un champagne irréel
Qui mousse comme un escargot
Ou comme un cerveau de poète
Tandis que chantait une rose

. . . . . .

Mais ce sont de petits secrets
Il en est d'autres plus profonds
Qui se dévoileront bientôt
Et feront de vous cent morceaux
A la pensée toujours unique                    [P. 144]

35

In his grandest tone of prophecy Apollinaire sets boldly out into the dangerous territory of free association, and in this passage he has been sufficiently restrained not to abandon all meaning. The emptiness of the gloves, the temptation of the apple, the death of the orchestra leader, and the sparkling of the champagne are all things to which meaning can be assigned. From the secret and unaccomplished sin of the second stanza we proceed to the need for violent demonstration in a life that has lost its direction. Finally, back on firm ground, we are told that these are only a few advance revelations. But beyond any attempt at exegesis, the images are undeniably striking. Hats and fruit are not quickly associated objects; gloves can be related to apples only through the omitted term of hands; and the man and woman, although standing next to one another, appear to be unconnected. The murder of the orchestra leader is here an *acte gratuit*; the sharp aroma of the orange is given the most vivid and specific figure in the passage—but one which surprisingly equates an olfactory sensation with a visual sensation. The linking of snail and brain is mildly unattractive, but this revulsion is immediately thrown into contrast by the mention of a rose. Thus one is battered back and forth through a repertory of emotions, sensations, attractions, withdrawals, and frustrations. In itself this short surrealistic passage is of a more consistent quality than the rest of "Les Collines", which often cannot sustain the attempted orphic tone.

In *Alcools*, Apollinaire utilized this imagery of wide association principally to season poems of traditional composition. In the early prose pieces, *Onirocritique* and *L'Enchanteur Pourrissant*, he gave full rein to the runaway imagination which he possessed from his earliest youth. Controlled for a time by the discipline of versification and by the force of simple lyric conceptions, it was to burst forth later in the visual innovations of *Calligrammes* and in such poems as "Souvenirs", "Océan de Terre", and "Les Collines". He became more certain of himself as time went on and dared to venture far into the reaches of surrealism where he is electrifying at his best moments. This element of surprise, of free association of objects in defiance of any ordinary compatibility or congruity, is a means of attaining what I have called the mystery of a work of art.

Apollinaire was truly a magician in his poetry. He wished to enchant

the world. Inanimate objects make sounds; subtle emotions take the shape of animals and gods; men are drowned alive in oceans where life continues; and in their daily actions ordinary people relive the fabulous deeds of legendary characters out of a distant past. Perhaps the most total and surprising transformation is worked on the war, to which Apollinaire assented as few modern poets have done. *Calligrammes* is full of poems which discover an astonishing beauty in the operations and accoutrements of war: the sound and sight of artillery, the quaking of the earth from marching troops, the slow encroachment of trenches upon the countryside, the fascination of no-man's-land, and the heart-breaking ascent of an airplane into a sky which it alone investigates. These things were not just illustrations of a fresh attitude toward war; through his gift of metamorphosis, Apollinaire made of them a new vision of the earth's beauty and man's dignity, tinged always with minor overtones of his melancholy. In spite of the ironic hints in this statement, René Guy Cadou understands the universal force of this vision.

> C'est le mérite d'Apollinaire d'avoir su faire tenir dans son oeil le monde sans bord qu'il a conçu comme un aveugle, préférant imaginer qu'accomoder, faisant gémir ce qui semblait condamné à rester une matière insensible.

But " preference " is not the word. It was his wilful courage to extend his transformations to the full. He built the world of his transformations upon a sound basis of familiar objects—buildings, streets, animals, weathers, and people. Among them his imagination moves mysteriously.

## VI

The passages quoted thus far, chosen to illustrate his style, give little idea of any singleness or unity in Apollinaire's content. In fact, his attention seems at first to be widely dispersed; he attached himself to as much of the world as his insatiable sensibilities could assimilate. Yet beneath the diffuseness of his interests, there is a center, a core, around which cluster the many subjects and ideas to which he turned.

*This core is a perpetual effort of self-identification.*

The nature of himself as an individual was the subject of his deepest investigations, but his purpose was not to separate himself from the rest of the world by this concentration upon his own ego. It was rather to

reach all the world through the very inclusiveness or extension of his self. This effort of self-discovery was no simple act of assertion or examination; it manifested itself in a number of forms and in various moods of happiness and distress. The two following examples, quoted at length to give a clear picture of his concern with the "I", illustrate two of its principal tones.

Un jour
Un jour je m'attendais moi-même
Je me disais Guillaume il est temps que tu viennes
Pour que je sache enfin celui-là que je suis
Moi qui connais les autres

Je les connais par les cinq sens et quelques autres
Il me suffit de voir leurs pieds pour pouvoir refaire ces gens à milliers
De voir leurs pieds paniques un seul de leurs cheveux
Ou leur langue quand il me plaît de faire le médecin
Ou leurs enfants quand il me plaît de faire le prophète. . .

Le cortège passait et j'y cherchais mon corps
Tous ceux qui survenaient et n'étaient pas moi-même
Amenaient un à un les morceaux de moi-même
On me bâtit peu à peu comme on élève une tour
Les peuples s'entassaient et je parus moi-même
Qu'ont formé tous les corps et les choses humaines

Temps passés Trépassés Les dieux qui me formâtes
Je ne vis que passant ainsi que vous passâtes
Et détournant mes yeux de ce vide avenir
En moi-même je vois tout le passé grandir                      [P. 74]

*     *     *

Je lègue à l'avenir l'histoire de Guillaume Apollinaire
Qui fut à la guerre et sut être partout
Dans les villes heureuses de l'arrière
Dans tout le reste de l'univers
Dans ceux qui meurent en piétinant dans le barbelé
Dans les femmes dans les canons dans les chevaux
Au zénith au nadir aux 4 points cardinaux
Et dans l'unique ardeur de cette veillée d'armes
Et ce serait sans doute bien plus beau
Si je pouvais supposer que toutes ces choses dans lesquelles je suis partout
Pouvaient m'occuper aussi
Mais dans ce sens il n'y a rien de fait
Car si je suis partout à cette heure il n'y a cependant que moi qui suis en moi
                                                              [P. 182]

In the first of these selections (from " Cortège ") Apollinaire clearly sets down the conviction of his own lack of identity as compared to his knowledge of his friends. He waited for himself as for another person whose acquaintance must be made. In this uncertainty there is a note of profound sadness, yet in the later sections of the poem he sees himself take a kind of provisional shape. In the very heaping up of familiar people his own personality finds a tenuous existence. It is the answer of *Alcools*, the young, sociable Apollinaire, surrounded by friends, lost for a short time but finding security and identity in the people about him.

Clearly the second selection (from " Merveilles de la Guerre ") asserts a far more positive conviction of identity. His own name now has a meaning in itself which he does not hesitate to use. The war especially, its battles, travels, promotions, hardships, and its insistence upon active participation in mass movements, gave Apollinaire a satisfaction he had not known before. The excitement with which he welcomed some of the circumstances of war has already been brought out, but his reactions were deeper than a surface acceptance. He had been active; he had extended himself. Having been in the war, he had been everywhere in the universe. He had come to contain the greatness of the world itself and the attainments of other men, and thus the exploration of himself was justified. In the last line of the second poem he attains the state of near exaltation in which " there is only I who am myself ". There is no longer a division of the world into I and not-I; the first person singular is capable of embracing all things. It is not a mystical experience, nor does Apollinaire ever lay claim to a special revelation. It is a complete attunement of the sensibilities of a poet to all he has ever felt and known.

In this same quotation from " Merveilles de la Guerre ", he implies the three principal ways in which he perceives his own expansion into these huge proportions: in time, in space, and in the sweeping power of love—primarily the love of women. These are the dimensions of his verse and of himself, and Marcel Raymond anticipates my analysis here in speaking of the " plasticity of the self ".

Une espèce d'esprit souterrain va pousser l'homme à expérimenter jusqu'à la limite les possibilitiés de métamorphose du moi, sa plasticité. En passant outre aux résistances de la raison et de l'habitude, aux consignes héritées, en violant les instincts, hors de toute voie tracée, peut-être parviendra-t-on à

enrichir d'autant sa nature et à prendre de son être global une nouvelle con-
science?...

The " I " within the dimension of time became a prophet. Apollinaire's
consciousness of his epoch made him lay claim to a rare vision into the
future. Restriction to the present moment is unnecessary, for all other
times grow naturally out of it. He foresaw the New Spirit affecting the
conduct of all mankind. At the same time all history was a very palpable
reality to which he referred in its remotest periods as easily and off-
handedly as if it were the news in the morning paper. He could thus
feel himself as a sort of hill (" Les Collines ") from which the view was
extensive in all directions.

It is unfortunate that this theme of prophecy and the extension of
himself to fill all time is often unsuccessful. To convey one's perception
of the future requires the possibility of describing that future. It must
usually be recorded in symbolic terms which will find their full inter-
pretation only after time has passed. Apollinaire did not have this sym-
bolic machinery at his disposal; he spoke more directly and more openly
than the symbolist poets. For this reason his assertion of prophetic
power, despite its apparent sincerity, often seems empty and unconvinc-
ing. Baudelaire who worked out a form for the future in terms of
colors, shapes, and places, and Rimbaud who did the same with more
violence and frenzy, are both more impressive in this respect than
Apollinaire. They had a better means of describing what they saw of
the future. There is one outstanding exception to this generalization:
" La Jolie Rousse ", a poem Apollinaire wrote shortly before his death.
It develops a transformation in which he comes to see the total possibility
of the future embodied in a single person whom he loves, " une adorable
rousse ". (It was his wife.) His devotion to this woman and to the spirit
she represents to him is so complete that he realizes he can be only pitiable
in the insufficiency of his expression. His very certainty of the future has
humbled him, and he finishes with a Villon-like appeal, " Ayez pitié de
moi ".

If Apollinaire's treatment of the self in time was occasionally weak,
his manner of investigating his identity in space was far more powerful.
The places he had visited in the world and the reaches of space which
surround it all laid claim to him. In the poem, " Zone ", the title suggests

its theme of the location of the individual expanding in space. The " tu " used throughout is addressed to the poet's own self. A section of the poem, too long to quote, describes the places he knows, the names of cities, oceans and rivers. It is a recitation of the locations which he still partially inhabits although his flesh is at the moment walking the streets of Paris. The consciousness of his simultaneous presence in so many places finally assumes the force of a stimulant.

> Et tu bois cet alcool brûlant comme ta vie
> Ta vie que tu bois comme une eau-de-vie [P. 124]

So intricate a geographical location leads to vertigo. It is a conquest of distance and of the separation which distance decrees to ordinary minds. In the calligraphic " Lettre-Océan " he attempts to leap any barrier of mileage between himself and his brother in America.

> J'étais au bord du Rhin quand tu partis pour le Mexique
> Ta voix me parvient malgré l'énorme distance
> Gens de mauvaise mine sur le quai à la Vera Cruz

He surpasses even geographic limitations to engage in cosmological voyages.

> Je chante toutes les possibilités de moi-même hors de ce monde et des
> autres
> Je chante la joie d'errer et la plaisir d'en mourir

The effort of identification has asserted itself to the utmost in these lines. The " I " has become all-inclusive.

The vigor with which Apollinaire affirmed his extension in time and space was exceeded only by the passion of the love with which he sought himself in other people. His friendship was spiritually very close to love; his purpose seemed to be always that of seduction. No relationship could long be cold or superficial, for he needed always to captivate the mind of the other. Several critics have treated his love poetry as if it were a separate category occasioned by specific circumstances. This approach is misleading in that it separates his passionate emotions of love from his similarly passionate relationship to the whole of the universe. Quite apart from their subject matter, a huge number of his poems are dedicated to his friends or mention them by name. Each poem is a deed, an act of

41

love, and an appeal for love. The term "self-expression", is insufficient to describe the drive which produced Apollinaire's poetry; a poem as he wrote it was often a gift or an act of protection or assistance. The theme of love of people runs through all his verse from the early "Dicts d'Amour à Linda" to "La Jolie Rousse". Any number of references could be made to poems where he is seeking his beloved with a voraciousness that is far more than physical. He needed people profoundly—as profoundly as he needed any part of himself, for, ultimately, they *were* himself. He speaks in *Le Bestiaire* of the friends "without whom I cannot live". "La Chanson du Mal-Aimé" is a prolonged and varied expression of this demanding love.

> Les cafés gonflés de fumée
> Crient tout l'amour de leurs tziganes
> De tous leurs siphons enrhumés
> Vers toi toi que j'ai tant aimée          [P. 94]

In poem after poem, in short lyrics and long free verse conversations with himself, he reveals an immense love for people, for animals, for things. In *Le Bestiaire*, every animal is somehow received into his life to make its contribution—the camel to allow him to travel, the crab to reveal to him his own backwardness, the mouse to make him feel the gnawings of despair. In "Vendémiaire" his heart goes out to all Europe, its cities and its people. A touching poem which Apollinaire has filled with his affection for his friends is the calligraphic "Le Jet d'Eau". The following lines are arranged in the shape of a spurting fountain.

> Où sont-ils Braque et Max Jacob
> Derain aux yeux gris comme l'aube
> Où sont Raynal Billy Dalize...
> Peut-être sont-ils mort déjà
> De souvenirs mon âme est pleine
> Le jet d'eau pleure sur ma peine

When Apollinaire was cut off from his friends at the time of his imprisonment, he wrote some of his most despairingly moving poetry. Through love he was related to the world; through love he became more certain of himself.

Within these dimensions of time, space, and love, Apollinaire did find himself, but not sustainedly. He both rejoiced and despaired in his intermittent knowledge of his identity and of the portion of the world he could encompass. Walt Whitman, with whose work we know Apollinaire was familiar, was a poet of startlingly similar compulsions. Certain passages from his work are very comparable to "Cortège", and one section from *Song of Myself* is worth quoting.

> These come to me days and nights and go from me again,
> But they are not the Me myself.

> Apart from the pulling and hauling stands what I am,
> Stands amused, complacent, compassionating, idle, unitary,
> Looks down, is erect, or bends an arm on an impalpable certain rest,
> Looking with side-curved head curious what will come next,
> Both in and out of the game and watching and wondering at it.

> Backward I see in my own days where I sweated through fog with linguists and contenders,
> I have no mockings or arguments, I witness and wait.

Other passages would reveal better Whitman's promiscuity in embracing the world, but here the similarity is too clear to miss. Whitman's confidence surpassed that of Apollinaire, all of whose poems, even the most expansive, contain moments of doubt and misery. Whitman also lacked the pervading humour which makes Apollinaire's personality far more acceptable. An ironic humility restrains the French poet from some of the extravagances of the other, and the sensitivity to the disparity and paradoxical nature of certain experiences which led Apollinaire eventually into surrealism, was lacking in Whitman's makeup. Introversion and extroversion become indistinguishable in the work of Whitman—a feat of some considerable importance—whereas the nature of Apollinaire's mind only made it possible for him to unite these two directions of thought at intervals.

In the case of Apollinaire, I think that there is a clear explanation of why he was absorbed in a continual attempt to establish his identity. There are times when his verse sounds as if it had been written in direct

answer to the question: Who are you? He launches into a long description of himself, his past, his surroundings, his friends, his sentiments. "Je suis", he says; "me voici . . ." And he turns his pockets inside out and strips himself in the desire to determine who he is.

Apollinaire, the facts of his biography reveal, lacked the security of identity that most men are surrounded by as they grow up. His background placed him within no single cultural, social, political, or even regional tradition. In describing his life I enumerated several of the factors in this lack of certainty, a lack of any externally imposed discipline or general attitude toward life which he could accept or reject. To begin with he had no father—and never anyone who replaced his father. Not on the surface but beneath it, illegitimacy troubled Apollinaire, and he had to find his place in the world of men without paternal aid. At the same time his wanderings across Europe during his first twenty years denied him the knowledge of a home. He was not long enough in any one place to assimilate a local tradition, until he settled in Paris. His wide studies and unpredictable reading were no help in placing him within any single culture. Thus, as well as having to be his own father, he had to create his own home and select his cultural tradition from among the many he knew. Finally, the religious education which deeply affected his youth, nevertheless did not provide him with a set of values by which he could live. He distorted and burlesqued the religious background of his childhood with obvious gusto, even though a genuine faith crept back into his thinking from time to time. This final source of identity then, the church and the security it offers, was unavailable to him.

With so many gaps in his life, Apollinaire naturally turned to those things which would make him sure of his position : the Bohemian life of Paris, the war, and, above all, his writing. I believe that he did ultimately achieve a certainty of himself which was solid because it was his own work. Yet it was an intermittent attainment which condemned him to many moments of despair. The tone of his life varies widely, and the peaks and the depressions are recorded with equal vividness. Since his life was entirely of his own choice and construction, there were few of the schizophrenic elements such as shattered the lives of Kafka, Rimbaud, Hart Crane, and the like. Each of these poets reacted violently against a combination of elements in his environment from which he

could only partially escape. They all felt the encirclement of their parents, their social class, their country, and their work, and their desire was to break out. (Or, in the case of Kafka, to retreat deeper into the impossible circumstances of life until they cancel each other out.) There is little happiness in these men; their sensibilities are intent upon their own tragedies. Apollinaire was not always happy, but his was not a problem of breaking with his environment. The very fact that he had constructed his own history attached him strongly to his past.

> J'ai eu le courage de regarder en arrière
> Les·cadavres de mes jours

He was content to be the result of his own past. After a childhood which established him in no tradition except that of a cosmopolitan Europe at the beginning of the twentieth century, Apollinaire forged for himself an " I " which had moments of greater scope than that of most poets who struggle painfully with the tradition thrust upon them from birth. The alternations of his self-discovery produced the two subordinate themes of tragedy and gaiety which color his work. When his search failed and when he felt the burden of restrictions on his imagination, he always sounded a pathetic note. The mood in which he wrote his name in the stanza below is totally different from that of " Merveilles de la Guerre ".

> Je suis Guillaume Apollinaire
> Dit d'un nom slave pour vrai nom
> Ma vie est triste tout entière
> Un écho répond toujours non
> Lorsque je dis une prière

This tragic aura spreads out over the great bulk of his work; any of the stanzas in " La Chanson du Mal-Aimé " is an example. The first line of " Zone " makes it felt immediately: " A la fin tu est las de ce monde ancien ". " Le Pont Mirabeau " is one of its most beautiful expressions.

The principal cause of melancholy was simply a consciousness of the elements of inescapable tragedy in the world: time passes, living creatures die, and man is always engaged in the pursuit of what is

inaccessible to him. The inexorability of time is the essence of this sense of the tragic. When Apollinaire did not succeed in rising above time to occupy it all, he was its most despondent victim. " Vienne la nuit sonne l'heure /Les jours s'en vont je demeure ". More than this he was profoundly disturbed by the emotions of his love relationships. He was never an easy man for a woman to live with, and he was extremely sensitive to the injury a woman can inflict. The biographical facts are not necessary to make the point that Apollinaire's poetry contains the essence of the melancholy that arose from his devotion to a few women. He was part libertine yet no fickle romantic; his passions were strong, insistent, and full of unusual demands.

If we add to the factors already mentioned only the frightening suddenness of his imprisonment, we have a fairly complete idea of the causes of Apollinaire's recurrent unhappiness. It haunts his verse with both the flagellant pathos of Villon and the lyric delicacy of Verlaine. These two poets, it will be remembered, also underwent shattering prison experiences.

But the sadness of Apollinaire's verse is balanced by a gaiety and a rich humour that enlivened his conversation as well. His effervescence led him to astonish, to entertain, and to captivate his audience.

> As-tu connu Guy au Galop
> Du temps qu'il était militaire
> As-tu connu Guy au Galop
> Du temps qu'il était artiflot
> A la guerre

The assurance of the moment allowed him to be gay instead of having to scour it for vestiges of his identity. In many of his works, humor became satire and burlesque; exaggeration is a device of which he made frequent use. Yet his gaiety of spirit found further and more curious manifestations. All of them could be considered as a form of his love of the exotic and mysterious. Magic fascinated him; anything fantastic or eccentric was sure to catch his attention, be it a rite of the church or the fortune telling of a gypsy. The great half-world of supernatural happenings is included in his verse and is the basis of the mysterious acts and subterranean movements with which it is filled. It is gay—yet it is serious, all this love of the fabulous and unusual. One paradox which obsessed him was

that of the fundamental similarity of mysticism and eroticism. " . . . le mysticisme touche le plus près à l'éroticisme", he wrote in the story, " L'Hérésiarque ". Erotic themes, bordering often on obscenity, inspire much of his work, and this interest led him to edit the series, *Les maîtres de l'Amour*, and to write several pornographic works both in prose and in verse. They are revealing, but his best work is not here. Most of the possible distastefulness is precluded by his reverence for the real values of sex. The beauty of the sexual act was indeed a mystical matter for him. He could be gross and heavy, yet this mood never seemed to last long. The eccentric side of his character was both playful and serious. In magical lore, in obscure texts, and in erotic literature he found materials to be brought into the stream of our lives. His themes are many, and his combinations of them novel and exciting.

## VII

The amazing reputation of Apollinaire—and its frequent inaccuracy and one-sidedness—require that any evaluation of him as a poet be very carefully made. He is probably the first truly European poet since Goethe, and his spirit and his work is widely known on the continent from which he drew his themes. His poems are never content to speak of France alone; their prophecies and conversations and descriptions are of all Europe. But his reputation seldom encompasses the whole man. He is known as the sensitive lyric poet, as the mystifying entertainer who could twist verse to his own unpredictable purposes, or as an erratic Paris bohemian. None of these is complete.

The evaluation of his poetry has already been begun herein according to the standard of a tension between mystery and clarity. Applied to his work as a whole, this standard gives him considerable stature as a poet. Clarity resides in the uncomplicated mechanics of his composition and in the familiarity of the objects to which he turned his sensibilities in order to transform them. The mystery resides in the world of new unities and relationships, of fresh experiences, which this transformation produced, and in the conviction with which he presented that world as real. It is

the world he would teach us to inhabit. The descriptions he gives us of Paris, of Europe, of love, of war, and of all of life are clear in the realism of their detail; however, from the undisturbed intervals between these details emanates the aura of magic and metamorphosis to which Apollinaire was so sensitive. This tension is most delicately established in his best poems: " Un Fantôme de Nuées ", " Crépuscule ", " Le Pont Mirabeau ", " Saltimbanques ", and sections from " Zone ", " La Chanson du Mal-Aimé ", " Les Collines ", and " Le Bestiaire ". One learns from a reading of these poems that physical reality is not a limit for the senses. It is rather a kind of screen, beautiful but really impalpable, through which we can pass to find unpredictable wonders beyond.

It is helpful in examining the submerged aspects of Apollinaire's work to consider the concept of *distortion*. We can approach the matter through his own comments on painting, for distortion was central to cubist practice. By distortion I mean any representation which violates the conventions upon which traditional representation is based. In an absolute sense any representation, any work of art, is a distortion of the world. However, by becoming accustomed to conventions of painting (Albertian vanishing-point perspective and the rectangular picture frame) and of poetry (syntactic construction and a recurring rhythm which arouses the imagination to poetic exercise), we accept as normal what are nevertheless artificial representations of nature. In *The Cubist Painters* Apollinaire writes thus:

> The picture will exist ineluctably. The vision will be entire, complete and its infinity, instead of indicating some imperfection, will simply express the relation between a newly created thing and a new creator....

> *Picasso: the world his creation.* The great revolution of the arts which he achieved almost unaided, was to make the world his new representation of it. Enormous conflagration.

Apollinaire is asserting a new freedom to flout the conventions which make a picture too facile an experience; it is a protest against the purely visual realism of impressionism in painting and against the annotative naturalism of Zola in literature. There must be creation—and we often see creation first and most vividly as distortion.

But distortion, to be art, cannot be a random defacement of the world. Cézanne's still lifes are a classic illustration of the reasoned use of distortion—the deforming of an object in order to make it conform to other objects and to the balance of composition. Distortion is both a manner of looking at the world and a technique of representing it. For instance Picasso's distinctly cubist *Le Poète* (1911) exists in a strong tension between the surface of the canvas and the spaces created through multiple geometrical constructions on that surface. We are not allowed any easy entry into the picture space, however, through a single perspective, nor is there a surface attractiveness of impressionist color. The picture is a sustained distortion; its purpose is to depict simultaneously several interrelated attitudes of the poet. Any one attitude we single out has been deformed in order to combine with the others. The distortion of any well-composed picture can be similarly analysed, whether the artist reasoned or intuited his transformation.

Apollinaire used distortion in order to include in one composition the states of gaiety and despair which alternately resulted from his quest for himself. In making this combination he took the final step toward discovering himself. Ordinary poetic images could not transform the world sufficiently for it to carry the meaning he desired. Therefore, in the natural fecundity of his imagination, he cultivated and arrived at surrealist distortion. By this means he surpassed in certain poems the intermittences of his emotions and combined the tragic and the comic into a new awareness where we feel the pull of both poles. It is not a hesitation between the two, not an indecision. It is so positive and so forceful an assertion of both attitudes that their contradictions fuse into fresh values. Apollinaire's particular technique of distortion has already been discussed: the animation of dead objects, the defiance of time and place, the most rash and distant of associations, and the gratuitous combination of things in order to produce unforeseen meanings. The usual logic both of reason and of our feelings is put aside in order to find the value of paradox insisted upon so tenaciously that it becomes a simple, positive fact.

To achieve this transformation, Apollinaire did not hesitate to enter realms whose fascination for him has already been mentioned. Magic recurs a great deal, its incantations, the names of its great figures, and

above all its supernatural powers of divination, resuscitation, conjuring, changing of appearance, and the like. But more than magic, mysticism is the tone of surrealism to which Apollinaire gave strong impetus. The absurd elements of the world are picked out to demonstrate their relevance to the understanding life. In physical objects and relationships are found all the enchantment and inspiration of supernatural belief. It becomes increasingly clear that Apollinaire felt no need or inclination to posit " another world " to which living spirits attain. Rather the material world itself, if manipulated and exploited to the full without the restraints normally observed upon absurdity, contradiction, and paradox, contains all the mystic promise of the future and of timelessness. The " I " which is entirely plastic within time and space and which sees the universe enjoying the same freedom, needs no further world. In " La Maison des Morts ", just as in *L'Enchanteur Pourrissant*, death does not remove either the spirit or the body from the material world; both are released from certain conventional limitations inherent in matter, but matter is still the locus of their existence.

The bravura association of physical objects will always extend the dimensions of the world, and it is according to this principle that we must approach the casual composition of Apollinaire's " poèmes conversations ". They are similar to the automatic writing in works like *Les Champs Magnétiques* which Breton and Soupault were to produce in a few years. They also anticipate the methods of surrealist painters like Tanguy, Seligmann, Ernst, and especially de Chirico (before 1920) and Dali. With the utmost clarity and meticulousness of painting technique they describe objects whose juxtaposition is both absurd and mysteriously suggestive. The emotional content of these poems is either nil or, if the spectator finds he can respond, explosive. A beautiful and restrained example of the power of surrealism—and also of the other features of Apollinaire's verse—is contained in the closing lines of " Un Fantôme de Nuées ". The delicately developed action creates a timelessness which is the greatest attainment of a work of art.

> Le petit saltimbanque fit la roue
> Avec tant d'harmonie
> Que l'orgue cessa de jouer
> Et que l'organiste se cacha le visage dans les mains

Aux doigts semblables aux descendants de son destin
Foetus minuscules qui lui sortaient de la barbe
Nouveaux cris de Peau-Rouge
Musique angélique des arbres
Disparition de l'enfant. . .
Mais chaque spectateur cherchait en lui l'enfant miraculeux
Siècle ô siècle des nuages                              [P. 164]

The profound emotion of the first few lines is movingly conveyed in complete bareness, but when the organ stops, the transformation begins as if by magic. Undoubtedly the theme here is immortality, a variation of the predominant theme of self-identity. The musician's fingers are both his heritage and the promise of the future. These swift changes, like a final cartwheel in the performance of a tumbler, bring us to the distant image of Indian cries. This is a tremendous leap which is difficult to interpret, yet surprise alone is not its purpose. It interjects a note of savagery into a scene of loveliness and grace; it is a vista suddenly opened and as quickly closed again, adding another dimension to the poem. Mystery is sustained to the last line in a kind of cry which explodes into the unknown gap between individuals in time and space. Each man, seeking in himself the graceful movements of the boy, suddenly perceives the infinite isolation in which he must exist—life becomes a " century of clouds ", a series of evasive realities of which this phantom boy is the most moving. The deceptive surface clarity of the poem leads one into depths where every man desperately seeks himself and understands that he must do violence to himself in order to make the discovery.

I am stressing Apollinaire's surrealist solution of the modern quest for identity because it seems to have been far more satisfying than his brief acceptance of other rôles and because it is important in its influence on subsequent developments in literature. Literary exploration today too often is unable to escape the ageing principles of surrealism. Before we can pass beyond the meshes of this doctrine, it must be thoroughly understood and assimilated. Apollinaire's boldly affirmative solution of the question which haunts all modern artists provides an early manifestation of surrealism where its qualities are still pure. In answer to the question: Who am I ? he states that he is not only what he chooses to be or what he thinks himself to be, but also everything

51

that he is shown to be by dream and hazard and past and future and every object in the physical world. To compare this answer with the answers of other modern writers points up significant differences. In Kafka, the search for identity became a retreat from himself into the very details of the search—a fear of real freedom and therefore an entanglement in increasingly unimportant decisions. His books are all a relation of encumbering circumstances, each of which his hero detests but which alone protect him from a fate he really fears. Hart Crane, a far different figure among American poets, is more typical in the manner in which he tried to skirt the personal problem by dissolving it in supposedly larger issues. He wrestled bravely with himself in his early verse (*Wine Menagerie, Recitative, Legend*), but in *The Bridge* he tried to transfer his attention to the nature of America and its myths and symbols. The fragments of *White Buildings*, despite their intensity, are not a sufficiently sure personal discovery to permit an undertaking of epic proportions. Apollinaire when he died was approaching a maturity in which he could perhaps have written a modern epic—an epic in the New Spirit such as he attributed to Picasso.

Having reached the principles of surrealist discovery, we are ready to consider again the so-called heresy discussed at the start of this essay: the separation of the three lives of the poet. Unflinching courage in facing the challenges of the absurd and paradoxical earned surrealism a precarious respect in a doubting world; and courage is the trait in terms of which we are able to refute the division of Apollinaire into man, myth, and poet. I must set aside now his many interesting but less important sides in order to speak of him as a hero. The word is awkward, but it must be used here. There are many ways in which Apollinaire was ordinary and ineffectual; but *his heroism lies in his having dared to live his art.* His sensibilities were not confined to writing or even to conversation; they guided equally his manner of living. Neither his art nor his life can be explained by calling it a compensation for the other. They are two manifestations of the same personality. The very dangerousness of his existence gave rise to the myth of a man whose life was an art.

What Apollinaire attained then, and what renders him so fascinating to a public which finds it hard to make any vital connection between art and life, is the *automatic life.* I spoke of it at the start as a way of acting in

that he is shown to be by dream and hazard and past and future and every object in the physical world. To compare this answer with the answers of other modern writers points up significant differences. In Kafka, the search for identity became a retreat from himself into the very details of the search—a fear of real freedom and therefore an entanglement in increasingly unimportant decisions. His books are all a relation of encumbering circumstances, each of which his hero detests but which alone protect him from a fate he really fears. Hart Crane, a far different figure among American poets, is more typical in the manner in which he tried to skirt the personal problem by dissolving it in supposedly larger issues. He wrestled bravely with himself in his early verse (*Wine Menagerie, Recitative, Legend*), but in *The Bridge* he tried to transfer his attention to the nature of America and its myths and symbols. The fragments of *White Buildings*, despite their intensity, are not a sufficiently sure personal discovery to permit an undertaking of epic proportions. Apollinaire when he died was approaching a maturity in which he could perhaps have written a modern epic—an epic in the New Spirit such as he attributed to Picasso.

Having reached the principles of surrealist discovery, we are ready to consider again the so-called heresy discussed at the start of this essay: the separation of the three lives of the poet. Unflinching courage in facing the challenges of the absurd and paradoxical earned surrealism a precarious respect in a doubting world; and courage is the trait in terms of which we are able to refute the division of Apollinaire into man, myth, and poet. I must set aside now his many interesting but less important sides in order to speak of him as a hero. The word is awkward, but it must be used here. There are many ways in which Apollinaire was ordinary and ineffectual; but *his heroism lies in his having dared to live his art*. His sensibilities were not confined to writing or even to conversation; they guided equally his manner of living. Neither his art nor his life can be explained by calling it a compensation for the other. They are two manifestations of the same personality. The very dangerousness of his existence gave rise to the myth of a man whose life was an art.

What Apollinaire attained then, and what renders him so fascinating to a public which finds it hard to make any vital connection between art and life, is the *automatic life*. I spoke of it at the start as a way of acting in

But distortion, to be art, cannot be a random defacement of the world. Cézanne's still lifes are a classic illustration of the reasoned use of distortion—the deforming of an object in order to make it conform to other objects and to the balance of composition. Distortion is both a manner of looking at the world and a technique of representing it. For instance Picasso's distinctly cubist *Le Poète* (1911) exists in a strong tension between the surface of the canvas and the spaces created through multiple geometrical constructions on that surface. We are not allowed any easy entry into the picture space, however, through a single perspective, nor is there a surface attractiveness of impressionist color. The picture is a sustained distortion; its purpose is to depict simultaneously several interrelated attitudes of the poet. Any one attitude we single out has been deformed in order to combine with the others. The distortion of any well-composed picture can be similarly analysed, whether the artist reasoned or intuited his transformation.

Apollinaire used distortion in order to include in one composition the states of gaiety and despair which alternately resulted from his quest for himself. In making this combination he took the final step toward discovering himself. Ordinary poetic images could not transform the world sufficiently for it to carry the meaning he desired. Therefore, in the natural fecundity of his imagination, he cultivated and arrived at surrealist distortion. By this means he surpassed in certain poems the intermittences of his emotions and combined the tragic and the comic into a new awareness where we feel the pull of both poles. It is not a hesitation between the two, not an indecision. It is so positive and so forceful an assertion of both attitudes that their contradictions fuse into fresh values. Apollinaire's particular technique of distortion has already been discussed: the animation of dead objects, the defiance of time and place, the most rash and distant of associations, and the gratuitous combination of things in order to produce unforeseen meanings. The usual logic both of reason and of our feelings is put aside in order to find the value of paradox insisted upon so tenaciously that it becomes a simple, positive fact.

To achieve this transformation, Apollinaire did not hesitate to enter realms whose fascination for him has already been mentioned. Magic recurs a great deal, its incantations, the names of its great figures, and

above all its supernatural powers of divination, resuscitation, conjuring, changing of appearance, and the like. But more than magic, mysticism is the tone of surrealism to which Apollinaire gave strong impetus. The absurd elements of the world are picked out to demonstrate their relevance to the understanding life. In physical objects and relationships are found all the enchantment and inspiration of supernatural belief. It becomes increasingly clear that Apollinaire felt no need or inclination to posit "another world" to which living spirits attain. Rather the material world itself, if manipulated and exploited to the full without the restraints normally observed upon absurdity, contradiction, and paradox, contains all the mystic promise of the future and of timelessness. The "I" which is entirely plastic within time and space and which sees the universe enjoying the same freedom, needs no further world. In " La Maison des Morts ", just as in *L'Enchanteur Pourrissant*, death does not remove either the spirit or the body from the material world; both are released from certain conventional limitations inherent in matter, but matter is still the locus of their existence.

The bravura association of physical objects will always extend the dimensions of the world, and it is according to this principle that we must approach the casual composition of Apollinaire's "poèmes conversations". They are similar to the automatic writing in works like *Les Champs Magnétiques* which Breton and Soupault were to produce in a few years. They also anticipate the methods of surrealist painters like Tanguy, Seligmann, Ernst, and especially de Chirico (before 1920) and Dali. With the utmost clarity and meticulousness of painting technique they describe objects whose juxtaposition is both absurd and mysteriously suggestive. The emotional content of these poems is either nil or, if the spectator finds he can respond, explosive. A beautiful and restrained example of the power of surrealism—and also of the other features of Apollinaire's verse—is contained in the closing lines of " Un Fantôme de Nuées ". The delicately developed action creates a timelessness which is the greatest attainment of a work of art.

> Le petit saltimbanque fit la roue
> Avec tant d'harmonie
> Que l'orgue cessa de jouer
> Et que l'organiste se cacha le visage dans les mains

> Aux doigts semblables aux descendants de son destin
> Foetus minuscules qui lui sortaient de la barbe
> Nouveaux cris de Peau-Rouge
> Musique angélique des arbres
> Disparition de l'enfant...
> Mais chaque spectateur cherchait en lui l'enfant miraculeux
> Siècle ô siècle des nuages [P. 164]

The profound emotion of the first few lines is movingly conveyed in complete bareness, but when the organ stops, the transformation begins as if by magic. Undoubtedly the theme here is immortality, a variation of the predominant theme of self-identity. The musician's fingers are both his heritage and the promise of the future. These swift changes, like a final cartwheel in the performance of a tumbler, bring us to the distant image of Indian cries. This is a tremendous leap which is difficult to interpret, yet surprise alone is not its purpose. It interjects a note of savagery into a scene of loveliness and grace; it is a vista suddenly opened and as quickly closed again, adding another dimension to the poem. Mystery is sustained to the last line in a kind of cry which explodes into the unknown gap between individuals in time and space. Each man, seeking in himself the graceful movements of the boy, suddenly perceives the infinite isolation in which he must exist—life becomes "century of clouds ", a series of evasive realities of which this phantom boy is the most moving. The deceptive surface clarity of the poem leads one into depths where every man desperately seeks himself and understands that he must do violence to himself in order to make the discovery.

I am stressing Apollinaire's surrealist solution of the modern quest for identity because it seems to have been far more satisfying than his brief acceptance of other rôles and because it is important in its influence on subsequent developments in literature. Literary exploration too too often is unable to escape the ageing principles of surrealism. Before we can pass beyond the meshes of this doctrine, it must be thoroughly understood and assimilated. Apollinaire's boldly affirmative solution of the question which haunts all modern artists provides an early manifestation of surrealism where its qualities are still pure. In answer to the question: Who am I ? he states that he is not only what he chooses to be or what he thinks himself to be, but also everything

total response to one's deepest nature without rejecting the contradictions or paradoxes inherent in that nature. This is not an entirely new endeavour, but the unflinching examination of its possibility becomes important principally in the literature of this century. It has been the tenor of Gide's writing through the years, and the " fervor " which he preaches is the devotion to a self which moves with increasing assurance toward what could be called the infinity of human nature. To deny any part of oneself is to choose death, and the only acceptable human discipline is that of shaping one's life to allow the completion of actions which commence deep inside one and whose ultimate direction cannot be foretold. André Breton, in *Nadja*, wrote directly and significantly of this automatic life, creating a character whose deeds at first seem so unrelated as not to add up to a human being. Yet Breton insists on the deeper truth: if each of Nadja's actions is followed back to its remotest origins beyond what we usually consider the seat of motivation, her actions will be found to converge and form a true person— but a person who partially escapes us because so much of her is hidden from our perceptions. We must attune ourselves to increasing areas of human nature, which will then gradually leave their submergence just as we are told that certain seacoasts are slowly rising to transform ocean bottom into dry land.

Considering the profound significance of the automatic life, it is not surprising that the legend of Apollinaire has become so strong. Doubtless it will continue to flourish as a force separate from his writing, just as the myth of Henri Rousseau will probably continue among painters and that of Erik Satie will continue among musicians. The real Apollinaire will bear many unveilings, many exposures. Yet occasionally this evasive figure seems to speak directly and frankly from the page, as in a letter to H. Martineau.

Toutefois, ce n'est pas la bizarrerie qui me plaît, c'est la vie quand on sait voir autour de soi . . . Je ne suis pas un grand liseur. . . Je n'ai jamais fait du farce et ne me suis livré à aucune mystification touchant mon oeuvre ou celle des autres. . .

Je crois n'avoir point imité, car chacun de mes poèmes est la commémoration d'un événement de ma vie et le plus souvent il s'agit de tristesse. Mais j'ai des

joies aussi que je chante. Je suis comme ces marines au bord de la mer qui amènent tant de choses imprévues où les spectacles sont toujours neufs et ne lassent point, mais brocanteur me paraît un qualificatif très injuste pour un poète qui a écrit un si petit nombre de pièces dans le long espace de quinze ans.

There is pathos and self-pity here, yet there is also a loyalty and above all a seriousness of purpose which he will not allow anyone to challenge.

A final statement must depart from documentation and employ only the universal terms which place Apollinaire in a true perspective. I have called him a " hero-poet "—hero because he had the courage to follow the beckonings of his irrepressible imagination in both his work and his life. Courage leads us to consider two complementary aspirations which compose one way of regarding all human endeavour: the quest for safety and the quest for danger. Neither is an ultimate value, for neither is satisfying alone. Moses set out to lead the Jews to the safety of the Promised Land, yet the accompanying dangers have made this an epic story. Christ, stating that salvation is found only by first putting everything one had in jeopardy, made a supreme paradox of the two aspirations. But there are less equivocal manifestations of the two currents than these. Icarus and Columbus and their bold progeny have always sought the unpredictable rewards of danger. On the other hand the fable of the Grasshopper and the Ant and hundreds of others like it confront us at an early age with the importance of safety and security.

Apollinaire seems at first to be completely contained within the tradition of danger, risking the loss of all normal joys to voyage with his reckless imagination to remote continents of happiness—or despair. But this observation is not conclusive. As the Christian religion is a paradoxical reconciliation of the two impulses, the great artist truly seeks safety in what appears to be danger. What Apollinaire had to search for was the security of his identity, but he could not be content with any easily discovered self. Until he had touched the limits of his individuality, just as Columbus had to touch what he thought were the limits of the world, he could not relax his quest. Apollinaire cultivated danger to find the safety which alone could satisfy him, and even this intermittently won safety is too challenging and too immense for many of us to see it as anything but dangerous.

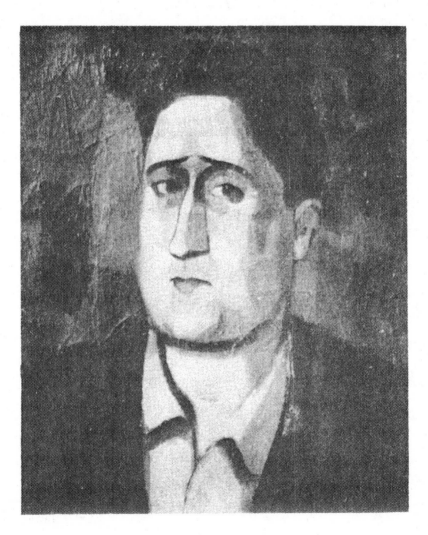

PORTRAIT OF APOLLINAIRE BY METZINGER

# VERSE

# LE BESTIAIRE

ORPHÉE

Admirez le pouvoir insigne
Et la noblesse de la ligne:
Elle est la voix que la lumière fit entendre
Et dont parle Hermès Trismégiste en son Pimandre.

LE CHEVAL

Mes durs rêves formels sauront te chevaucher,
Mon destin au char d'or sera ton beau destin
Qui pour rênes tiendra tendus à frénésie,
Mes vers, les paragons de toute poésie.

LA CHÈVRE

Les poils de cette chèvre et même
Ceux d'or pour qui prit tant de peine
Jason, ne valent rien au prix
Des cheveux dont je suis épris.

LE SERPENT

Tu t'acharnes sur la beauté.
Et quelles femmes ont été
Victimes de ta cruauté!
Ève, Eurydice, Cléopâtre;
J'en connais encore trois ou quatre.

LE CHAT

Je souhaite dans ma maison:
Une femme ayant sa raison,
Un chat passant parmi les livres,
Des amis en toute saison
Sans lesquels je ne peux pas vivre.

LE DROMADAIRE

Avec ses quatre dromadaires
Don Pedro d'Alfaroubeira
Courut le monde et l'admira.
Il fit ce que je voudrais faire
Si j'avais quatre dromadaires.

# THE BESTIARY

**ORPHEUS**    Admire the signal forcefulness
And true nobility of line;
It is the voice which light makes audible,
Which Hermes talked of in hermetic books.

**THE HORSE**    My strict and formal dreams ride up to you,
My fate will make me coachman for your car
Whose reins, straining in violence, will be
My verses, paragons of poetry.

**THE GOAT**    The coat which this goat wears, and even more
The Golden Fleece which Jason battled for
Are worthless, reckoning the treasure of
The hair I am enamoured of.

**THE SNAKE**    Beauty alone arouses you,
And what unrivalled women are
The victims of your cruelty!
Eve, Cleopatra, Eurydice:
I myself know two or three.

**THE CAT**    I want in my own home:
A wife of sound reason
A cat among the books
Friends in every season
Without which I cannot live.

**THE
DROMEDARY**    Four dromedaries bearing him
Don Pedro of Alfaroubeira
Enjoyed the world while traveling.
He did what I should love to do
Four dromedaries bearing me.

LA SOURIS    Belles journées, souris du temps,
             Vous rongez peu à peu ma vie.
             Dieu ! Je vais avoir vingt-huit ans,
             Et mal vécus, à mon envie.

L'ÉLÉPHANT   Comme un éléphant son ivoire,
             J'ai en bouche un bien précieux.
             Pourpre mort ! . . . J'achète ma gloire
             Au prix des mots mélodieux.

L'ÉCREVISSE  Incertitude, ô mes délices
             Vous et moi nous nous en allons
             Comme s'en vont les écrevisses,
             A reculons, à reculons.

SIRENES      Saché-je d'où provient, Sirènes, votre ennui
             Quand vous vous lamentez, au large, dans la nuit ?
             Mer, je suis comme toi, plein de voix machinées
             Et mes vaisseaux chantants se nomment les années.

ORPHÉE       Que ton cœur soit l'appât et le ciel la piscine !
             Car, pécheur, quel poisson d'eau ou bien marine
             Egale-t-il, et par la forme et la saveur,
             Ce beau poisson divin qu'est JESUS, Mon Sauveur ?

LE PAON      En faisant la roue, cet oiseau
             Dont le pennage traîne à terre
             Apparaît encore plus beau,
             Mais se découvre le derrière.

| | |
|---|---|
| THE MOUSE | Lovely days, the mice of time, |
| | You slowly gnaw my life away. |
| | O God! I shall be twenty-eight, |
| | Years poorly spent, I am afraid. |
| | |
| THE ELEPHANT | As an elephant grows ivory |
| | I bear in my mouth a precious gift. |
| | O purple death!... I buy my fame |
| | At the expense of tuneful words. |
| | |
| THE CRAYFISH | Uncertainty, O my delight |
| | You and I must move along |
| | As crayfish always move in flight, |
| | Backwards, though it may seem wrong. |
| | |
| THE SIRENS | Could I know, Sirens, whence your troubles rise |
| | When you proclaim your sorrows to the skies? |
| | Like you, Sea, I have voices filled with fears, |
| | My singing ships are grievously called years. |
| | |
| ORPHEUS | Bait with your heart your hook, to cast in the sky's |
| | Deep pool. For, fisherman, what ocean catch |
| | Can equal both in form and in delight |
| | This holy fish, my Saviour, Jesus Christ. |
| | |
| THE PEACOCK | By spreading his tail this bird so fair, |
| | Whose plumage drags the forest floor, |
| | Appears more lovely than before, |
| | But thus unveils his derrière. |

# CREPUSCULE

*A Mademoiselle Marie Laurencin*

Frôlée par les ombres des morts
Sur l'herbe où le jour s'exténue
L'arlequine s'est mise nue
Et dans l'étang mire son corps

Un charlatan crépusculaire
Vante les tours que l'on va faire
Le ciel sans teinte est constellé
D'astres pâles comme du lait

Sur les tréteaux l'arlequin blême
Salue d'abord les spectateurs
Des sorciers venus de Bohême
Quelques fées et les enchanteurs

Ayant décroché une étoile
Il la manie à bras tendu
Tandis que des pieds un pendu
Sonne en mesure les cymbales

L'aveugle berce un bel enfant
La biche passe avec ses faons
Le nain regarde d'un air triste
Grandir l'arlequin trismégiste

# TWILIGHT

*To Mademoiselle Marie Laurencin*

Grazed by the shadows of the dead
Where day expires on the grass
Columbine takes off her clothes
Looks at her body in the pool

A charlatan out of the dusk
Praises the tricks to be performed
The sky is colorless and set
With Constellations pale as milk

From platform height the harlequin
Wanly salutes the audience
Magicians from Bohemia
Some fairies and some sorcerers

He brandishes with outstretched arms
The star he unhooked from the night
And all the while a hanged man rings
A cymbal with his hanging feet

The blind man rocks a lovely child
The roe walks by with all her fauns
The dwarf regards with sad demean
The magic growth of harlequin

# LA TZIGANE

La tzigane savait d'avance
Nos deux vies barrées par les nuits
Nous lui dîmes adieu et puis
De ce puits sortit l'Espérance

L'amour lourd comme un ours privé
Dansa debout quand nous voulûmes
Et l'oiseau bleu perdit ses plumes
Et les mendiants leurs *Ave*

On sait très bien que l'on se damne
Mais l'espoir d'aimer en chemin
Nous fait penser main dans la main
A ce qu'a prédit la tzigane

# THE GYPSY

The gypsy knew ahead of time
Our secret night-imprisoned lives
We said good-bye to her and hope
Sprang without reason from that well

Love like a lugubrious bear
Danced upright at our slightest will
The blue-bird lost his lovely plumes
And all the mendicants their beads

You know when you have damned yourself
But hopes of love along the way
Make us think hand in hand of what
The gypsy once foretold for us

# LE PONT MIRABEAU

Sous le pont Mirabeau coule la Seine
Et nos amours
Faut-il qu'il m'en souvienne
La joie venait toujours après la peine

Vienne la nuit sonne l'heure
Les jours s'en vont je demeure

Les mains dans les mains restons face à face
Tandis que sous
Le pont de nos bras passe
Des éternels regards l'onde si lasse

Vienne la nuit sonne l'heure
Les jours s'en vont je demeure

L'amour s'en va comme cette eau courante
L'amour s'en va
Comme la vie est lente
Et comme l'Espérance est violente

Vienne la nuit sonne l'heure
Les jours s'en vont je demeure

Passent les jours et passent les semaines
Ni temps passé
Ni les amours reviennent
Sous le pont Mirabeau coule la Seine

Vienne la nuit sonne l'heure
Les jours s'en vont je demeure

# LE PONT MIRABEAU

Under the pont Mirabeau flows the Seine
Our loves flow too
Must it recall them so
Joy came to us always after pain

    May night come and the hours ring
    The days go by and I remain

Facing each other hand in hand
Thus we will stand
While under our arms' bridge
Our longing looks pass in a weary band

    May night come and the hours ring
    The days go by and I remain

Love leaves us like this flowing stream
Love flows away
How slow life is and mild
And oh how hope can suddenly run wild

    May night come and the hours ring
    The days go by and I remain

May the long days and the weeks go by
Neither the past
Nor former loves return
Under the pont Mirabeau flows the Seine

    May night come and the hours ring
    The days go by and I remain

# LES FIANÇAILLES

*A Picasso*

Le printemps laisse errer les fiancés parjures
Et laisse feuilloler longtemps les plumes bleues
Que secoue le cyprès où niche l'oiseau bleu

Une Madone à l'aube a pris les églantines
Elle viendra demain cueillir les giroflées
Pour mettre aux nids des colombes qu'elle destine
Au pigeon qui ce soir semblait le Paraclet

Au petit bois de citronniers s'enamourèrent
D'amour que nous aimons les dernières venues
Les villages lointains sont comme leurs paupières
Et parmi les citrons leurs cœurs sont suspendus

Mes amis m'ont enfin avoué leur mépris
Je buvais à pleins verres les étoiles
Un ange a exterminé pendant que je dormais
Les agneaux les pasteurs des tristes bergeries
De faux centurions emportaient le vinaigre
Et les gueux mal blessés par l'épurge dansaient
Etoiles de l'éveil je n'en connais aucune
Lec becs de gaz pissaient leur flamme au clair de lune
Des croque-morts avec des bocks tintaient des glas
A la clarté des bougies tombaient vaille que vaille
Des faux cols sur des flots de jupes mal brossées
Des accouchées masquées fêtaient leurs relevailles
La ville cette nuit semblait un archipel
Des femmes demandaient l'amour et la dulie
Et sombre sombre fleuve je me rappelle
Les ombres qui passaient n'étaient jamais jolies

66

# THE BETROTHAL

*To Picasso*

The spring time lets the perjured lovers stray
And quietly brings out the bluish plumes
Which cypresses shake down where blue-birds nest

At dawn a Madonna picked some eglantine
Tomorrow she will gather fragrant cloves
To line the doves' nests and for one rare bird
Which looks this evening like the Paraclete

The last arrivals in the lemon grove
Fell in love and love love as we do
The villages are eyelids from afar
And their hearts dangle in the lemon trees

My friends finally admitted their contempt
Out of brimming glasses I drank down the stars
And while I slept an angel massacred
The lambs and shepherds of a woeful fold
Some false centurions brought vinegar
The wounded wretches danced as the purge took hold
I put my faith in no star's auguries
The gas-jets pissed their silent flame in the moonlight
The undertakers banged their steins of bock
By candle light for better or for worse
Some collars fell on full and unbrushed skirts

Women were churched in masks after delivery
That night the city was an archipelago
Women demanded love and reverence
And somber somber river I recall
How sad the shadows were which passed

Je n'ai plus même pitié de moi
Et ne puis exprimer mon tourment de silence
Tous les mots que j'avais à dire se sont changés en étoiles
Un Icare tente de s'élever jusqu'à chacun de mes yeux
Et porteur de soleils je brûle au centre de deux nébuleuses
Qu'ai-je fait aux bêtes théologales de l'intelligence
Jadis les morts sont revenus pour m'adorer
Et j'espérais la fin du monde
Mais la mienne arrive en sifflant comme un ouragan

J'ai eu le courage de regarder en arrière
Les cadavres de mes jours
Marquent ma route et je les pleure
Les uns pourrissent dans les églises italiennes
Ou bien dans de petits bois de citronniers
Qui fleurissent et fructifient
En même temps et en toute saison
D'autres jours ont pleuré avant de mourir dans des tavernes
Ou d'ardents bouquets rouaient
Aux yeux d'une mulâtresse qui inventait la poésie
Et les roses de l'électricité s'ouvrent encore
Dans le jardin de ma mémoire

Pardonnez-moi mon ignorance
Pardonnez-moi de ne plus connaître l'ancien jeu des vers
Je ne sais plus rien et j'aime uniquement
Les fleurs à mes yeux redeviennent des flammes
Je médite divinement
Et je souris des êtres que je n'ai pas créés
Mais si le temps venait ou l'ombre enfin solide
Se multipliait en réalisant la diversité formelle de mon
    amour
J'admirerais mon ouvrage

I no longer have pity for myself
Nor can I express my torment of silence
All the words I have to say have become stars
An Icarus tries to rise as high as each of my eyes
And like a sun god I flame between these two nebulae
What have I done to the theological beasts of the mind
At one time the dead came back to revere me
And I hoped for the end of the world
But mine arrived whistling like a hurricane

I have had the courage to look behind me
At the corpses of my days
Which strew my path and I mourn them
Some rot inside Italian churches
Or else in little lemon groves
Which blossom and bear fruit
At the same time and in all seasons
Other days cried before they died in taverns
Where vivid bouquets were wheeling about
Before the eyes of a mulatto woman who improvised
    poetry
And the roses of electricity still open
In the garden of my memory

Forgive my ignorance
Forgive me for no longer knowing the old game of riming
I know nothing any more and I can only love
The flowers in my eyes become flames again
I meditate with divine power
And I smile at beings which I have not created
But if the time came when shadow took solid form
And multiplied so as to show the formal diversity of my
    love
I should admire my work

69

J'observe le repos du dimanche
Et je loue la paresse
Comment comment réduire
L'infiniment petite science
Que m'imposent mes sens
L'un est pareil aux montagnes au ciel
Aux villes à mon amour
Il ressemble aux saisons
Il vit décapité sa tête est le soleil
Et la lune son cou tranché
Je voudrais éprouver une ardeur infinie
Monstre de mon ouïe tu rugis et tu pleures
Le tonnerre te sert de chevelure
Et tes griffes répètent le chant des oiseaux
Le toucher monstrueux m'a pénétré m'empoisonne
Mes yeux nagent loin de moi
Et les astres intacts sont mes maîtres sans épreuve
La bête des fumées à la tête fleurie
Et le monstre le plus beau
Ayant la saveur du laurier se désole

A la fin les mensonges ne me font plus peur
C'est la lune qui cuit comme un œuf sur le plat
Ce collier de gouttes d'eau va parer la noyée
Voici mon bouquet de fleurs de la Passion
Qui offrent tendrement deux couronnes d'épines
Les rues sont mouillées de la pluie de naguère
Des anges diligents travaillent pour moi à la maison
La lune et la tristesse disparaîtront pendant
Toute la sainte journée
Toute la sainte journée j'ai marché en chantant
Une dame penchée à sa fenêtre m'a regardé longtemps
M'éloigner en chantant

I observe the repose of Sunday
And I praise its listlessness
How how reduce
The infinitely small knowledge
Which my senses thrust on me
One alone is equal to mountains to the sky
To cities to my love
It is like the seasons
It lives decapitated and its head is the sun
And the moon is its lopped neck
I wanted to experience an infinite passion
The monster in my ear roared and cried
Thunder does you for hair
And your claws repeat bird-songs
The monstrousness of touch pierces and poisons me
My eyes swim far away
And the remote stars are my untested masters
The beast of smoke with the flowered head
And the most attractive monster
Who carries the scent of laurel is in despair

Finally lies frighten me no more
It is the moon which fries like an egg in the pan
This necklace of drops of water will adorn the drowned
    woman
Here is my bouquet of passion flowers
Which offer tenderly two crowns of thorns
The streets are wet with the water of other days
Diligent angels work at home for me
Sadness will disappear with the moon during
The whole blessed day
The whole blessed day I walked about singing
A woman leaning out of her window watched me for a
    long time
As I went away singing

Au tournant d'une rue je vis des matelots
Qui dansaient le cou nu au son d'un accordéon
J'ai tout donné au soleil
Tout sauf mon ombre

Les dragues les ballots les sirènes mi-mortes
A l'horizon brumeux s'enfonçaient les trois-mats
Les vents ont expiré couronnés d'anémones
O Vierge signe pur du troisième mois

Templiers flamboyants je brûle parmi vous
Prophétisons ensemble ô grand maître je suis
Le désirable feu qui pour vous se dévoue
Et la girande tourne ô belle ô belle nuit

Liens déliés par une libre flamme Ardeur
Que mon souffle éteindra O Morts à quarantaine
Je mire de ma mort la gloire et le malheur
Comme si je visais l'oiseau de la quintaine

Incertitude oiseau feint peint quand vous tombiez
Le soleil et l'amour dansaient dans le village
Et tes enfants galants bien ou mal habillés
Ont bâti ce bûcher le nid de mon courage

At a corner I saw some sailors
Who danced with bared throats to an accordion
I gave everything to the sun
Everything but my shadow

Dredges packs and half-drowned sirens
Three-masters sink below the misty horizon
The winds died crowned with sea anemones
O Virgin pure sign of the third month

I smoulder in the midst of flaming templars
O master let us prophesy as one
I am your exquisite devoted flame
The fireworks unfurl the lovely night

Bonds are released by Ardor a leaping flame
Which my breath stops O dead at forty years
I sight both shame and glory in my death
As if I aimed at a quintain's bull's-eye mark

During your fall feigned painted bird of doubt
The sun and love were dancing in the street
Your galant children in their strange attire
Have built this pyre the nest my courage needs

# CORTEGE

*A M. Léon Bailby*

Oiseau tranquille au vol inverse oiseau
Qui nidifie en l'air
A la limite où notre sol brille déjà
Baisse ta deuxième paupière la terre t'éblouit
Quand tu lèves la tête

Et moi aussi de près je suis sombre et terne
Une brume qui vient d'obscurcir les lanternes
Une main qui tout à coup se pose devant les yeux
Une voûte entre vous et toutes les lumières
Et je m'éloignerai m'illuminant au milieu d'ombres
Et d'alignements d'yeux des astres bien-aimés

Oiseau tranquille au vol inverse oiseau
Qui nidifie en l'air
A la limite où brille déjà ma mémoire
Baisse ta deuxième paupière
Ni à cause du soleil ni à cause de la terre
Mais pour ce feu oblong dont l'intensité ira s'augmentant
Au point qu'il deviendra un jour l'unique lumière

Un jour
Un jour je m'attendais moi-même
Je me disais Guillaume il est temps que tu viennes
Pour que je sache enfin celui-là que je suis
Moi qui connais les autres

Je les connais par les cinq sens et quelques autres
Il me suffit de voir leurs pieds pour pouvoir refaire ces gens à
  milliers

74

# CORTEGE

*To M. Léon Bailby*

Tranquil bird in inverted flight bird
Nesting in air
At the limit where our sun still shines
Lower your other eyelid for the landscape dazzles you
Where you raise your head

And I also nearby am sad and wan
A fog which has just obscured the lanterns
A hand which is suddenly put in front of the eyes
A vault between you and every light
And I go away lighting myself up among shadows
And the ordered eyes of much loved stars

Tranquil bird in inverted flight bird
Nesting in air
At the limit where memory already shines
Lower your other eyelid
Neither because of the sun nor because of the land
But for this oblong fire whose intensity will grow
Until it is one day the only light

One day
One day I waited for myself
I said to myself Guillaume it's time you came
So I could know just who I am
I who know others

I know them by my five senses and a few more
It is enough to see their feet to be able to reconstruct
    thousands of them

De voir leurs pieds paniques un seul de leurs cheveux
Ou leur langue quand il me plaît de faire le médecin
Ou leurs enfants quand il me plaît de faire le prophète
Les vaisseaux des amateurs la plume de mes confrères
La monnaie des aveugles les mains des muets
Ou bien encore à cause du vocabulaire et non de l'écriture
Une lettre écrite par ceux qui ont plus de vingt ans
Il me suffit de sentir l'odeur de leurs églises
L'odeur des fleuves dans leurs villes
Le parfum des fleurs dans les jardins publics
O Corneille Agrippa l'odeur d'un petit chien m'eût suffi
Pour décrire exactement tes concitoyens de Cologne
Leurs rois-mages et la ribambelle ursuline
Qui t'inspirait l'erreur touchant toutes les femmes
Il me suffit de goûter la saveur du laurier qu'on cultive pour
     que j'aime ou que je bafoue
Et de toucher les vêtements
Pour ne pas douter si l'on est frileux ou non
O gens que je connais
Il me suffit d'entendre le bruit de leurs pas
Pour pouvoir indiquer à jamais la direction qu'ils ont prise
Il me suffit de tous ceux-là pour me croire le droit
De ressusciter les autres
Un jour je m'attendais moi-même
Je me disais Guillaume il est temps que tu viennes
Et d'un lyrique pas s'avançaient ceux que j'aime
Parmi lesquels je n'étais pas
Les géants couverts d'algues passaient dans leurs villes
Sous-marines où les tours seules étaient des îles
Et cette mer avec les clartés de ses profondeurs
Coulait sang de mes veines et fait battre mon cœur
Puis sur terre il venait mille peuplades blanches
Dont chaque homme tenait une rose à la main
Et le langage qu'ils inventaient en chemin
Je l'appris de leur bouche et je le parle encore

To see their frightened feet one of their hairs
Or their tongue when I play the doctor
Or their children when I play the prophet
The ships of amateurs the pen of my fellows
The money of the blind the hands of the deaf
Or else because of the vocabulary and not the writing
A letter written by anyone over twenty
It is enough for me to know the odor of their churches
The smell of the rivers in their cities
The scent of flowers in public gardens
Oh Corneille Agrippa the smell of a little dog is enough for me
To describe exactly your fellow citizens of Cologne
Their wise men and the Ursuline kyrie
Which inspired your error regarding all women
It is enough for me to know the scent of cultivated laurel
    to fall in love or to scoff
And to touch clothing
To have no doubts whether someone is chilly or not
Those people I know
It is enough to hear the sound of their steps
To be able to point out for all time the direction they have taken
All of this is enough to make me believe in the right
To raise the rest from the dead
One day I was waiting for myself
I said to myself Guillaume it's time that you came
And with a lyric step all those that I love came forward
And I was not among them
The giants covered with seaweed moved in their under-
    water cities
Where only the towers were islands
And this sea with the brightness of its depths
Flowed as blood in my veins and made my heart beat
Then there appeared on the earth a thousand white races
Of which each man held a rose in his hand
And the language they invented on the way
I learned from their mouths and I still speak it

Le cortège passait et j'y cherchais mon corps
Tous ceux qui survenaient et n'étaient pas moi-même
Amenaient un à un les morceaux de moi-même
On me bâtit peu à peu comme on élève une tour
Les peuples s'entassaient et je parus moi-même
Qu'ont formé tous les corps et les choses humaines

Temps passés Trépassés Les dieux qui me formâtes
Je ne vis que passant ainsi que vous passâtes
Et détournant mes yeux de ce vide avenir
En moi-même je vois tout le passé grandir

Rien n'est mort que ce qui n'existe pas encore
Près du passé luisant demain est incolore
Il est informe aussi près de ce qui parfait
Présente tout ensemble et l'effort et l'effet

The procession passed and I looked in it for my body
All these turned up and were not myself
Brought one by one the pieces of myself
They built me little by little as a tower is raised
The people heaped themselves up and I appeared myself
Who was formed of all bodies and all human things

The past the Dead The gods who created me
I live to move on as you yourselves have lived
And turning from the future's emptiness
I watch within me all the past arise

Nothing is dead but what has never been
The colored past outshines tomorrow's grey
Besides whose formlessness it can display
The sequence of the effort and effect

# A LA SANTE

## I

Avant d'entrer dans ma cellule
Il a fallu me mettre nu
Et quelle voix sinistre ulule
Guillaume qu'es-tu devenu

Le Lazare entrant dans la tombe
Au lieu d'en sortir comme il fit
Adieu adieu chantante ronde
O mes années ô jeunes filles

## II

Non je ne me sens plus là
    Moi-même
Je suis le quinze de la
    Onzième

Le soleil filtre à travers
    Les vitres
Ses rayons font sur mes vers
    Les pitres

Et dansent sur le papier
    J'écoute
Quelqu'un qui frappe du pied
    La voûte

## III

Dans une fosse comme un ours
Chaque matin je me promène
Tournons tournons tournons toujours
Le ciel est bleu comme une chaîne
Dans une fosse comme un ours
Chaque matin je me promène

# IN *LA SANTE*

## I

Before I could enter my cell
I had to strip to the skin
A dire voice moaned in my ear
Guillaume what have you done

Lazarus thus entering the tomb
Instead of coming out of it
Goodbye goodbye the round is sung
My years and O my pretty girls

## II

For there I seem no more
    Myself
I am the fifteenth of
    The eleventh

The sun comes brightly through
    The panes
Its rays light on my verse
    Like clowns

And dance across my words
    I hear
A foot which taps against
    The vault

## III

No better than a captive bear
My morning walk is in a ditch
Turning turning turning turning
The sky is azure like a chain
No better than a captive bear
My morning walk is in a ditch

Dans la cellule d'à côté
On y fait couler la fontaine
Avec les clefs qu'il fait tinter
Que le geôlier aille et revienne
Dans la cellule d'à côté
On y fait couler la fontaine

## IV

Que je m'ennuie entre ces murs tout nus
Et peints de couleurs pâles
Une mouche sur le papier à pas menus
Parcourt mes lignes inégales

Que deviendrai-je ô Dieu qui connais ma douleur
Toi qui me l'as donnée
Prends en pitié mes yeux sans larmes ma pâleur
Le bruit de ma chaise enchaînée

Et tous ces pauvres cœurs battant dans la prison
L'Amour qui m'accompagne
Prends en pitié surtout ma débile raison
Et ce désespoir qui la gagne

## V

Que lentement passent les heures
Comme passe un enterrement

Tu pleureras l'heure où tu pleures
Qui passera trop vitement
Comme passent toutes les heures

Inside the cell right next to mine
The water tap was just turned on
With keys which ring and rattle as
The jailer makes his rounds outside
Inside the cell right next to mine
The water tap just turned on

## IV

How dull inside these barren walls
      Painted in faded tints
A fly with mincing steps walks up
      The slope my lines make on the page

What will become of me grief-knowing God
      You who gave it me
Have pity on my tearless eyes my paleness
      And the clank of my fettered chair

And these poor hearts which beat in prison
      Love which stays with me
Pity most my tired mind
      The despair which crushes it

## V

How slowly all the hours pass
Like a funeral going by

You will mourn this time of weeping
Which will be gone too soon
As all the hours go by

83

# VI

J'écoute les bruits de la ville
Et prisonnier sans horizon
Je ne vois rien qu'un ciel hostile
Et les murs nus de ma prison

Le jour s'en va voici que brûle
Une lampe dans la prison
Nous sommes seuls dans ma cellule
Belle clarté Chère raison

*September* 1911

## VI

I hear the sounds the city makes
With no horizon in my view
I only see a hostile sky
And the bareness of my prison walls

The day at last departs and now
A light burns dimly in the jail
We share alone my little cell
Resplendent light Most treasured reason

*September* 1911

# SALTIMBANQUES

*A Louis Dumur*

Dans la plaine les baladins
S'éloignent au long des jardins
Devant l'huis des auberges grises
Par les villages sans églises

Et les enfants s'en vont devant
Les autres suivent en rêvant
Chaque arbre fruitier se résigne
Quand de très loin ils lui font signe

Ils ont des poids ronds ou carrés
Des tambours des cerceaux dorés
L'ours et le singe animaux sages
Quêtent des sous sur leur passage

# L'ADIEU

J'ai cueilli ce brin de bruyère
L'automne est morte souviens-t'en
Nous ne nous verrons plus sur terre
Odeur du temps brin de bruyère
Et souviens toi que je t'attends

# ACROBATS

*To Louis Dumur*

Across the plain the troop of clowns
Moves by along the garden walls
Before the doors of greying inns
Through churchless villages and towns

And children scamper out in front
While others follow dreamily
Each fruit tree submits readily
When from afar they give the sign

The weights they bear are round and square
And tambourines and gilded hoops
Wise animals the ape and bear
Beg for their keep along the way

# THE FAREWELL

I picked this fragile sprig of heather
Autumn has died long since remember
Never again shall we see one another
Odor of time sprig of heather
Remember I await our life together

# POEME LU AU MARIAGE
# D'ANDRE SALMON

*Le 13 juillet* 1909

En voyant des drapeaux ce matin je ne me suis pas dit
Voilà les riches vêtements des pauvres
Ni la pudeur démocratique veut me voiler sa douleur
Ni la liberté en honneur fait qu'on imite maintenant
Les feuilles ô liberté végétale ô seule liberté terrestre
Ni les maisons flambent parce qu'on partira pour ne plus revenir
Ni ces mains agitées travailleront demain pour nous tous
Ni même on a pendu ceux qui ne savaient pas profiter de la vie
Ni même on renouvelle le monde en reprenant la Bastille
Je sais que seuls le renouvellent ceux qui sont fondés en poésie
On a pavoisé Paris parce que mon ami André Salmon s'y marie

Nous nous sommes rencontrés dans un caveau maudit
Au temps de notre jeunesse
Fumant tous deux et mal vêtus attendant l'aube
Épris épris des mêmes paroles dont il faudra changer le sens
Trompés trompés pauvres petits et ne sachant pas encore rire
La table et les deux verres devinrent un mourant qui nous jeta le dernier
 regard d'Orphée
Les verres tombèrent se brisèrent
Et nous apprîmes à rire
Nous partîmes alors pèlerins de la perdition
A travers les rues à travers les contrées à travers la raison
Je le revis au bord du fleuve sur lequel flottait Ophélie
Qui blanche flotte encore les nénuphars
Il s'en allait au milieu des Hamlets blafards
Sur la flûte jouant les airs de la folie
Je le revis près d'un moujik mourant compter les béatitudes
En admirant la neige semblable aux femmes nues

# POEM READ AT THE MARRIAGE
# OF ANDRE SALMON

*July 13, 1909*

Seeing the flags this morning I didn't say to myself
Those are the rich garments of the poor
Nor does democratic modesty wish to veil from me its grief
Nor does the honoring of liberty require now that one imitate
The newspapers O fertile liberty O sole earthly liberty
Nor do houses flame because people are going away never to return
Nor will these hurried hands work for us tomorrow
Nor even have those men been hung who cannot make a go of life
Nor even is the world made over by retaking the Bastille
I know that only those will remake the world who are rooted in poetry
Paris is decked out in flags because my friend André Salmon is to be
    married here

We met in some miserable cellar
During the years of our youth
Both of us smoking and awaiting the dawn in ragged clothes
Concerned with the same words whose meaning will have to be changed
Deceived deceived poor boys and not yet knowing how to laugh
The table and two glasses became a dying man who regarded us with
    Orpheus' last look
The glasses fell and broke
And we learned how to laugh
We left then pilgrims of perdition
Across streets across countries across reason
I saw him again on the shore of the river on which Ophelia floated
And the lasting whiteness of lotus flowers
He went away among wan Hamlets
Playing tunes of folly on a flute
I saw him beside a dying moujik reciting the beatitudes
Admiring the snow which was like naked women

Je le revis faisant ceci ou cela en l'honneur des mêmes paroles
Qui changent la face des enfants et je dis toutes ces choses
Souvenir et Avenir parce que mon ami André Salmon se marie

Réjouissons-nous non pas parce que notre amitié a été le fleuve qui nous
    a fertilisés
Terrains riverains dont l'abondance est la nourriture que tous espèrent
Ni parce que nos verres nous jettent encore une fois le regard d'Orphée
    mourant
Ni parce que nous avons tant grandi que beaucoup pourraient confondre
    nos yeux et les étoiles
Ni parce que les drapeaux claquent aux fenêtres des citoyens qui sont
    contents depuis cent ans d'avoir la vie et de menues choses à défendre
Ni parce que fondés en poésie nous avons des droits sur les paroles qui
    forment et défont l'Univers
Ni parce que nous pouvons pleurer sans ridicule et que nous savons rire
Ni parce que nous fumons et buvons comme autrefois
Réjouissons-nous parce que directeur du feu et des poètes
L'amour qui emplit ainsi que la lumière
Tout le solide espace entre les étoiles et les planètes
L'amour veut qu'aujourd'hui mon ami André Salmon se marie

I saw him doing this or that in honor of the same words
Which change children's expressions and I am saying everything
Recollection and Prediction because my friend André Salmon is being
    married

Let us rejoice not because our friendship has been the stream which
    enriched us
River lands whose fertility is the nourishment all hope for
Nor because our glasses cast at us again Orpheus' dying look
Nor because we have grown so much that many people mistake our eyes
    for stars
Nor because the flags flap outside the windows of citizens who have been
    content for a hundred years to have life and petty things to defend
Nor because rooted in poetry we have rights over the words which make
    and unmake the world
Nor because we can cry without ridicule and because we know how to
    laugh
Nor because we smoke and drink as in the old days
Let us rejoice because the director of fire and of poets
Love which like light fills
All solid space between the stars and the planets
Love desires that my friend André Salmon should get married today

# MARIZIBILL

Dans la Haute-Rue à Cologne
Elle allait et venait le soir
Offerte à tous en tout mignonne
Puis buvait lasse des trottoirs
Très tard dans les brasseries borgnes

Elle se mettait sur la paille
Pour un maquereau roux et rose
C'était un juif il sentait l'ail
Et l'avait venant de Formose
Tirée d'un bordel de Changaï

Je connais gens de toutes sortes
Ils n'égalent pas leurs destins
Indécis comme feuilles mortes
Leurs yeux sont des feux mal éteints
Leurs cœurs bougent comme leurs portes

# MARIZIBILL

Up and down High Street in Cologne
She used to walk all evening long
Offered to all her darling grace
Tired of pavements she would drink
Till morning in a dingy bar

She lay down on the putrid straw
For a ruddy-faced red-headed pimp
A Jew with garlic on his breath
He took her from a Shanghai house
Returning from a Taiwan trip

Of all the many men I know
Few equal their own destinies
They drift like dry and fallen leaves
Their eyes are half-quenched flickerings
Their hearts move listlessly as doors

# LA CHANSON DU
# MAL-AIME

*A Paul Léautard*

Et je chantais cette romance
En 1903 sans savoir
Que mon amour a la semblance
Du beau Phénix s'il meurt un soir
Le Matin voit sa renaissance

*Un soir de demi-brume à Londres*
*Un voyou qui ressemblait à*
*Mon amour vint à ma rencontre*
*Et le regard qu'il me jeta*
*Me fit baisser les yeux de honte*

*Je suivis ce mauvais garçon*
*Qui sifflotait mains dans les poches*
*Nous semblions entre les maisons*
*Onde ouverte de la mer Rouge*
*Lui les Hébreux moi Pharaon*

*Que tombent ces vagues de briques*
*Si tu ne fus pas bien aimée*
*Je suis le souverain d'Egypte*
*Sa sœur-épouse son armée*
*Si tu n'es pas l'amour unique*

*Au tournant d'une rue brûlant*
*De tous les feux de ses façades*
*Plaies du brouillard sanguinolent*
*Où se lamentaient les façades*
*Une femme lui ressemblant*

# THE SONG OF THE
# POORLY-LOVED

*To Paul Léautaud*

I used to sing this plaintive song
In 1903 and never knew
How much my love was Phoenix-like
If in the evening it should die
The Morning brought it back to life

*One evening in a London fog*
*A waif who might have been my love*
*Came boldly walking up to me*
*The look he threw me as we passed*
*Forced me to drop my eyes in shame*

*I followed this malicious boy*
*Who whistled as he strolled along*
*In front of him the buildings yawned*
*As the Red Sea opened to the Jews*
*For I was Pharaoh in pursuit*

*May all those waves of brick wash down*
*If you were not most dearly loved*
*I am the great Egyptian king*
*His army and his sister-wife*
*If you are not my only love*

*The street in turning flamed to light*
*The wounds of its facades oozed out*
*A bloody fog into the night*
*The discharge of their dark lament*
*A woman who resembled him*

95

C'était son regard d'inhumaine
La cicatrice à son cou nu
Sortit saoule d'une taverne
Au moment où je reconnus
La fausseté de l'amour même

Lorsqu'il fut de retour enfin
Dans sa patrie le sage Ulysse
Son vieux chien de lui se souvint
Près d'un tapis de haute lisse
Sa femme attendait qu'il revînt

L'époux royal de Sacontale
Las de vaincre se réjouit
Quand il la retrouva plus pâle
D'attente et d'amour yeux pâlis
Caressant sa gazelle mâle

J'ai pensé à ces rois heureux
Lorsque le faux amour et celle
Dont je suis encore amoureux
Heurtant leurs ombres infidèles
Me rendirent si malheureux

Regrets sur quoi l'enfer se fonde
Qu'un ciel d'oubli s'ouvre à mes vœux
Pour son baiser les rois du monde
Seraient morts les pauvres fameux
Pour elle eussent vendu leur ombre

J'ai hiverné dans mon passé
Revienne le soleil de Pâques
Pour chauffer un cœur plus glacé
Que les quarante de Sébaste
Moins que ma vie martyrisés

It was her dark inhuman glance
The scar upon her naked neck
Came tipsy from a dingy bar
Just at the time I recognised
How deep in falsehood love must lie

When wise Ulysses did at last
Come back to his own land and home
His aging dog remembered him
While by a thickly woven rug
His wife awaited his return

The stately king of Sacontale
Tired of victory rejoiced
To find her paler than before
And misty eyed with love and hope
Caressing her small male gazelle

I had these happy kings in mind
The night when this false love and she
To whom I give my deepest love
Jostled their shadows in my sight
And brought me to unhappiness

Regrets compose a lonely hell
I prayed that I might just forget
For her warm kiss all worldly kings
Would die a glorious death poor fools
They would have sold their souls for her

I hibernated in my past
Let the Easter sun return in time
To warm again a colder heart
Than forty chill Sebastus hearts
Less martyred than my martyred life

Mon beau navire ô ma mémoire
Avons-nous assez navigué
Dans une onde mauvaise à boire
Avons-nous assez divagué
De la belle aube au triste soir

Adieux faux amour confondu
Avec la femme qui s'éloigne
Avec celle que j'ai perdue
L'année dernière en Allemagne
Et que je ne reverrai plus

Voie lactée ô sœur lumineuse
Des blancs ruisseaux de Chanaan
Et des corps blancs des amoureuses
Nageurs morts suivrons-nous d'ahan
Ton cours vers d'autres nébuleuses

Je me souviens d'une autre année
C'était l'aube d'un jour d'avril
J'ai chanté ma joie bien-aimée
Chanté l'amour à voix virile
Au moment d'amour de l'année

AUBADE CHANTÉE
A LÆTARE UN
AN PASSÉ

C'est le printemps viens-t'en Pâquette
Te promener au bois joli
Les poules dans la cour caquètent
L'aube au ciel fait de roses plis
L'amour chemine à ta conquête

Mars et Vénus sont revenus
Ils s'embrassent à bouches folles
Devant des sites ingénus
Où sous les roses qui feuillolent
De beaux dieux roses dansent nus

98

*My lovely ship my memory*
*We never have sailed far enough*
*In a dreary sea too vile to drink*
*Nor wandered wholly aimlessly*
*From dawn to melancholy dusk*

*Farewell false love whom I mistook*
*For her whom distance keeps apart*
*For her whom I most gravely lost*
*A year ago in Germany*
*And whom I shall not see again*

*That sister light the Milky Way*
*Whose whiteness flows from Canaan streams*
*And from the white of lovers' flesh*
*Shall we at death not follow her*
*And swim toward further nebulae*

*I recollect another year*
*At sunrise on an April day*
*I sang the rapture of my love*
*Sang love songs in a manly voice*
*While the year itself awoke to love*

AUBADE   SUNG     Now that it's spring come back Paquette
AT LAETARE ONCE   To walk with me in the lovely wood
UPON A TIME       The hens are cackling in the yard
                  The dawn makes pink folds in the sky
                  And love sets out to conquer you

                  Mars and Venus have come back
                  To kiss with madness on their lips
                  In places where no guile can live
                  And where beneath the blooming rose
                  Bright naked gods dance tenderly

Viens ma tendresse est la régente
De la floraison qui paraît
La nature est belle et touchante
Pan sifflote dans la forêt
Les grenouilles humides chantent

Beaucoup de ces dieux ont péri
C'est sur eux que pleurent les saules
Le grand Pan l'amour Jésus-Christ
Sont bien morts et les chats miaulent
Dans la cour je pleure à Paris

Moi qui sais des lais pour les reines
Les complaintes de mes années
Des hymnes d'esclave aux murènes
La romance du mal-aimé
Et des chansons pour les sirènes

L'amour est mort j'en suis tremblant
J'adore de belles idoles
Les souvenirs lui ressemblent
Comme la femme de Mausole
Je reste fidèle et dolent

Je suis fidèle comme un dogue
Au maître le lierre au tronc
Et les Cosaques Zaporogues
Ivrognes pieux et larrons
Aux steppes et au décalogue

Portez comme un joug le Croissant
Qu'interrogent les astrologues
Je suis le Sultan tout-Puissant
O mes Cosaques Zaporogues
Votre Seigneur éblouissant

Come here my tenderness is queen
Of all this blooming foliage
Nature is at her loveliest
While Pan pipes sweetly in the wood
And frogs sing moistly in the swamp

*Most of those gods have perished now*
*It is for them the willows weep*
*Pan's spirit and the love of Christ*
*Are dead the cats howl grievously*
*In the Paris court where I grieve too*

*I who know sad lays for queens*
*The ballads of regretful years*
*The choruses of sea-doomed slaves*
*The romance of the poorly-loved*
*And songs which only sirens sing*

*I tremble in the death of love*
*For I adore an idol's spell*
*These memories resemble her*
*And like Mausolus' grieving wife*
*I live in a despondent faith*

*My loyalty is like a dog's*
*Or that of ivy to the tree*
*And that of Zaporogan Cossacks*
*Drunken pious rascals to*
*The steppes and the decalogue*

*Carry the Crescent like a yoke*
*Which the astrologers consult*
*I am the all-prevailing Sultan*
*O my Zaporogan Cossacks*
*Your lord of brightest majesty*

101

*Devenez mes sujets fidèles*
*Leur avait écrit le Sultan*
*Ils rirent à cette nouvelle*
*Et répondirent à l'instant*
*A la lueur d'une chandelle*

Plus criminel que Barrabas
Cornu comme les mauvais anges
Quel Belzébuth es-tu là-bas
Nourri d'immondice et de fange
Nous n'irons pas à tes sabbats

Poisson pourri de Salonique
Long collier des sommeils affreux
D'yeux arrachés à coup de pique
Ta mère fit un pet foireux
Et tu naquis de sa coique

Bourreau de Podolie Amant
Des plaies des ulcères des croûtes
Groin de cochon cul de jument
Tes richesses garde-les toutes
Pour payer tes médicaments

*Voie lactée ô sœur lumineuse*
*Des blancs ruisseaux de Chanaan*
*Et des corps blancs des amoureuses*
*Nageurs morts suivrons-nous d'ahan*
*Ton cours vers d'autres nébuleuses*

*Regret des yeux de la putain*
*Et belle comme une panthère*
*Amour vos baisers florentins*
*Avaient une saveur amère*
*Qui a rebuté nos destins*

102

*Become my subjects  in good faith*
*The sultan wrote them hopefully*
*They laughed aloud at this request*
*And answered almost instantly*
*By flickering candlelight*

THE ANSWER OF
THE ZAPOROGAN
COSSACKS TO THE
SULTAN OF CON-
STANTINOPLE

More evil than Barrabas was
Horned like all the wicked angels
What black Beelzebub are you
Fattened on sewage and on mud
We cannot join your revelries

Rotting fish of Salonica
The halter of repulsive dreams
Of eyes torn out by pointed stakes
Your mother farted helplessly
And bore you in a colic pool

Butcher of Padolie Lover
Of ulcerated skin and scabs
Of pig's snout and of horse's arse
Keep all your riches for yourself
To pay for your medicinals

*That sister light the Milky Way*
*Whose whiteness flows from Canaan streams*
*And from the white of lover's flesh*
*Shall we at death not follow her*
*And swim toward further nebulae*

*The deep regret of harlots' eyes*
*Who can display  a panther's grace*
*O love your Florentine kisses had*
*The bitterest of savours which*
*Rebuffed our fondest destinies*

103

Ses regards laissaient une traîne
D'étoiles dans les soirs tremblants
Dans ses yeux nageaient les sirènes
Et nos baisers mordus sanglants
Faisaient pleurer nos fées marraines

Mais en vérité je l'attends
Avec mon cœur avec mon âme
Et sur le pont des Reviens-t'en
Si jamais revient cette femme
Je lui dirai Je suis content

Mon cœur et ma tête se vident
Tout le ciel s'écoule par eux
O mes tonneaux des Danaïdes
Comment faire pour être heureux
Comme un petit enfant candide

Je ne veux jamais l'oublier
Ma colombe ma blanche rade
O marguerite exfoliée
Mon île au loin ma Désirade
Ma rose mon giroflier

Les satyres et les pyraustes
Les égypans les feux follets
Et les destins damnés ou faustes
La corde au cou comme à Calais
Sur ma douleur quel holocauste

Douleur qui doubles les destins
La licorne et le capricorne
Mon âme et mon corps incertain
Te fuient ô bûcher divin qu'ornent
Des astres des fleurs du matin

As evening trembles a train of stars
Followed the movement of her look
Sirens swam idly in her eyes
The way our kisses bit to blood
Made our fairy godmothers cry

I have been waiting endlessly
With all my heart with all my soul
And on the bridge called Reviens-t'en
If ever she should once come back
I'll tell her that I am content

My heart and mind empty themselves
And all the sky pours out through them
Into my Danaidean casks
How can one find the happiness
And guilelessness of a little child

I wish never to forget her
My whitest harbor and my dove
My daisy blossoming to joy
My distant isle my Guadaloupe
My rose bush and my tree of cloves

Satyrs and Pyraustidae
Egypans will o' the wisps
And happy destinies or damned
The Calais noose snug at my neck
What holocaust heightens my grief

A grief which doubles destinies
Unicorn and capricorn
My soul and doubting body flee
Your holy pyre emblazoned with
The morning scene of stars and flowers

Malheur dieu pâle aux yeux d'ivoire
Tes prêtres fous t'ont-ils paré
Tes victimes en robe noire
Ont-elles vainement pleuré
Malheur dieu qu'il ne faut pas croire

Et toi qui me suis en rampant
Dieu de mes dieux morts en automne
Tu mesures combien d'empans
J'ai droit que la terre me donne
O mon ombre ô mon vieux serpent

Au soleil parce que tu l'aimes
Je t'ai menée souviens-t'en bien
Ténébreuse épouse que j'aime
Tu es à moi en n'étant rien
O mon ombre en deuil de moi-même

L'hiver est mort tout enneigé
On a brûlé les ruches blanches
Dans les jardins et les vergers
Les oiseaux chantent sur les branches
Le printemps clair l'avril léger

Mort d'immortels argyraspides
La neige aux boucliers d'argent
Fuit les dendrophores livides
Du printemps cher aux pauvres gens
Qui resourient les yeux humides

Et moi j'ai le cœur aussi gros
Qu'un cul de dame damascène
O mon amour je t'aimais trop
Et maintenant j'ai trop de peine
Les sept épées hors du fourreau

Ivory-eyed pale god of woe
Have your crazy priests adorned you well
And have your victims robed in black
Been weeping vainly at your feet
Grief is a god that must be scorned

And you who crawl to follow me
God of my gods who died last fall
You slowly count how many spans
The earth will grant me as my due
My shadow O my ancient snake

Do you recall our many walks
In sunlight which you loved so much
Although you are a dusky love
In being nothing you are mine
My shadow mourning for myself

Winter died beneath the snow
Whose hives of white have disappeared
In gardens and in orchard groves
Birds sing from distant branches how
Bright spring and April change the world

Killed by the famed Agyraspids
The snow holds up its silver shield
To flee the livid Dendrophori
Of spring which cheers the poorer folk
Who smile again with humid eyes

My heart meanwhile swells larger than
The arse of a Damascan wife
O my beloved too dearly loved
And now the torment is too great
The seven swords are all unsheathed

*Sept épées de mélancolie*
*Sans morfil & claires douleurs*
*Sont dans mon cœur et la folie*
*Veut raisonner pour mon malheur*
*Comment voulez-vous que j'oublie*

LES SEPT ÉPÉES

La première est toute d'argent
Et son nom tremblant c'est Pâline
Sa lame un ciel d'hiver neigeant
Son destin sanglant gibeline
Vulcain mourut en la forgeant

La seconde nommée Noubosse
Est un bel arc-en-ciel joyeux
Les dieux s'en servent à leurs noces
Elle a tué trente Bé-Rieux
Et fut douée par Carabosse

La troisième bleu féminin
N'en est pas moins un chibriape
Appelé Lul de Faltenin
Et que porte sur une nappe
L'Hermès Ernest devenu nain

La quatrième Malourène
Est un fleuve vert et doré
C'est le soir quand les riveraines
Y baignent leurs corps adorés
Et des chants de rameurs s'y traînent

La cinquième Sainte-Fabeau
C'est la plus belle des quenouilles
C'est un cyprès sur un tombeau
Où les quatre vents s'agenouillent
Et chaque nuit c'est un flambeau

*Unhappiness is seven swords*
*Honed to a keen edge of despair*
*Each stabs my heart and folly pleads*
*The cause of my unreasoned grief*
*How can I find forgetfulness*

THE SEVEN
SWORDS

The first is wrought of solid silver
Its name which trembles is Paline
Its blade a winter sky of snow
Its bleeding fate is Ghibelline
And Vulcan died in forging it

The second one is called Noubosse
A rainbow edge which flashes joy
Gods use it on their wedding days
It killed full thirty Bé-Rieux
Cabrosse charmed it with evil spells

The third glows femininely blue
But none the less a Chibriape
Aptly called Lul de Faltenin
Which Earnest Hermes as a dwarf
Bears proudly on a tablecloth

The fourth is Malpourine by name
A stream of shining green and gold
The river folk most piously
At dusk bathe their white bodies there
The rowers' songs pass slowly by

The fifth sword is St. Fabeau
The fairest of these distaff blades
It is a cypress at a grave
Where all four winds must kneel at last
And every night flames like a torch

La sixième métal de gloire
C'est l'ami aux si douces mains
Dont chaque matin nous sépare
Adieu voilà votre chemin
Les coqs s'épuisaient en fanfares

Et la septième s'exténue
Une femme une rose morte
Merci que le dernier venu
Sur mon amour ferme la porte
Je ne vous ai jamais connue

*Voie lactée ô sœur lumineuse*
*Des blancs ruisseaux de Chanaan*
*Et des corps blancs des amoureuses*
*Nageurs morts suivrons-nous d'ahan*
*Ton cours vers d'autres nébuleuses*

*Les démons du hasard selon*
*Le chant du firmament nous mènent*
*A sons perdus leurs violons*
*Font danser notre race humaine*
*Sur la descente à reculons*

*Destins destins impénétrables*
*Rois secoués par la folie*
*Et ces grelottantes étoiles*
*De fausses femmes dans vos lits*
*Aux déserts que l'histoire accable*

*Luitpold le vieux prince régent*
*Tuteur de deux royautés folles*
*Sanglote-t-il en y songeant*
*Quand vacillent les lucioles*
*Mouches dorées de la Saint-Jean*

The sixth is metal wrought for fame
A friend with firm but gentle hands
Each morning makes us separate
Goodbye there is the road you take
The cocks are feeble from fanfares

The seventh one alone is weak
A woman and a faded rose
Thank heaven that the last to come
Can shut the door upon my love
I never knew you all the time

*That sister light the Milky Way*
*Whose whiteness flows from Canaan streams*
*And from the white of lovers' flesh*
*Shall we at death not follow her*
*And swim to further nebulae*

*Demons of chance lead us along*
*While all the firmament sings on*
*The lost sounds of their violins*
*Make our poor helpless human race*
*Dance backwards in its long descent*

*O most impenetrable dooms*
*The kings whom folly shakes apart*
*And those stars cold and shivering*
*Are all false women in your beds*
*In deserts time alone destroys*

*Leopold the regent prince*
*Protector of two crazy kings*
*The thought of them must make him weep*
*When all the fireflies light up*
*The locusts of St. John in flame*

Près d'un château sans châtelaine
La barque aux barcarols chantants
Sur un lac blanc et sous l'haleine
Des vents qui tremblent au printemps
Voguait cygne mourant sirène

Un jour le roi dans l'eau d'argent
Se noya puis la bouche ouverte
Il s'en revint en surnageant
Sur la rive dormir inerte
Face tournée au ciel changeant

Juin ton soleil ardente lyre
Brûle mes doigts endoloris
Triste et mélodieux délire
J'erre à travers mon beau Paris
Sans avoir le cœur d'y mourir

Les dimanches s'y éternisent
Et les orgues de Barbarie
Y sanglotent dans les cours grises
Les fleurs aux balcons de Paris
Penchent comme la tour de Pise

Soirs de Paris ivres du gin
Flambent de l'électricité
Les tramways feux verts sur l'échine
Musiquent au long des portées
De rails leur folie de machines

Les cafés gonflés de fumée
Crient tout l'amour de leurs tziganes
De tous leurs siphons enrhumés
De leurs garçons vêtus d'un pagne
Vers toi toi que j'ai tant aimée

Beside a ladyless chateau
A ship to the sound of barcarolles
On a pure white lake beneath the breath
Of winds which brought a trembling spring
Sailed like a swan to a siren's death

One day the king drowned silently
With a gaping mouth in the silver lake
He rose again and floated there
By the further bank inert asleep
His face turned toward the changing sky

The flaming lyre of June's sun
Burns my fingers' tender skin
Tuneful and sad delirium
I stray through Paris' loveliness
Without the heart to perish there

Sundays become eternal here
And hand-organs from Barbary
Sob heavily in murky courts
Flowers on Paris balconies
Lean as the tower of Pisa leans

Drunk on gin the Paris nights
Blaze with electricity
The trolleys flashing greenish lights
Warble along their staves of tracks
The folly of machinery

The street cafes swollen with smoke
Proclaim the spell of gypsy love
In all their siphons' husky growls
In the waiters' wilted apron-strings
Toward you whom I so dearly loved

*Moi qui sais des lais pour les reines*
*Les complaintes de mes années*
*Des hymnes d'esclave aux murènes*
*La romance du mal-aimé*
*Et des chansons pour les sirènes*

*I who know sad lays for queens*
*The ballads of regretful years*
*The choruses of sea-doomed slaves*
*The romance of the poorly-loved*
*And songs which only sirens sing*

# ZONE

A la fin tu es las de ce monde ancien

Bergère ô tour Eiffel le troupeau des ponts bêle ce matin

Tu en as assez de vivre dans l'antiquité grecque et romaine

Ici même les automobiles ont l'air d'être anciennes
La religion seule est restée toute neuve la religion
Est restée simple comme les hangars de Port-Aviation

Seul en Europe tu n'es pas antique ô Christianisme
L'Européen le plus moderne c'est vous Pape Pie X
Et toi que les fenêtres observent la honte te retient
D'entrer dans une église et de t'y confesser ce matin
Tu lis les prospectus les catalogues les affiches qui chantent tout haut
Voilà la poésie ce matin et pour la prose il y a les journaux
Il y a les livraisons à 25 centimes pleines d'aventures policières
Portraits des grands hommes et mille titres divers

J'ai vu ce matin une jolie rue dont j'ai oublié le nom
Neuve et propre du soleil elle était le clairon
Les directeurs les ouvriers et les belles sténo-dactylographes
Du lundi matin au samedi soir quatre fois par jour y passent
Le matin par trois fois la sirène y gémit
Une cloche rageuse y aboie vers midi
Les inscriptions des enseignes et des murailles
Les plaques les avis à la façon des perroquets criaillent
J'aime la grâce de cette rue industrielle
Située à Paris entre la rue Aumont-Thiéville et l'avenue des Ternes
Voilà la jeune rue et tu n'es encore qu'un petit enfant
Ta mère ne t'habille que de bleu et de blanc
Tu es très pieux et avec le plus ancien de tes camarades René Dalize
Vous n'aimez rien tant que les pompes de l'Église

# ZONE

You are tired at last of this old world

O shepherd Eiffel Tower the flock of bridges bleats at the morning

You have had enough of life in this Greek and Roman antiquity

Even the automobiles here seem to be ancient
Religion alone has remained entirely fresh religion
Has remained simple like the hangars at the airfield

You alone in all Europe are not antique O Christian faith
The most modern European is you Pope Pius X
And you whom the windows look down at shame prevents you
From entering a church and confessing this morning
You read prospectuses catalogues and posters which shout aloud
Here is poetry this morning and for prose there are the newspapers
There are volumes for 25 centimes full of detective stories
Portraits of famous men and a thousand assorted titles

This morning I saw a pretty street whose name I have forgotten
Shining and clean it was the sun's bugle
Executives and workers and lovely secretaries
From Monday morning to Saturday evening pass here four times a day
In the morning the siren wails three times
A surly bell barks around noon
Lettering on signs and walls
Announcements and billboards shriek like parrots
I love the charm of this industrial street
Located in Paris somewhere between the rue Aumont-Thiéville and the
    avenue des Ternes
Here is the young street and you are once again a little child
Your mother dresses you only in blue and white
You are very pious and with your oldest friend René Dalize
You like nothing so well as the ceremonies of church

Il est neuf heures le gaz est baissé tout bleu vous sortez du dortoir en
  cachette
Vous priez toute la nuit dans la chapelle du collège
Tandis qu'éternelle et adorable profondeur améthyste
Tourne à jamais la flamboyante gloire du Christ
C'est le beau lys que tous nous cultivons
C'est la torche aux cheveux roux que n'éteint pas le vent
C'est le fils pâle et vermeil de la douloureuse mère
C'est l'arbre toujours touffu de toutes les prières
C'est la double potence de l'honneur et de l'éternité
C'est l'étoile à six branches
C'est Dieu qui meurt le vendredi et ressuscite le dimanche
C'est le Christ qui monte au ciel mieux que les aviateurs
Il détient le record du monde pour la hauteur
Pupille Christ de l'œil
Vingtième pupille des siècles il sait y faire
Et changé en oiseau ce siècle comme Jésus monte dans l'air
Les diables dans les abîmes lèvent la tête pour le regarder
Ils disent qu'il imite Simon Mage en Judée
Ils crient s'il sait voler qu'on l'appelle voleur
Les anges voltigent autour du joli voltigeur
Icare Enoch Elie Apollonius de Thyane
Flottent autour du premier aéroplane
Ils s'écartent parfois pour laisser passer ceux que transporte la Sainte-
  Eucharistie
Ces prêtres qui montent éternellement en élevant l'hostie
L'avion se pose enfin sans refermer les ailes
Le ciel s'emplit alors de millions d'hirondelles
A tire-d'aile viennent les corbeaux les faucons les hiboux
D'Afrique arrivent les ibis les flamands les marabouts
L'oiseau Roc célébré par les conteurs et les poètes
Plane tenant dans les serres le crâne d'Adam la première tête
L'aigle fond de l'horizon en poussant un grand cri
Et d'Amérique vient le petit colibri
De Chine sont venus les pihis longs et souples

It is nine o'clock the gas is down to the blue you come secretly out of
 the dormitory
You pray the whole night in the college chapel
While eternal and adorable an amethyst profundity
The flaming glory of Christ turns for ever
It is the beautiful lily we all cultivate
It is the red-headed torch which the wind cannot blow out
It is the pale and ruddy son of a sorrowful mother
It is the tree always thick with prayers
It is the double gallows of honor and of eternity
It is a six-pointed star
It is God who died on Friday and rose again on Sunday
It is Christ who soars in the sky better than any aviator
He breaks the world's altitude record
Christ the pupil of the eye
Twentieth pupil of the centuries he knows how
And turned into a bird this century rises in the air like Jesus
The devils in their abysses lift their heads to look at it
They say it is imitating Simon Magus in Judea
They shout that if it knows how to fly it should be called a flyer
Angels hover about the lovely aerialist
Icarus Enoch Elijah Apollonius of Tyana
Flutter around the original airplane
They separate occasionally to give passage to those whom the Holy
 Eucharist carries up
Those priests who rise eternally in lifting the host
The airplane lands at last without folding its wings
The sky fills up then with millions of swallows
In a flash crows falcons and owls arrive
Ibis flamingoes and marabous arrive from Africa
The great Roc celebrated by story tellers and poets
Glides down holding in its claws Adam's scull the first head
The eagle rushes out of the horizon giving a great cry
From America comes the tiny humming-bird
From China have come long supple pihis

Qui n'ont qu'une seule aile et qui volent par couples
Puis voici la colombe esprit immaculé
Qu'escortent l'oiseau-lyre et le paon ocellé
Le phénix ce bûcher qui soi-même s'engendre
Un instant voile tout de son ardente cendre
Les sirènes laissant les périlleux détroits
Arrivent en chantant bellement toutes trois
Et tous aigle phénix et pihis de la Chine
Fraternisent avec la volante machine

Maintenant tu marches dans Paris tout seul parmi la foule
Des troupeaux d'autobus mugissants près de toi roulent
L'angoisse de l'amour te serre le gosier
Comme si tu ne devais jamais plus être aimé
Si tu vivais dans l'ancien temps tu entrerais dans un monastère
Vous avez honte quand vous vous surprenez à dire une prière
Tu te moques de toi et comme le feu de l'Enfer ton rire pétille
Les étincelles de ton rire dorent le fonds de ta vie
C'est un tableau pendu dans un sombre musée
Et quelquefois tu vas la regarder de près

Aujourd'hui tu marches dans Paris les femmes sont ensanglantées
C'était et je voudrais ne pas m'en souvenir c'était au déclin de la beauté

Entourée de flammes ferventes Notre-Dame m'a regardé à Chartres
Le sang de votre Sacré-Cœur m'a inondé à Montmartre
Je suis malade d'ouïr les paroles bienheureuses
L'amour dont je souffre est une maladie honteuse
Et l'image qui te possède te fait survivre dans l'insomnie et dans l'angoisse
C'est toujours près de toi cette image qui passe

Maintenant tu es au bord de la Méditerranée
Sous les citronniers qui sont en fleur toute l'année
Avec tes amis tu te promènes en barque
L'un est Nissard il y a un Mentonasque et deux Turbiasques
Nous regardons avec effroi les poulpes des profondeurs
Et parmi les algues nagent les poissons images du Sauveur

Which only have one wing and fly tandem
Then the dove immaculate spirit
Escorted by the lyre bird and the ocellated peacock
The phoenix that pyre which recreates itself
Veils everything for an instant with its glowing coals
Sirens leaving their perilous straits
Arrive all three of them singing beautifully
And everything eagle phoenix and Chinese pihis
Fraternize with the flying machine

Now you walk through Paris all alone in the crowd
Herds of bellowing busses roll by near you
The agony of love tightens your throat
As if you could never be loved again
If you were living in olden days you would enter a monastery
You are ashamed when you catch yourself saying a prayer
You ridicule yourself and your laughter bursts out like hell fire
The sparks of your laughter gild the depths of your life
It is a picture hung in a somber museum
And sometimes you go to look at it closely

Today you walk through Paris the women are blood-stained
It was and I would prefer not to remember it was during beauty's decline

Surrounded by fervent flames Notre Dame looked at me in Chartres
The blood of your Sacred Heart flooded me in the Montmartre
I am ill from hearing happy words
The love from which I suffer is a shameful sickness
And the image which possesses you makes you survive in sleeplessness
    and anguish
It is always near you this passing image

Now you are on the shore of the Mediterranean
Under the lemon trees which blossom all year
With your friends you take a boat ride
One from Nice one from Menton and two from Turbie
We look down in fear at the octopodes on the bottom
And amid the algae swim fish images of our Saviour

Tu es dans le jardin d'une auberge aux environs de Prague
Tu te sens tout heureux une rose est sur la table
Et tu observes au lieu d'écrire ton conte en prose
La cétoine qui dort dans le cœur de la rose

Epouvanté tu te vois dessiné dans les agates de Saint-Vit
Tu étais triste à mourir le jour où tu t'y vis
Tu ressembles au Lazare affolé par le jour
Les aiguilles de l'horloge du quartier juif vont à rebours
Et tu recules aussi dans ta vie lentement
En montant au Hradchin et le soir en écoutant
Dans les tavernes chanter des chansons tchèques

Te voici à Marseille au milieu des pastèques

Te voici à Coblence à l'hôtel du Géant

Te voici à Rome assis sous un néflier du Japon

Te voici à Amsterdam avec une jeune fille que tu trouves belle et qui
    est laide
Elle doit se marier avec un étudiant de Leyde
On y loue des chambres en latin Cubicula locanda
Je m'en souviens j'y ai passé trois jours et autant à Gouda

Tu es à Paris chez le juge d'instruction
Comme un criminel on te met en état d'arrestation
Tu as fait de douloureux et de joyeux voyages
Avant de t'apercevoir du mensonge et de l'âge
Tu as souffert de l'amour à vingt et à trente ans
J'ai vécu comme un fou et j'ai perdu mon temps
Tu n'oses plus regarder tes mains et à tous moments je voudrais sangloter
Sur toi sur celle que j'aime sur tout ce qui t'a épouvanté

Tu regardes les yeux pleins de larmes ces pauvres émigrants
Ils croient en Dieu ils prient les femmes allaitent des enfants

You are in the garden of an inn on the outskirts of Prague
You feel completely happy a rose is on the table
And instead of writing your story in prose you watch
The rosebug which is sleeping in the heart of the rose

Astonished you see yourself outlined in the agates of St. Vitus
You were sad enough to die the day you saw yourself in them
You looked like Lazarus bewildered by the light
The hands of the clock in the Jewish quarter turn backwards
And you go slowly backwards in your life
Climbing up to Hradchin and listening at night
In taverns to the singing of Czech songs

Here you are in Marseilles amid the watermelons

Here you are in Coblenz at the Hotel of the Giant

Here you are in Rome sitting under a Japanese medlar tree

Here you are in Amsterdam with a girl you find pretty and who is ugly
She is to marry a student from Leyden
There are rooms for rent in Latin Cubicula locanda
I remember I stayed three days there and as many at Gouda

You are in Paris at the *juge d'instruction*
Like a criminal you are placed under arrest
You have made sorrowful and happy trips
Before noticing that the world lies and grows old
You suffered from love at twenty and thirty
I have lived like a fool and wasted my time
You no longer dare look at your hands and at every moment I want to
    burst out sobbing
For you for her I love for everything that has frightened you

With tear-filled eyes you look at those poor emigrants
They believe in God they pray the women nurse their children

Ils emplissent de leur odeur le hall de la gare Saint-Lazare
Ils ont foi dans leur étoile comme les rois-mages
Ils espèrent gagner de l'argent dans l'Argentine
Et revenir dans leur pays après avoir fait fortune
Une famille transporte un édredon rouge comme vous transportez votre
    cœur
Cet édredon et nos rêves sont aussi irréels
Quelques-uns de ces émigrants restent ici et se logent
Rue des Rosiers ou rue des Écouffes dans des bouges
Je les ai vus souvent le soir ils prennent l'air dans la rue
Et se déplacent rarement comme les pièces aux échecs
Il y a surtout des Juifs leurs femmes portent perruque
Elles restent assises exsangues au fond des boutiques

Tu es debout devant le zinc d'un bar crapuleux
Tu prends un café à deux sous parmi les malheureux

Tu es la nuit dans un grand restaurant

Ces femmes ne sont pas méchantes elles ont des soucis cependant
Toutes même la plus laide a fait souffrir son amant
Elle est la fille d'un sergent de ville de Jersey

Ses mains que je n'avais pas vues sont dures et gercées
J'ai une pitié immense pour les coutures de son ventre

J'humilie maintenant à une pauvre fille au rire horrible ma bouche

Tu es seul le matin va venir
Les laitiers font tinter leurs bidons dans les rues

La nuit s'éloigne ainsi qu'une belle Métive
C'est Ferdine la fausse ou Léa l'attentive

Et tu bois cet alcool brûlant comme ta vie
Ta vie que tu bois comme une eau-de-vie

Their odor fills the waiting room of the gare Saint-Lazare
They have faith in their star like the Magi
They hope to make money in Argentina
And come back to their countries having made their fortunes
One family carries a red quilt as one carries one's heart
That quilt and our dream are both unreal
Some of these emigrants stay here and find lodging
In hovels in the rue des Rosiers or the rue des Écouffes
I have often seen them in the evening they take a stroll in the street
And rarely travel far like men on a checker board
There are mostly Jews their wives wear wigs
They sit bloodlessly in the backs of little shops

You are standing at the counter of a dirty bar
You have a cheap coffee with the rest of the riffraff

At night you are in a big restaurant

These women are not wicked still they have their worries
All of them even the ugliest has made her lover suffer
She is the daughter of a policeman on the Isle of Jersey

Her hands which I have not seen are hard and chapped
I have an immense pity for the scars on her belly

I humble my mouth by offering it to a poor slut with a horrible laugh

You are alone the morning is almost here
The milkmen rattle their cans in the street

The night departs like a beautiful half-caste
False Ferdine or waiting Leah

And you drink this burning liquor like your life
Your life which you drink like an eau-de-vie

Tu marches vers Auteuil tu veux aller chez toi à pied
Dormir parmi tes fétiches d'Océanie et de Guinée
Ils sont des Christ d'une autre forme et d'une autre croyance
Ce sont les Christ inférieurs des obscures espérances

Adieu Adieu

Soleil cou coupé

You walk toward Auteuil you want to walk home on foot
To sleep among your fetishes from Oceania and Guinea
They are all Christ in another form and of another faith
They are inferior Christs obscure hopes

Adieu adieu

The sun a severed neck

# LES COLCHIQUES

Le pré est vénéneux mais joli en automne
Les vaches y paissant
Lentement s'empoisonnent
Le colchique couleur de cerne et de lilas
Y fleurit tes yeux sont comme cette fleur-là
Violâtres comme leur cerne et comme cet automne
Et ma vie pour tes yeux lentement s'empoisonne

Les enfants de l'école viennent avec fracas
Vêtus de hoquetons et jouant de l'harmonica
Ils cueillent les colchiques qui sont comme des mères
Filles de leurs filles et sont couleur de tes paupières

Qui battent comme les fleurs battent au vent dément

Le gardien de troupeau chante tout doucement
Tandis que lentes et meuglant les vaches abandonnent
Pour toujours ce grand pré mal fleuri par l'automne

# SAFFRON

The meadow is poisonous but pretty in the fall
The cows graze there
Slowly poisoning themselves
The saffron ringed and lilac-colored
Blooms there your eyes are like that flower
Near-violet like their rings and like this autumn
And my life slowly poisons itself for your eyes

The school children come up noisily
Dressed in jackets and playing the harmonica
They pick the saffron flowers which are like mothers
Daughters of their daughters and are the color of your
eyelids

Which move as flowers wave in a demented wind

The shepherd sings softly
While slow and lowing the cows leave
For ever this wide meadow evilly blooming in the autumn

# CORS DE CHASSE

Notre histoire est noble et tragique
Comme le masque d'un tyran
Nul drame hasardeux ou magique
Aucun détail indifférent
Ne rend notre amour pathétique

Et Thomas de Quincey buvant
L'opium poison doux et chaste
A sa pauvre Anne allait rêvant
Passons passons puisque tout passe
Je me retournerai souvent

Les souvenirs sont cors de chasse
Dont meurt le bruit parmi le vent

# HUNTING HORNS

Our history is noble and tragic
Like a tyrant's glaring mask
No hazard nor magical drama
No trivial detail
Makes pathos of our love

Opium possessed de Quincey
Chaste poison drunk to Anne
He dreamed his life away
On on since all must pass
I'll frequently turn back

Memories are hunting horns
Whose sound dies out along the wind

# VENDEMIAIRE

Hommes de l'avenir souvenez-vous de moi
Je vivais à l'époque où finissaient les rois
Tour à tour ils mouraient silencieux et tristes
Et trois fois courageux devenaient trismégistes

Que Paris était beau à la fin de septembre
Chaque nuit devenait une vigne où les pampres
Répandaient leur clarté sur la ville et là-haut
Astres mûrs becquetés par les ivres oiseaux
De ma gloire attendaient la vendange de l'aube

Un soir passant le long des quais déserts et sombres
En rentrant à Auteuil j'entendis une voix
Qui chantait gravement se taisant quelquefois
Pour que parvînt aussi sur les bords de la Seine
La plainte d'autres voix limpides et lointaines

Et j'écoutai longtemps tous ces chants et ces cris
Qu'éveillait dans la nuit la chanson de Paris

J'ai soif villes de France et d'Europe et du monde
Venez toutes couler dans ma gorge profonde

Je vis alors que déjà ivre dans la vigne Paris
Vendangeait le raisin le plus doux de la terre
Ces grains miraculeux qui aux treilles chantèrent

Et Rennes répondit avec Quimper et Vannes
Nous voici ô Paris Nos maisons nos habitants

Ces grappes de nos sens qu'enfanta le soleil
Se sacrifient pour te désaltérer trop avide merveille
Nous t'apportons tous les cerveaux les cimetières les murailles

# VINTAGE MONTH

Men of future time remember me
I lived at the time when kings were perishing
They died in quiet sadness one by one
And thrice courageous turned into conjurers

How beautiful Paris was at the end of September
Each night became a vine whose leafy limbs
Spread splendor over the city and up above
Ripe stars pecked by the drunken birds
Of my fame awaited the vintage of the dawn

One night walking along dark deserted quays
On the way back to Auteuil I heard a voice
Which gravely sang with measured silences
So that the clear lament of other distant voices
Might reach the banks of the Seine

I listened long to all those songs and cries
Which woke in the night the song which Paris sings

I am thirsty cities of France and of Europe and of the world
Come flow into the cavern of my throat

Then I saw that Paris already drunk on wine
Was harvesting the sweetest grapes in the world
Those marvellous grapes which sang on the trellises

And Rennes replies with Quimper and with Vannes
O Paris here we are   Our houses and our residents

These grapes which the sun begets from our senses
Sacrifice themselves to quench your thirst too eager a marvel
We bring you all intellects graveyards and walls

Ces berceaux pleins de cris que tu n'entendras pas
Et d'amont en aval nos pensées ô rivières
Les oreilles des écoles et nos mains rapprochées
Aux doigts allongés nos mains les clochers
Et nous t'apportons aussi cette souple raison
Que le mystère clôt comme une porte la maison
Ce mystère courtois de la galanterie
Ce mystère fatal fatal d'une autre vie

Double raison qui est au delà de la beauté
Et que la Grèce n'a pas connue ni l'Orient
Double raison de la Bretagne où lame à lame
L'océan châtre peu à peu l'ancien continent

Et les villes du Nord répondirent gaîment

O Paris nous voici boissons vivantes

Les viriles cités où dégoisent et chantent
Les métalliques saints de nos saintes usine.
Nos cheminées à ciel ouvert engrossent les nuées
Comme fit autrefois l'Ixion mécanique
Et nos mains innombrables
Usines manufactures fabriques mains
Où les ouvriers nus semblables à nos doigts
Fabriquent du réel à tant par heure
Nous te donnons tous cela

Et Lyon répondit tandis que les anges de Fourvières
Tissaient un ciel nouveau avec la soie des prières

Désaltère-toi Paris avec les divines paroles
Que mes lèvres le Rhône et la Saône murmurent
Toujours le même culte de sa mort renaissant
Divise ici les saints et fait pleuvoir le sang
Heureuse pluie ô gouttes tièdes ô douleur
Un enfant regarde les fenêtres s'ouvrir
Et des grappes de têtes à d'ivres oiseaux s'offrir

.   .   .   .   .

134

The cradles filled with cries you do not hear
And upstream and downstream the rivers of our thoughts
The ears of schools and our hands
Held like steeples with the fingers extended
And we shall also bring that supple reasoning
Which mystery can shut out like the door of a house
The courtly mystery of gallantry
And that fatal fatal mystery of another life

Double reason which is beyond beauty
Which neither Greece nor the orient knew
Double reason of Brittany where wave by wave
The ocean gradually castrates the ancient continent

And the cities of the North answer gaily

O Paris here we are stimulating drinks

The virile cities where the metallic saints
Of our holy factories prattle and sing
Our chimneys open to the sky fatten the clouds
As Ixion's wheel once flamed
And our innumerable hands
Factories mills works hands
Where naked workers like fingers
Construct reality at so much an hour
We give you all of that

And Lyon replies while the angels of Fourvieres
Weave a new sky out of the silk of prayers

Slake your thirst Paris with the divine words
Which my lips the Rhône and the Saône can murmur
Always the same cult of his reviving death
Divides the saints and brings a rain of blood
Joyous rain O grief of warm drops
A child watches the windows opening
And the grapes at the top offer themselves to drunken birds

.   .   .   .   .

La Moselle et le Rhin se joignent en silence
C'est l'Europe qui prie nuit et jour à Coblence
Et moi qui m'attardais sur le quai à Auteuil
Quand les heures tombaient parfois comme les feuilles
Du cep lorsqu'il est temps j'entendis la prière
Qui joignait la limpidité de ces rivières

O Paris le vin de ton pays est meilleur que celui
Qui pousse sur nos bords mais aux pampres du nord

Tous les grains ont mûri pour cette soif terrible
Mes grappes d'hommes forts saignent dans le pressoir
Tu boiras à longs traits tout le sang de l'Europe
Parce que tu es beau et que seul tu es noble
Parce que c'est dans toi que Dieu peut devenir
Et tous mes vignerons dans ces belles maisons
Qui reflètent le soir leurs feux dans nos deux eaux
Dans ces belles maisons nettement blanches et noires
Sans savoir que tu es la réalité chantent ta gloire
Mais nous liquides mains jointes pour la prière
Nous menons vers le sel les eaux aventurières
Et la ville entre nous comme entre des ciseaux
Ne reflète en dormant nul feu dans ses deux eaux
Dont quelque sifflement lointain parfois s'élance
Troublant dans leur sommeil les filles de Coblence

Les villes répondaient maintenant par centaines
Je ne distinguais plus leurs paroles lointaines
Et Trèves la ville ancienne
A leur voix mêlait la sienne

L'univers tout entier concentré dans ce vin
Qui contentait les mers les animaux les plantes
Les cités les destins et les astres qui chantent
Les hommes à genoux sur la rive du ciel
Et le docile fer notre bon compagnon
Le feu qu'il faut aimer comme on s'aime soi-même

The Moselle and the Rhine join in silence
It is Europe which prays day and night at Coblenz
And I who was lingering along the quay at Auteuil
As the hours fell at intervals like leaves
From the vine when it is time I heard the prayer
Which joined the limpidity of these rivers

O Paris the wine of your country is better than that
Which grows on our banks but from northern vines

All the grapes have ripened for this terrible thirst
My grapes of sturdy men bleed in the press
You will drink in draughts all Europe's blood
Because you are beautiful and you alone are noble
Because it is in you that God can grow
And all my wine growers in these lovely houses
Which in the evening reflect their lights in our two waters
In these lovely houses perfectly white and black
Without knowing that you are reality they sing your glory
But our liquid hands joined in prayer
We led the adventurous waters toward the salt
And the city between us like a pair of scissors
Reflects no light in its two waters while sleeping
Whose distant murmur rises up at times
To trouble the daughters of Coblenz in their sleep

The cities answer by hundreds now
I can no longer distinguish their distant words
And Trèves the ancient city
Mingles its voice with theirs

The entire universe concentrated in this wine
Which contained oceans animals plants
Cities destinies and stars which sing
Men on their knees on the bank of heaven
And docile iron our good companion
Fire which one must love as one loves oneself

137

Tous les fiers trépassés qui sont un sous mon front
L'éclair qui luit ainsi qu'une pensée naissante
Tous les noms six par six les nombres un à un
Des kilos de papier tordus comme des flammes
Et ceux-là qui sauront blanchir nos ossements
Les bons vers immortels qui s'ennuient patiemment
Des armées rangées en bataille
Des forêts de crucifix et mes demeures lacustres
Au bord des yeux de celle que j'aime tant
Les fleurs qui s'écrient hors de bouches
Et tout ce que je ne sais pas dire
Tout ce que je ne connaîtrai jamais
Tout cela tout cela changé en ce vin pur

Dont Paris avait soif
Me fut alors présenté

Actions belles journées sommeils terribles
Végétation Accouplements musiques éternelles
Mouvements Adorations douleur divine
Mondes qui vous ressemblez et qui nous ressemblez
Je vous ai bu et ne fus pas désaltéré

Mais je connus dès lors quelle saveur a l'univers

Je suis ivre d'avoir bu tout l'univers
Sur le quai d'où je voyais l'onde couler et dormir les bélandres

Ecoutez-moi je suis le gosier de Paris
Et je boirai encore s'il me plaît l'univers

Ecoutez mes chants d'universelle ivrognerie

Et la nuit de septembre s'achevait lentement
Les feux rouges des ponts s'éteignaient dans la Seine
Les étoiles mouraient le jour naissait à peine

All the proud dead who are one under my brow
The flash which lights up like a sudden thought
All names by sixes and numbers one at a time
Pounds of paper twisted like flames
And those which will know how to whiten our bones
The good immortal lines of verse which patiently bore themselves
Armies drawn up in battle
Forests of crucifixes and my lacustral dwellings
Beside her eyes whom I love so
Flowers which cry out from mouths
And all I do not know how to say
All that I shall never know
All that all that changed into this pure wine

What Paris was thirsty for
Was presented to me then

Actions beautiful days terrible sleeps
Vegetation Couplings eternal music
Movements Adorations divine grief
Worlds which resemble each other and resemble us
I have drunk you without quenching my thirst

But I have known since then the flavour of the universe

I am drunk from having swallowed all the universe
On the quay where I saw the darkness flowing and the barges sleeping

Listen to me I am the gullet of all Paris
And I shall drink the universe again if I want

Listen to my songs of universal drunkenness

And the September night drew slowly to a close
The red fires of the bridges dissolved in the Seine
The stars died and day was barely visible

# LES FENETRES

Du rouge au vert tout le jaune se meurt
Quand chantent les aras dans les forêts natales
Abatis de pihis
Il y a un poème à faire sur l'oiseau qui n'a qu'une aile
Nous l'enverrons en message téléphonique
Traumatisme géant
Il fait couler les yeux
Voilà une jolie jeune fille parmi les jeunes Turinaises
Le pauvre jeune homme se mouchait dans sa cravate blanche
Tu soulèveras le rideau
Et maintenant voilà que s'ouvre la fenêtre
Araignées quand les mains tissaient la lumière
Beauté pâleur insondables violets
Nous tenterons en vain de prendre du repos
On commencera à minuit
Quand on a le temps on a la liberté
Bigorneaux Lotte multiples Soleils et l'Oursin du couchant
Une vielle paire de chaussures jaunes devant la fenêtre
Tours
Les Tours ce sont les rues
Puits
Puits ce sont les places
Puits
Arbres creux qui abritent les Câpresses vagabondes
Les Chabins chantent des airs à mourir
Aux Chabines marronnes
Et l'oie oua-oua trompette au nord
Où les chasseurs de ratons
Raclent les pelleteries
Etincelant diamant
Vancouver
Où le train blanc de neige et de feux nocturnes fuit l'hiver

140

# WINDOWS

The yellow fades from red to green
When aras sing in their native forest
Pihis giblets
There is a poem to be done on the bird with only one wing
We will send it by telephone
Giant traumatism
It makes one's eyes run
There is one pretty one among all the young girls from Turin
The unfortunate young man blows his nose in his white necktie
You will lift the curtain
And now look at the window opening
Spiders when hands were weaving light
Beauty paleness unfathomable violet tints
We shall try in vain to take our ease
They start at midnight
When one has time one has liberty
Periwinkles Burbot multiple Suns and the Sea-urchin of the
    setting sun
An old pair of yellow shoes in front of the window
Towers
Towers are streets
Wells
Wells are market places
Wells
Hollow trees which shelter vagabond Capresses
The Octoroons sing songs of dying
To their chestnut-colored wives
And the goose honk honk trumpets in the north
When racoon hunters
Scrape their pelts
Gleaming diamond
Vancouver
Where the train white with snow and fires of the night flees
    the winter

O Paris
Du rouge au vert tout le jaune se meurt
Paris Vancouver Hyères Maintenon New-York et les Antilles
La fenêtre s'ouvre comme une orange
Le beau fruit de la lumière

O Paris
The yellow fades from red to green
Paris Vancouver Hyères Maintenon New York and the Antilles
The window opens like an orange
Lovely fruit of light

# LES COLLINES

Au-dessus de Paris un jour
Combattaient deux grands avions
L'un était rouge et l'autre noir
Tandis qu'au zénith flamboyait
L'éternel avion solaire

L'un était toute ma jeunesse
Et l'autre c'était l'avenir
Ils se combattaient avec rage
Ainsi fit contre Lucifer
L'Archange aux ailes radieuses

Ainsi le calcul au problème
Ainsi la nuit contre le jour
Ainsi attaque ce que j'aime
Mon amour ainsi l'ouragan
Déracine l'arbre qui crie

Mais vois quelle douceur partout
Paris comme une jeune fille
S'éveille langoureusement
Secoue sa longue chevelure
Et chante sa belle chanson

Où donc est tombée ma jeunesse
Tu vois que flambe l'avenir
Sache que je parle aujourd'hui
Pour annoncer au monde entier
Qu'enfin est né l'art de prédire

Certains hommes sont des collines
Qui s'élèvent d'entre les hommes
Et voient au loin tout l'avenir
Mieux que s'il était le présent
Plus net que s'il était passé

. . . . . .

# THE HILLS

High over Paris roofs one day
Two airplanes struggled in the sky
The one was red the other black
While at the zenith timelessly
The airplane-sun flamed in its track

One of them was my long youth
The other held the future's hate
Each fought with the ferocity
Which Archangel of radiant wings
Opposed to Lucifer's great might

Thus calculus the problem's core
Thus night the clarity of day
Thus all that I love will attack
My love and thus the hurricane
Uproots the deep clutch of a tree

But everywhere a sweetness comes
And Paris like a youthful girl
Langorously wakes to day
Shakes out the glory of her hair
And sings what she has known of joy

When did my youth fall from so high
See how the future flames as well
Know that I raise my voice today
To tell the peoples of the world
Prediction is at last an art

Certain men stand out like hills
Rising above their fellow men
To see the future from afar
Better then they see today
Clearer than if it were the past

. . . . .

Je m'arrête pour regarder
Sur la pelouse incandescente
Un serpent erre c'est moi-même
Qui suis la flûte dont je joue
Et le fouet qui châtie les autres

Il vient un temps pour la souffrance
Il vient un temps pour la bonté
Jeunesse adieu voici le temps
Où l'on connaîtra l'avenir
Sans mourir de sa connaissance

C'est le temps de la grâce ardente
La volonté seule agira
Sept ans d'incroyables épreuves
L'homme se divinisera
Plus pur plus vif et plus savant

Il découvrira d'autres mondes
L'esprit languit comme les fleurs
Dont naissent les fruits savoureux
Que nous regarderons mûrir
Sur la colline ensoleillée

Je dis ce qu'est au vrai la vie
Seul je pouvais chanter ainsi
Mes chants tombent comme des graines
Taisez-vous tous vous qui chantez
Ne mêlez pas l'ivraie au blé

.    .    .    .    .

Habituez-vous comme moi
A ces prodiges que j'annonce
A la bonté qui va régner
A la souffrance que j'endure
Et vous connaîtrez l'avenir

I stop in wonderment to see
Upon the incandescent lawn
A serpent glide it is myself
Who am the flute I play upon
A whip to punish other men

A time comes meant for suffering
And a time for goodness to be known
Farewell my youth the time is here
In which the future can be known
Without death as a consequence

This is a time of ardent grace
The will alone will have effect
For seven years of wonderment
Man will behold himself as purer
Wiser more awake to life

He will discover other worlds
Pure mind wilts like the blooms from which
Is born the savor of ripe fruit
Which we will watch as it fills out
On hillsides ravished by the sun

I speak the deepest truths of life
And I alone can sing them thus
In songs that fall like seeds to earth
You other voices must be still
And not mix tares with my good wheat

.   .   .   .   .

Accustom yourself as I have done
To the miracles which I foretell
To goodness which will fill the world
To the suffering which I endure
And the future will appear to you

147

C'est de souffrance et de bonté
Que sera faite la beauté
Plus parfaite que n'était celle
Qui venait des proportions
Il neige et je brûle et je tremble

Maintenant je suis à ma table
J'écris ce que j'ai ressenti
Et ce que j'ai chanté là-haut
Un arbre élancé que balance
Le vent dont les cheveux s'envolent

Un chapeau haut de forme est sur
Une table chargée de fruits
Les gants sont morts près d'une pomme
Une dame se tord le cou
Auprès d'un monsieur qui s'avale

Le bal tournoie au fond du temps
J'ai tué le beau chef d'orchestre
Et je pèle pour mes amis
L'orange dont la saveur est
Un merveilleux feu d'artifice

Tous sont morts le maître d'hôtel
Leur verse un champagne irréel
Qui mousse comme un escargot
Ou comme un cerveau de poète
Tandis que chantait une rose

L'esclave tient une épée nue
Semblable aux sources et aux fleuves
Et chaque fois quelle s'abaisse
Un univers est éventré
Dont il sort des mondes nouveaux

From goodness and from suffering
A beauty will be finally formed
More perfect than what now is found
In all displays of symmetry
It snows I smoulder and I quake

I am seated here before my desk
To write exactly what I felt
And what I sang up there
A graceful tree bent back and forth
By a wind with flying hair

An opera hat is lying on
A table loaded down with fruit
The gloves have died beside an apple
A lady cranes her neck beside
A gentleman who gulps himself

The dance revolves in the depths of time
I killed the leader of the band
And for my watching friends I peel
The orange whose pungent odor is
A brilliant fireworks display

When all are dead the *maître d'hôtel*
Pours over them unreal champagne
Which lathers like a sticky snail
Or like a poet's foaming brain
A rose was singing all the time

The slave holds up a naked sword
Quite similar to springs and streams
And every time it is brought down
A universe is disembowelled
From which new worlds are born again

Le chauffeur se tient au volant
Et chaque fois que sur la route
Il corne en passant le tournant
Il paraît à perte de vue
Un univers encore vierge

Et le tiers nombre c'est la dame
Elle monte dans l'ascenseur
Elle monte monte toujours
Et la lumière se déploie
Et ces clartés la transfigurent

Mais ce sont de petits secrets
Il en est d'autres plus profonds
Qui se dévoileront bientôt
Et feront de vous cent morceaux
A la pensée toujours unique

Mais pleure pleure et repleurons
Et soit que la lune soit pleine
Ou soit qu'elle n'ait qu'un croissant
Ah ! pleure pleure et repleurons
Nous avons tant ri au soleil

Des bras d'or supportent la vie
Pénétrez le secret doré
Tout n'est qu'une flamme rapide
Que fleurit la rose adorable
Et d'où monte un parfum exquis

The driver grips the steering wheel
And every time along the road
He blows the horn rounding a curve
There appears on the horizon's rim
A universe as yet unknown

The third one is the lady who
Is taking the elevator up
She keeps on going up and up
And light seems to unfold itself
In brilliance which transfigures her

But these are just some little secrets
Of many others more profound
Which will reveal themselves so soon
That you will burst a hundred ways
At thought so constantly unique

But weep and weep and weep again
And though the moon wax to its full
Or be it but a crescent moon
Ah! weep and weep and weep again
For we have laughed long at the sun

Golden arms sustain life
Penetrate its secret gold
All is but a fleeting flame
Which the adorable rose adorns
Shedding rises an exquisite perfume

# LE MUSICIEN DE
# SAINT-MERRY

J'ai enfin le droit de saluer des êtres que je ne connais pas
Ils passent devant moi et s'accumulent au loin
Tandis que tout ce que j'en vois m'est inconnu
Et leur espoir n'est pas moins fort que le mien

Je ne chante pas ce monde ni les autres astres
Je chante toutes les possibilités de moi-même hors de ce monde et
    des astres
Je chante la joie d'errer et le plaisir d'en mourir

Le 21 du mois de mai 1913
Passeur des morts et les mordonnantes mériennes
Des millions de mouches éventaient une splendeur
Quand un homme sans yeux sans nez et sans oreilles
Quittant le Sébasto entra dans la rue Aubry-le-Boucher
Jeune l'homme était brun et cette couleur de fraise sur les joues
Homme Ah! Ariane
Il jouait de la flûte et la musique dirigeait ses pas
Il s'arrêta au coin de la rue Saint-Martin
Jouant l'air que je chante et que j'ai inventé
Les femmes qui passaient s'arrêtaient près de lui
Il en venait de toutes parts
Lorsque tout à coup les cloches de Saint-Merry se mirent à sonner
Le musicien cessa de jouer et but à la fontaine
Qui se trouve au coin de la rue Simon-Le-Franc
Puis Saint-Merry se tut
L'inconnu reprit son air de flûte
Et revenant sur ses pas marcha jusqu'à la rue de la Verrerie
Où il entra suivi par la troupe des femmes
Qui sortaient des maisons
Qui venaient par les rues traversières les yeux fous
Les mains tendues vers le mélodieux ravisseur

# THE MUSICIAN OF SAINT-MERRY

Finally I have the right to greet creatures whom I do not know
They pass in front of me and assemble further on
Whereas all that I see of them is unknown
And their hope is not less strong than mine

I do not sing of this world nor of the other stars
I sing all the possibilities of myself beyond this world and the stars
I sing the joy of wandering and the pleasure of dying thus

The 21st of the month of May 1913
Death's ferryman and St. Merry's ruddy buzzing wives
Millions of flies air out a splendor
When a man without eyes without a nose and without ears
Leaving the Sébasto turned into rue Aubry-le-Boucher
The young man was dark with a strawberry color on his cheeks
Man Ah! Ariane
He played the flute and the music guided his steps
He stopped at the corner of rue Saint-Martin
Playing the tune I am singing and which I made up
The women who passed stopped near him
Coming from all directions
When the bells of Saint-Merry began to ring
The musician stopped playing and took a drink from the fountain
Which is at the corner of rue Simon-le-Franc
Then Saint-Merry was silent
The stranger began his tune again on the flute
And retracing his steps walked as far as rue de la Verrerie
Which he turned into followed by his troop of women
Who came out of the houses
Who came out of the side streets with wild eyes
Their hands stretched out toward the melodious seducer

Il s'en allait indifférent jouant son air
Il s'en allait terriblement
Puis ailleurs
A quelle heure un train partira-t-il pour Paris

A ce moment
Les pigeons des Moluques fientaient des noix muscades
En même temps
Mission catholique de Bôma qu'as-tu fait du sculpteur

Ailleurs
Elle traverse un pont qui relie Bonn à Beuel et disparaît à travers
Pützchen

Au même instant
Une jeune fille amoureuse du maire

Dans un autre quartier
Rivalise donc poète avec les étiquettes des parfumeurs

En somme ô rieurs vous n'avez pas tiré grand chose des hommes
Et à peine avez-vous extrait un peu de graisse de leur misère
Mais nous qui mourons de vivre loin l'un de l'autre
Tendons nos bras et sur ces rails roule un long train de marchandises

Tu pleurais assise près de moi au fond du fiacre
Et maintenant
Tu me ressembles tu me ressembles malheureusement

Nous nous ressemblions comme dans l'architecture du siècle dernier
Ces hautes cheminées pareilles à des tours

Nous allons plus haut maintenant et ne touchons plus le sol

Et tandis que le monde vivait et variait
Le cortège des femmes long comme un jour sans pain
Suivait dans la rue de la Verrerie l'heureux musicien

He strolled along indifferently playing his tune
It was terrible the way he went along
Then somewhere else
What time does a train leave for Paris

At that moment
The pigeons of the Moluccas voided nutmeg droppings
At the same time
Catholic mission of Bôma what have you done with the sculptor

Elsewhere
She crosses a bridge which links Bonn with Beuel and disappears
    across Pützchen

At the same time
A girl in love with the mayor

In another quarter
Poet competes with perfume labels

In all O mockers you have not gotten a great deal out of men
You have barely gotten a little fat out of their misery
But we who die from living far apart from one another
Hold out our arms and on those rails rolls a long train of merchandise

Seated next to me you were crying in the depths of the fiacre
And now
You look like me you look distressingly like me

We resemble one another as in the architecture of the last century
Those high chimneys almost like towers

We are going higher now and touch the ground no longer

And while the world lived and changed
The procession of women as long as a breadless day
Followed the happy musician in the rue de la Verrerie

Cortèges ô cortèges
C'est quand jadis le roi s'en allait à Vincennes
Quand les ambassadeurs arrivaient à Paris
Quand le maigre Suger se hâtait vers la Seine
Quand l'émeute mourait autour de Saint-Merry

Cortèges ô cortèges
Les femmes débordaient tant leur nombre était grand
Dans toutes les rues avoisinantes
Et se hâtaient raides comme balle
Afin de suivre le musicien

Ah ! Ariane et toi Pâquette et toi Amine
Et toi Mia et toi Simone et toi Mavise
Et toi Colette et toi la belle Geneviève
Elles ont passé tremblantes et vaines
Et leurs pas légers et prestes se mouvaient selon la cadence
De la musique pastorale qui guidait
Leurs oreilles avides

L'inconnu s'arrêta un moment devant une maison à vendre
Maison abandonnée
Aux vitres brisées
C'est un logis du seizième siècle
La cour sert de remise à des voitures de livraisons
C'est là qu'entra le musicien
Sa musique qui s'éloignait devint langoureuse
Les femmes le suivirent dans la maison abandonnée
Et toutes y entrèrent confondues en bande
Toutes toutes y entrèrent sans regarder derrière elles
Sans regretter ce qu'elles ont laissé
Ce qu'elles ont abandonné
Sans regretter le jour la vie et la mémoire
Il ne resta bientôt plus personne dans la rue de la Verrerie
Sinon moi-même et un prêtre de Saint-Merry

Processions O processions
It is as when formerly the king left for Vincennes
When the ambassadors arrived in Paris
When thin Suger hurried toward the Seine
When the disturbance died out around Saint-Merry

Processions O processions
So great was their number the women overflowed
Into the neighboring streets
And hastened straightaway
To follow the musician

Ah! Ariane and you Paquette and you Amine
And you Mia and you Simone and you Mavise
And you Colette and you beautiful Genevieve
They passed trembling and vain
And their quick light steps obeyed the cadence
Of the pastoral music which guided
Their avid ears

The stranger stopped a moment in front of a house for sale
An abandoned house
With broken window panes
A sixteenth century house
Delivery trucks parked in the courtyard
It is there that the musician went in
His music as it went away became more languorous
The women followed him into the empty house
And all went in in a confused band
All all of them went in without a backward look
Without missing what they were leaving
What they were abandoning
Without missing light life and memory
Soon there was no one left in the rue de la Verrerie
Only myself and a priest of Saint-Merry

Nous entrâmes dans la vieille maison

Mais nous n'y trouvâmes personne

Voici le soir
A Saint-Merry c'est l'Angélus qui sonne
Cortèges ô cortèges

C'est quand jadis le roi revenait de Vincennes
Il vint une troupe de casquettiers
Il vint des marchands de bananes
Il vint des soldats de la garde républicaine
O nuit
Troupeau de regards langoureux de femmes
O nuit
Toi ma douleur et mon attente vaine
J'entends mourir le son d'une flûte lointaine

We entered the old house

But we found no one there

Here it is evening
At Saint-Merry the Angelus rings
Processions O processions

When the king of old came back from Vincennes
A band of hatters came along
Banana merchants came
Soldiers of the republican guard came
O night
Flock of langorous glances of women
O night
You my grief and my vain expectation
The sound of a distant flute I hear as it fades away

# UN FANTOME DE NUEES

Comme c'était la veille du quatorze juillet
Vers les quatre heures de l'après-midi
Je descendis dans la rue pour aller voir les saltimbanques

Ces gens qui font des tours en plein air
Commencent à être rares à Paris
Dans ma jeunesse on en voyait beaucoup plus qu'aujourd'hui
Ils s'en sont allés presque tous en province

Je pris le boulevard Saint-Germain
Et sur une petite place située entre Saint-Germain-des-Prés et la statue de
    Danton
Je recontrai les saltimbanques
La foule les entourait muette et résignée à attendre
Je me fis une place dans ce cercle afin de tout voir

Poids formidable
Villes de Belgique soulevées à bras tendu par un ouvrier russe de Longwy
Haltères noirs et creux qui ont pour tige un fleuve figé
Doigts roulant une cigarette amère et délicieuse comme la vie

De nombreux tapis sales couvraient le sol
Tapis qui ont des plis qu'on ne défera pas
Tapis qui sont presque entièrement couleur de la poussière
Et où quelques taches jaunes ou vertes ont persisté
Comme un air de musique qui vous poursuit

Vois-tu le personnage maigre et sauvage
La cendre de ses pères lui sortait en barbe grisonnante
Il portait ainsi toute son hérédité au visage
Il semblait rêver à l'avenir
En tournant machinalement un orgue de Barbarie
Dont la lente voix se lamentait merveilleusement
Les glouglous les couacs et les sourds gémissements

# PHANTOM OF THE CLOUDS

It was the day before July 14
About four in the afternoon
I went out to see the acrobats

Those men who do tumbling in the open
Are beginning to be rare in Paris
In my youth one saw many more than today
They have almost all gone to the provinces

I took the boulevard Saint-Germain
And on a little square betweeen Saint-Germain-des-Prés and the statue
   of Danton
I found some acrobats
The crowd which surrounded them was silent and resigned to waiting
I found a place in the group where I could see everything

Formidable weights
Whole Belgian cities held up at arm's length by a Russian worker from
   Longwy
Black hollow dumb-bells with a frozen river for a shaft
Fingers rolling a cigarette as bitter and delicious as life

Several dirty rugs lie on the ground
Rugs with creases that will never come out
Rugs which are almost entirely the color of dust
And on which a few yellow and green spots still show
Like a tune which will not leave you

See that thin savage looking one
The ashes of his ancestors are coming out in his grey beard
He carries all his heredity in his face
And seems to dream of the future
While mechanically turning a barrel-organ
Whose sweet voice wails marvellously
Gurgling false notes and muffled groans

Les saltimbanques ne bougeaient pas
Le plus vieux avait un maillot couleur de ce rose violâtre qu'ont aux
   joues certaines jeunes filles fraîches mais près de la mort
Ce rose-là se niche surtout dans les plis qui entourent souvent leur bouche
Ou près des narines
C'est un rose plein de traîtrise

Cet homme portait-il ainsi sur le dos
La teinte ignoble de ses poumons

Les bras les bras partout montaient la garde

Le second saltimbanque
N'était vêtu que de son ombre
Je le regardai longtemps
Son visage m'échappe entièrement
C'est un homme sans tête

Un autre enfin avait l'air d'un voyou
D'un apache bon et crapule à la fois
Avec son pantalon bouffant et les accroche-chaussettes
N'aurait-il pas eu l'apparence d'un maquereau à sa toilette

La musique se tut et ce furent des pourparlers avec le public
Qui sou à sou jetta sur le tapis la somme de deux francs cinquante
Au lieu des trois francs que le vieux avait fixés comme prix des tours

Mais quand il fut clair que personne ne donnerait plus rien
On se décida à commencer la séance
De dessous l'orgue sortit un tout petit saltimbanque habillé de rose
   pulmonaire
Avec de la fourrure aux poignets et aux chevilles
Il poussait des cris brefs
Et saluait en écartant gentiment les avant-bras
Mains ouvertes

The saltimbanques didn't move
The oldest wore tights of that purplish rose color which glows in the
   cheeks of lively little girls who are near death
That rose nestles most in the lines around their mouths
Or next to their nostrils
It is a color full of treachery

Did that man carry thus around his waist
The vile color of his lungs

Arms arms everywhere mounted guard

The second saltimbanque
Was clothed only in his shadow
I looked at him a long time
His face escapes me entirely
He was a man without a head

Another one looked like an urchin
A good Apache but debauched
With his comic pants and garters
Wouldn't he have looked like a pimp getting dressed

The music stopped for a parley with the audience
Which tossed the sum of 2 francs 50 sou by sou on the rug
Instead of the three francs which the old one had set as the price of a
   performance

But when it was clear that no one would give anything more
They decided to begin
From behind the organ a small saltimbanque came out dressed in con-
   sumptive red
With fur at his wrists and ankles
He gave a few brief cries
And saluted with his forearms prettily held
His hands spread out

Une jambe en arrière prête à la génuflexion
Il salua ainsi aux quatre points cardinaux
Et quand il marcha sur une boule
Son corps mince devint une musique si délicate que nul parmi les specta-
   teurs n'y fut insensible
Un petit esprit sans aucune humanité
Pensa chacun
Et cette musique des formes
Détruisit celle de l'orgue mécanique
Que moulait l'homme au visage couvert d'ancêtres

Le petit saltimbanque fit la roue
Avec tant d'harmonie
Que l'orgue cessa de jouer
Et que l'organiste se cacha le visage dans les mains
Aux doigts semblables aux descendants de son destin
Fœtus minuscules qui lui sortaient de la barbe
Nouveaux cris de Peau-Rouge
Musique angélique des arbres
Disparition de l'enfant

Les saltimbanques soulevèrent les gros haltères à bout de bras
Ils jonglèrent avec les poids

Mais chaque spectateur cherchait en soi l'enfant miraculeux
Siècle ô siècle des nuages

With one leg back ready to genuflect
He bowed to the four cardinal points
And when he balanced on a ball
His slim body became so delicate a music that none of the spectators
  could resist it
A tiny spirit without humanity
Everyone thought
And this music of shapes
Destroyed that of the mechanical organ
Which was ground by the man with his face covered with his ancestors

The little saltimbanque turned a cart-wheel
With so much harmony
That the organ stopped playing
And the organist hid his face in his hands
With fingers like descendants of his destiny
Small foetuses which came out of his beard
New Indian cries
The angelic music of trees
The disappearance of the child

The saltimbanques lifted the great dumb-bells in their arms
And juggled with the weights

But each spectator looked in himself for the miraculous child
Century O century of clouds

# HEART

MY HEART like a flame turned upside down

# MIRROR

In this mirror I am enclosed living and true as one imagines angels not as reflections are **Guillaume Apollinaire**

# CŒUR ET MIROIR

                    N          N
              E   V E R S É E    O   C
            R                   M      Œ
          E                             U
          M                             R
          M                             P
            A                         A
              L                     R
                F                 E
                  E             I
                    N         I
                      U   L
                        à

                DANS
            FLETS       CE
          RE            MI
          LES           ROIR
          SONT          JE
          ME            SUIS
          COM   Guillaume   EN
          NON           CLOS
          ET   Apollinaire   VI
          GES           VANT
          AN            ET
          LES           VRAI
            NE          COM
              GI        ME
                MA    ON
                  I

# THE CARNATION

May this carnation tell you the law of odors which has not yet been announced and which one day will come to rule in our minds far more precisely and more subtly than the sounds which guide us

I prefer your nose to all your organs O my love. It is the throne of future knowledge

# L'ŒILLET

que cet œillet te dise
la loi        des odeurs
qu'on n'a pas encore
promulguée et qui viendra
un  jour
régner  sur
nos cerveaux
bien            +
précise & + subtile
que
les
sons
qui  dirigent
Je préfère  nous
ton nez
à
tous
tes
org
Il est le trône  de  anes ô mon amie
la
future
SA
GES
SE

# IT'S RAINING

Its raining women's voices as if they had died even in memory
And it's raining you as well marvellous encounters of my life
    O little drops
Those rearing clouds begin to neigh a whole universe of auricular cities
Listen if it rains while regret and disdain weep to an ancient music
Listen to the bonds fall off which hold you above and below

# IL PLEUT

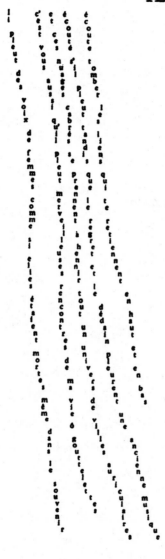

Il pleut des voix de femmes comme si elles étaient mortes même dans le souvenir

c'est vous aussi qu'il pleut merveilleuses rencontres de ma vie ô gouttelettes

et ces nuages cabrés se prennent à hennir tout un univers de villes auriculaires

écoute s'il pleut tandis que le regret et le dédain pleurent une ancienne musique

écoute tomber les liens qui te retiennent en haut et en bas

# AIM

*To Madame René Berthier*

Cherry colored horses boundary of the Zealanders
Machine guns made of gold croak legends
I love you liberty who hide in basement rooms
Silver stringed harp O rain O my music
The invisible enemy a silver wound in the sun
And the secret future which the rocket illuminates
Listen to the Word swim subtle fish
One by one the cities become keys
The blue mask just as God puts on his sky
Peacable ascetic war metaphysical solitude
A child with its hands cut off among roses like flags

# VISEE

A Madame René Berthier

Chevaux couleur cerise limite des Zélandes

Des mitrailleuses d'or coassent les légendes

Je t'aime liberté qui veilles dans les hypogées

Harpe aux cordes d'argent ô pluie ô ma musique

L'invisible ennemi plaie d'argent au soleil

Et l'avenir secret que la fusée élucide

Entends nager le Mot poisson subtil

Les villes tour à tour deviennent des clefs

Le masque bleu comme met Dieu son ciel

Guerre paisible ascèse solitude métaphysique

Enfant aux mains coupées parmi les roses oriflammes

# GUERRE

Rameau central de combat
    Contact par l'écoute
Ou tire dans la direction « des bruits entendus »
  Les jeunes de la classe 1915
Et ces fils de fer électrisés
Ne pleurez donc pas sur les horreurs de la guerre
Avant elle nous n'avions que la surface
De la terre et des mers
Après elle nous aurons les abîmes
Les sous-sol et l'espace aviatique
Maîtres du timon
Après après
Nous prendrons toutes les joies
Des vainqueurs qui se délassent
    Femmes Jeux Usines Commerce
    Industrie Agriculture Métal
    Feu Cristal Vitesse
Voix Regard Tact à part
Et ensemble dans le tact venu de loin
De plus loin encore
De l'Au-delà de cette terre

# WAR

The central combat sector
    Contact by listening post
Or shoot in the direction of " audible noises "
    The young men in the class of 1915
And these electrified wires
Yet don't cry about these horrors of war
Before it we only had the surface
Of the earth and of the sea
After it we shall have the depths
The underground and free space overhead
Men at the tiller
Afterwards afterwards
We shall have all the joys
Of conquerors who rest
    Women Games Factories Commerce
    Industry Agriculture Iron
    Fire Crystal Speed
Voice Light Touch separately
And together in the touch of distant things
Of far greater distances
Beyond this earth even

# TOUJOURS

*A Madame Faure-Favier*

Toujours
Nous irons plus loin sans avancer jamais
Et de planète en planète

De nébuleuse en nébuleuse
Le don Juan des mille et trois comètes
Même sans bouger de la terre
Cherche les forces neuves
Et prend au sérieux les fantômes

Et tant d'univers s'oublient
Quels sont les grands oublieurs
Qui donc saura nous faire oublier telle ou telle partie du
    monde
Où est le Christophe Colomb à qui l'on devra l'oubli d'un
    continent
                Perdre
Mais perdre vraiment
Pour laisser place à la trouvaille
                    Perdre
La vie pour trouver la Victoire

# ALWAYS

*To Madame Faure-Favier*

Always
We are going farther without ever advancing
And from planet to planet

From nebula to nebula
The Don Juan of a thousand and three comets
Without even rising from the earth
Look for new forces
And take phantoms seriously

And so many of the universe forget themselves
Who are the great forgetters
Who will know just how to make us forget such and
    such a part of the world
Where is Christopher Columbus to whom is owed the
    forgetting of a continent
                            To lose
But to lose genuinely
In order to make room for discovery
                                    To lose

Life in order to find Victory

# LA BOUCLE RETROUVEE

Il retrouve dans sa mémoire
La boucle de cheveux châtains
T'en souvient-il à n'y point croire
De nos deux étranges destins

Du boulevard de la Chapelle
Du joli Montmartre et d'Auteuil
Je me souviens murmure-t-elle
Du jour où j'ai franchi ton seuil

Il y tomba comme un automne
La boucle de mon souvenir
Et notre destin qui t'étonne
Se joint au jour qui va finir

# THE RECAPTURED LOCK

He finds within his memory
The curl of chestnut colored hair
Does it remind you not to trust
In our two alien destinies

From the boulevard de la Chapelle
From lovely Montmartre and Auteuil
She murmured now I can recall
The day I crossed your threshold there

The thin curl of my memory
Fell in the tingling autumn air
Our destiny which dazzles you
Is linked to this expiring day

# OCEAN DE TERRE

*A G. de Chirico*

J'ai bâti une maison au milieu de l'Océan
Ses fenêtres sont les fleuves qui s'écoulent de mes yeux
Des poulpes grouillent partout où se tiennent les murailles
Entendez battre leur triple cœur et leur bec cogner aux
vitres

> Maison humide
> Maison ardente
> Saison rapide
> Saison qui chante
> Les avions pondent des œufs
> Attention on va jeter l'ancre

Attention à l'encre que l'on jette
Il serait bon que vous vinssiez du ciel
Le chèvrefeuille du ciel grimpe
Les poulpes terrestres palpitent
Et puis nous sommes tant et tant à être nos propres
fossoyeurs
Pâles poulpes des vagues crayeuses ô poulpes aux becs
pâles
Autour de la maison il y a cet océan que tu connais
Et qui ne se repose jamais

# OCEAN OF EARTH

*To G. de Chirico*

I built a house in the middle of the ocean
Its windows are rivers which flow out of my eyes
Octopus stir all around its walls
Listen to the triple beat of their hearts and their beaks
   which tap on the window panes
           Humid house
           Burning house
           Rapid season
           Season which sings
       Airplanes drop eggs
       Watch out for the anchor
Watch out for the ink which they squirt
It's a good thing you came from the sky
The honeysuckle of the sky climbs up
The earthly octopus throb
And then we are closer and closer to being our own
   gravediggers
Pale octopus of chalky waves O octopus with pale beaks
Around the house there is this ocean which you know
And which is never still

# MERVEILLES DE LA GUERRE

Que c'est beau ces fusées qui illuminent la nuit
Elles montent sur leur propre cime et se penchent pour regarder
Ce sont des dames qui dansent avec leur regard pour yeux bras et cœurs

J'ai reconnu ton sourire et ta vivacité

C'est aussi l'apothéose quotidienne de toutes mes Bérénices dont les
    chevelures sont devenues des comètes
Ces danseuses surdorées appartiennent à tous les temps et à toutes les
    races
Elles accouchent brusquement d'enfants qui n'ont que le temps de mourir
Comme c'est beau toutes ces fusées
Mais ce serait bien plus beau s'il y en avait plus encore
S'il y en avait des millions qui auraient un sens complet et relatif comme
    les lettres d'un livre
Pourtant c'est aussi beau que si la vie même sortait des mourants

Mais ce serait plus beau encore s'il y en avait plus encore
Cependant je les regarde comme une beauté qui s'offre et s'évanouit
    aussitôt
Il me semble assister à un grand festin éclairé à giorno
C'est un banquet que s'offre la terre
Elle a faim et ouvre de longues bouches pâles
La terre a faim et voici son festin de Balthasar cannibale

Qui aurait dit qu'on pût être à ce point anthropophage
Et qu'il fallût tant de feu pour rôtir le corps humain
C'est pourquoi l'air a un petit goût empyreumatique qui n'est ma foi
    pas désagréable
Mais le festin serait plus beau encore si le ciel y mangeait avec la terre
Il n'avale que les âmes
Ce qui est une façon de ne pas se nourrir
Et se contente de jongler avec des feux versicolores

# THE MARVELS OF WAR

How beautiful those rockets are lighting up the night
They rise to their own summit and then lean down to look at us
They are women who dance with an awareness of eyes arms and hearts

I recognized your smile and your vivacity

It is also the daily apotheosis of all my Berenices whose flowing hair
   turned into comets' tails
These twice gilded dancers belong to all times and all races
They quickly bear children who only have time to die
How beautiful those rockets are
But it would be more beautiful if there were even more
If there were millions of them which would have a full and relevant
   meaning like the letters of a book
However it is as lovely as if life itself emerged from creatures about to die

But it would be more beautiful if there were still more of them
However I watched them like a beauty which presents itself and immed-
   iately fades away
I seem to be at a feast lighted *a giorno*
The banquet which the earth offers to herself
She is hungry and opens these long pale mouths
The earth is hungry and behold her cannibal Balthasar's feast

Who would have said that one could be anthropophagous to this extent
And that it took so much fire to roast human flesh
That is why the air has a slight empyrheumatic taste which is not bad
   by god
But the feast would be even better if the sky ate with the earth
It only swallows souls
Which is a manner of not feeding itself
And is content with juggling multi-colored fires

Mais j'ai coulé dans la douceur de cette guerre avec toute ma compagnie
   au long des longs boyaux
Quelques cris de flamme annoncent sans cesse ma présence
J'ai creusé le lit où je coule en me ramifiant en mille petits fleuves qui
   vont partout
Je suis dans la tranchée de première ligne et cependant je suis partout ou
   plutôt je commence à être partout
C'est moi qui commence cette chose des siècles à venir
Ce sera plus long à réaliser que non la fable d'Icare volant

Je lègue à l'avenir l'histoire de Guillaume Apollinaire
Qui fut à la guerre et sut être partout
Dans les villes heureuses de l'arrière
Dans tout le reste de l'univers
Dans ceux qui meurent en piétinant dans le barbelé
Dans les femmes dans les canons dans les chevaux
Au zénith au nadir aux 4 points cardinaux
Et dans l'unique ardeur de cette veillée d'armes
Et ce serait sans doute bien plus beau
Si je pouvais supposer que toutes ces choses dans lesquelles je suis partout
Pouvaient m'occuper aussi
Mais dans ce sens il n'y a rien de fait
Car si je suis partout à cette heure il n'y a cependant que moi qui suis en
   moi

But I have flowed into the sweetness of this war with all my company
    along the trenches
A few cries of flame continually announce my presence
I have dug the bed in which I flow and branch out into a thousand little
    streams which go everywhere
I am in the front line trenches and also everywhere or rather I begin to
    be everywhere
It is I who am launching this whole business of the coming centuries
It will take longer to attain than not the myth of Icarus

I bequeath to the future the story of Guillaume Apollinaire
Who was in the war and could be everywhere
In happy villages behind the lines
In all the rest of the universe
In those who died tangled in the barbed wire
In women in cannon in horses
At the zenith and the nadir and the four cardinal points
And in the unique intensity of this eve of battle
And without doubt it would be more beautiful
If I could suppose that all the things everywhere in which I reside
Could be also in me
But there is nothing so made in this respect
For if I am everywhere right now there is still only I who can be in me

# UN OISEAU CHANTE

Un oiseau chante ne sais où
C'est je crois ton âme qui veille
Parmi tous les soldats d'un sou
Et l'oiseau charme mon oreille

Ecoute il chante tendrement
Je ne sais pas sur quelle branche
Et partout il va me charmant
Nuit et jour semaine et dimanche

Mais que dire de cet oiseau
Que dire des métamorphoses
De l'âme en chant dans l'arbrisseau
Du cœur en ciel du ciel en roses

L'oiseau des soldats c'est l'amour
Et mon amour c'est une fille
La rose est moins parfaite et pour
Moi seul l'oiseau bleu s'égosille

Oiseau bleu comme le cœur bleu
De mon amour au cœur céleste
Ton chant si doux répète-le
A la mitrailleuse funeste

Qui claque à l'horizon et puis
Sont-ce les astres que l'on sème
Ainsi vont les jours et les nuits
Amour bleu comme est le cœur même

# A BIRD SINGS

A bird sings and I know not where
It is I think your waking soul
Somewhere among these two-bit troops
The bird casts spells upon my ear

Listen how tenderly he sings
On a branch I cannot see or find
He charms me everywhere I go
Both day and night the whole week long

What can be said of this sweet bird
And of the metamorphoses
Of a soul which sings in the shrubbery
Of the heart in the sky and the sky in a rose

The bird which soldiers hear is love
And my love is a little girl
More perfect than the rose and for
Me only does the blue bird shrill

Blue bird blue as is the heart
Which my love bears in the heart of heaven
Sing your sweet song on and on
In the sound of deadly rifle fire

Which cracks at the horizon's edge
Are those the stars one scatters there
Thus the days and nights go by
And love is blue as the heart itself

# CHEVAUX DE FRISE

Pendant le blanc et nocturne novembre
Alors que les arbres déchiquetés par l'artillerie
Vieillissaient encore sous la neige
Et semblaient à peine des chevaux de frise
Entourés de vagues de fils de fer
Mon cœur renaissait comme un arbre au printemps
Un arbre fruitier sur lequel s'épanouissent
   Les fleurs de l'amour

Pendant le blanc et nocturne novembre
Tandis que chantaient épouvantablement les obus
Et que les fleurs mortes de la terre exhalaient
   Leurs mortelles odeurs
Moi je décrivais tous les jours mon amour à Madeleine
La neige met de pâles fleurs sur les arbres
  Et toisonne d'hermine les chevaux de frise
   Que l'on voit partout
    Abandonnés et sinistres
    Chevaux muets
  Non chevaux barbes mais barbelés
   Et je les anime tout soudain
  En troupeau de jolis chevaux pies
Qui vont vers toi comme de blanches vagues
   Sur la Méditerranée
   Et t'apportent mon amour
Roselys ô panthère ô colombes étoile bleue
    ô Madeleine
Je t'aime avec délices
Si je songe à tes yeux je songe aux sources fraîches
Si je pense à ta bouche les roses m'apparaissent
Si je songe à tes seins le Paraclet descend
   O double colombe de ta poitrine

# FRISIAN HORSES*

During the dismal white November days
When the trees tattered by artillery
Still grew old beneath the snow
And scarcely looked like horses on a frieze
Surrounded by waves of wire
My heart was born again like a tree in the spring
A fruit tree on which unfold
        The flowers of love

During the dismal white November days
Although the shells shrieked frightfully
And the earth's dead flowers breathed out
        Their mortal smells
I described my love each day to Madeleine
The snow brings out pale flowers on the trees and gives
      An ermine coat to all the frisian horses
        Which are seen everywhere
          Abandoned and sinister
            Mute horses
     Not bearded horses but barbed
        And I suddenly bring them to life
      As a herd of beautiful piebald horses
Which move toward you in white waves
        On the Mediterranean
       And bring you my love
Roselilies O panther O doves blue star
        O Madeleine
I love you in delight
If I think of your eyes I think of clear springs
If I think of your mouth roses appear
If I think of your breasts the Paraclete descends
       O double dove in your breast

Et vient délier ma langue de poète
            Pour te redire
            Je t'aime
Ton visage est un bouquet de fleurs
        Aujourd'hui je te vois non Panthère
                    Mais Toutefleur
Et je te respire ô ma Toutefleur
Tous les lys montent en toi comme des cantiques d'amour
        et d'allégresse
Et ces chants qui s'envolent vers toi
                M'emportent à ton côté
            Dans ton bel Orient où les lys
Se changent en palmiers qui de leurs belles mains
Me font signe de venir
La fusée s'épanouit fleur nocturne
                Quand il fait noir
Et elle retombe comme une pluie de larmes amoureuses
De larmes heureuses que la joie fait couler
        Et je t'aime comme tu m'aimes
                Madeleine

And comes to loose my poet's tongue
                 To tell you again
                 How I love you
Your face is a bouquet of flowers
      I see you today not panther
                             But Prettyflower
And I can savor you O my Prettyflower
All lilies grow in you like canticles of love and joy
And these songs which take flight toward you
                 Carry me to your side
                 Into your fair Orient where lilies
Change into palm trees which with their flat hands
Beckon to me
The rocket spreads out nocturnal flower
                 When it is dark
And falls back like a rain of devoted tears
Happy tears which flow for joy
                 And I love you as you love me
                 Madeleine

* An old military term, still current during the First World War, for wooden
or wire entanglements to obstruct the advance of troops and horses. *Frise*
also means " frieze "—allowing a secondary reading as " horses on a frieze ".

# TRISTESSE D'UNE ETOILE

Une belle Minerve est l'enfant de ma tête
Une étoile de sang me couronne à jamais
La raison est au fond et le ciel est au faîte
Du chef où dès longtemps Déesse tu t'armais

C'est pourquoi de mes maux ce n'était pas le pire
Ce trou presque mortel et qui s'est étoilé
Mais le secret malheur qui nourrit mon délire
Est bien plus grand qu'aucune âme ait jamais celé

Et je porte moi cette ardente souffrance
Comme le ver luisant tient son corps enflammé
Comme au cœur du soldat il palpite la France
Et comme au cœur du lys le pollen parfumé

# SADNESS OF A STAR

Minerva stepped out calmly from my head
And I will be forever crowned with blood
There is reason within and sky above my skull
Where Goddess you were buckling on your arms

Of my misfortunes this is not the worst
This almost mortal wound became a star
The secret sorrow which is my despair
Is more than any other soul could hide

I bear with me a suffering of fire
Just as a glow-worm bears his body's flame
As in a soldier's heart France is on fire
Just as rich pollen fills the lily's heart

# LA JOLIE ROUSSE

Me voici devant tous un homme plein de sens
Connaissant la vie et de la mort ce qu'un vivant peut connaître
Ayant éprouvé les douleurs et les joies de l'amour
Ayant su quelquefois imposer ses idées
Connaissant plusieurs langages
Ayant pas mal voyagé
Ayant vu la guerre dans l'Artillerie et l'Infanterie
Blessé à tête trépané sous le chloroforme
Ayant perdu ses meilleurs amis dans l'effroyable lutte
Je sais d'ancien et de nouveau autant qu'un homme seul pourrait des
   deux savoir
Et sans m'inquiéter aujourd'hui de cette guerre
Entre nous et pour nous mes amis
Je juge cette longue querelle de la tradition et de l'invention
          De l'Ordre de l'Aventure

Vous dont la bouche est faite à l'image de celle de Dieu
          Bouche qui est l'ordre même

Soyez indulgents quand vous nous comparez
A ceux qui furent la perfection de l'ordre
Nous qui quêtons partout l'aventure

Nous ne sommes pas vos ennemis
Nous voulons vous donner de vastes et d'étranges domaines
Où le mystère en fleurs s'offre à qui veut le cueillir
Il y a là des feux nouveaux des couleurs jamais vues
Mille phantasmes impondérables
Auxquels il faut donner de la réalité
Nous voulons explorer la bonté contrée énorme où tout se tait
Il y a aussi le temps qu'on peut chasser ou faire revenir
Pitié pour nous qui combattons toujours aux frontières
De l'illimité et de l'avenir
Pitié pour nos erreurs pitié pour nos péchés

# THE PRETTY RED-HEAD

Behold me before all a man of good sense
Knowing life and of death what a living man can know
Having experienced the griefs and the joys of love
Having been able to assert his ideas on occasion
Knowing several languages
Having travelled a good bit
Having seen the war in the Artillery and Infantry
Wounded in the head trepanned under chloroform
Having lost his best friends in that frightful struggle
I know of the old and of the new as much as one man alone can know of
    them
And without being uneasy today about this war
Between us and for us my friends
I pronounce judgement on this long quarrel of tradition and innovation
             Of Order and Adventure

You whose mouths are made in the image of God's
           Mouths which are order itself

Be indulgent when you compare us
To those who have been the perfection of order
We who seek everywhere for adventure

We are not your enemies
We wish to offer you vast and strange domains
Where flowering mystery offers itself to whoever wishes to pick it
There are new fires there and colors never yet seen
A thousand imponderable phantasms
To which reality must be given
We would explore goodness a vast country where everything is silent
There is also time which one can banish or call back
Pity us who fight always in the front lines
Of the limitless and of the future
Pity our errors pity our sins

Voici que vient l'été la saison violente
Et ma jeunesse est morte ainsi que le printemps
O Soleil c'est le temps de la Raison ardente
    Et j'attends
Pour la suivre toujours la forme noble et douce
Qu'elle prend afin que je l'aime seulement
Elle vient et m'attire ainsi qu'un fer l'aimant
    Elle a l'aspect charmant
    D'une adorable rousse

Ses cheveux sont d'or on dirait
Un bel éclair qui durerait
Ou ces flammes qui se pavanent
Dans les roses-thé qui se fanent

Mais riez riez de moi
Hommes de partout surtout gens d'ici
Car il y a tant de choses que je n'ose vous dire
Tant de choses que vous ne me laisseriez pas dire
Ayez pitié de moi

Behold the return of summer season of violence
And my youth died like the spring
O Sun it is the time for flaming Judgement
                          And I wait
To follow for ever the sweet noble form
It assumes in order that I may love it alone
It comes and it attracts me as a magnet does the needle
                  It looks for all the world just like
                  My redhead darling my beloved

Her hair is really gold you'd say
A flash of lightning which endures
Or flames which dance a proud pavane
In roses as they slowly fade

But laugh laugh long at me
Men from anywhere above all men of this place
For there are so many things I dare not tell you
So many things you will not let me say
Have pity on me

# LE PHOQUE

J'ai les yeux d'un vrai veau marin
Et de Madame Ygrec l'allure
On me voit dans tous nos meetings
Je fais de la littérature
Je suis phoque de mon état
Et comme il faut qu'on se marie
Un beau jour j'épouserai Lota
Du matin au soir l'Otarie
      Papa Maman
Pipe et tabac crachoir caf' conc'
      Laï Tou

# THE SEAL

I've the eyes of a sea-going calf
And Madame Ygrec's lofty air
You'll see me at every meeting
I work in literature
I'm merely a seal by profession
And since one must marry at last
I'll marry my Lota some morning
A sea-lion proud of his past
      Papa Mama
Pipe and spitoon a café concert
      Heigh Ho

# VOYAGE A PARIS

Ah la charmante chose
Quitter un pays morose
        Pour Paris
        Paris joli
        Qu'un jour
Dut créer l'Amour
Ah la charmante chose
Quitter un pays morose
        Pour Paris

# TRIP TO PARIS

Ah what a charming ride
To leave a gloomy countryside
   For Paris
   Lovely Paris
   Which long ago
Love must have beautified
Ah what a charming ride
To leave a gloomy countryside
   For Paris

# HOTEL

Ma chambre a la forme d'une cage
Le soleil passe son bras par la fenêtre
Mais moi qui veux fumer pour faire des mirages
J'allume au feu du jour ma cigarette
Je ne veux pas travailler je veux fumer

# HOTEL

My room has the dismal shape of a cage
But the sun slips its arm in at the window
And I thinking of a cigarette's mirage
I have this sunbeam for a light
I don't want to work I want to smoke

# LA CUEILLETTE

Nous vînmes au jardin fleuri pour la cueillette.
Belle, sais-tu combien de fleurs, de roses-thé,
Roses pâles d'amour qui couronnent ta tête,
   S'effeuillent chaque été ?

Leurs tiges vont plier au grand vent qui s'élève.
Des pétales de rose ont chu dans le chemin.
O Belle, cueille-les, puisque nos fleurs de rêve
   Se faneront demain !

Mets-les dans une coupe et toutes portes closes,
Alanguis et cruels, songeant aux jours défunts,
Nous verrons l'agonie amoureuse des roses
   Aux râles de parfums.

Le grand jardin est défleuri, fleuri, mon égoïste,
Les papillons de jour vers d'autres fleurs ont fui,
Et seuls dorénavant viendront au jardin triste
   Les papillons de nuit.

Et les fleurs vont mourir dans la chambre profane.
Nos roses tour à tour effeuillent leur douleur.
Belle, sanglote un peu . . . Chaque fleur qui se fane,
   C'est un amour qui meurt !

# FLOWER PICKING

The garden proffered bloom for us to pick.
My beauty, do you know how many flowers,
Tea roses pale from love around your head,
         Wither and die each year ?

Their stems will bend before the rising wind.
Rose petals are strewn before us on the path.
Gather them, lovely, for our own dreams' flowers
         Will fade tomorrow too !

Put them in a cup and close the doors.
Languid and cruel, thinking of days gone by,
We shall watch the roses' agony of love
         A death-rattle amid perfume.

The garden blooms no more, my egotist.
Day's butterflies have fled to other flowers,
And now the only visitors will be
         The butterflies of night.

The flowers will die profaned to be indoors.
Our roses one by one shed all their grief.
O beauty, shed a tear . . . Each flower that fades,
         It is a love that dies !

# EPOUSAILLES

*A une qui est au bord de l'Océan*

L'amour a épousé l'absence un soir d'été;
Si bien que mon amour pour votre adolescence
Accompagne à pas lents sa femme, votre absence,
Qui, très douce, le mène et, tranquille, se tait.
Et l'amour qui s'en vint aux bords océaniques,
Où le ciel serait grec si toutes étaient nues,
Y pleure d'être dieu encore et inconnu,
Ce dieu jaloux comme le sont les dieux uniques.

# WEDDING

*To One who is at the Seashore*

Love wed the absence of a summer night;
So much so that my love for your soft youth
Slowly accompanies its wife, your absence,
Who, sweet and tranquil, leads him and is still.
And love which went away to find the sea,
Where nudes would make the sky seem Greek,
Weeps to be still a god and still unknown,
A jealous god as only gods can be.

# MONTPARNASSE

O porte de l'hôtel avec deux plantes vertes
Vertes qui jamais
Ne porteront de fleurs
Où sont mes fruits.  Où me planté-je
O porte de l'hôtel un ange est devant toi
Distribuant des prospectus
On n'a jamais si bien défendu la vertu
Donnez-moi pour toujours une chambre à la semaine
Ange barbu vous êtes en réalité
Un poète lyrique d'Allemagne
Qui voulez connaître Paris
Vous connaissez de son pavé
Ces raies sur lesquelles il ne faut pas que l'on marche
              Et vous rêvez
D'aller passer votre Dimanche à Garches

Il fait un peu lourd et vos cheveux sont longs
O bon petit poète un peu bête et trop blond
Vos yeux ressemblent tant à ces deux grands ballons
Qui s'en vont dans l'air pur
A l'aventure

# MONTPARNASSE

O hotel door with two green plants
Simply green
Which never bear flowers
Where are my fruits where can I plant myself
O door in front of you an angel stands
Distributing prospectuses
Never has virtue been so well protected
Rent me a room at weekly rates for all time
Bearded angel you are in reality
A lyric German poet
Who wishes to know Paris
You know this pavement
And the cracks on which one must not step
        And you dream
Of spending Sunday at Garches

The air is heavy and your hair is long
My little poet a little stupid and too blond
Your eyes look terribly like those two big balloons
Which rise in the pure air
At random

# 1904

A Strasbourg en 1904
J'arrivai pour le lundi gras
A l'hôtel m'assis devant l'âtre
Près d'un chanteur de l'Opéra
Qui ne parlait que de théâtre

La Kellnerine rousse avait
Mis sur sa tête un chapeau rose
Comme Hébé que les dieux servaient
N'en eut jamais ô belles choses
Carnaval chapeau rose Ave !

A Rome à Nice et à Cologne
Dans les fleurs et les confetti
Carnaval j'ai revu ta trogne
O roi plus riche et plus gentil
Que Crésus Rothschild et Torlogne

Je soupai d'un peu de foie gras
De chevreuil tendre à la compote
De tartes flancs etc
Un peu de kirsch me ravigote

Que ne t'avais-je entre mes bras

# 1904

I arrived Monday of Holy Week
In Strasbourg during 1904
I sat before the hotel grate
Next to an opera singer who
Talked theatre and knew nothing else

The young redheaded waitress had
Put on a lovely hat of rose
As Hebe whom gods waited on
Could never have shown off to them
A festive hat and bright Lord knows!

In Rome in Nice and in Cologne
Decked in confetti and in flowers
O Carnival I saw again
Your face of cheer a kinder king
Than Crœsus Rothschild or Torlogne

I supped on a bit of liver paste
A stew of tender venison
A bit of pie and all the rest
A drop of kirsch to comfort me

That you were not there in my arms

# VITAM IMPENDERE AMORI

L'amour est mort entre tes bras
Te souviens-tu de sa rencontre
Il est mort tu le referas
Il s'en souvient à ta rencontre

Encore un printemps de passé
Je songe à ce qu'il eut de tendre
Adieu saison qui finissez
Vous nous reviendrez aussi tendre

Dans le crépuscule fané
Où plusieurs amours se bousculent
Ton souvenir gît enchaîné
Loin de nos ombres qui reculent

O mains qu'enchaîne la mémoire
Et brulantes comme un bûcher
Où le dernier des phénix noire
Perfection vient se jucher

La chaîne s'use maille à maille
Ton souvenir riant de nous
S'enfuit l'entends-tu qui nous raille
Et je retombe à tes genoux

Tu n'as pas surpris mon secret
Déjà le cortège s'avance
Mais il nous reste le regret
De n'être pas de connivence

# VITAM IMPENDERE AMORI

Love died in your encircling arms
Do you remember how it was
You will bring back her wayward charms
For you recall the world to her

Another spring out of the past
I think of all its tenderness
Adieu fond season as you pass
You will be back as tenderly

As twilight dies and ancient loves
Rub shoulders in its fading hour
Your fonder memory lies in chains
Far from our shadows which draw back

O hands which memory binds
Hands burning as a flaming pyre
Perfection is a phoenix come
To roost at last within their flame

Link by link the chain wears through
Your memory escapes its bonds
And scoffs in fleeing at our plight
Once more you have me at your feet

My secret is beyond your reach
The cortège wanders slowly on
But we still feel the strange regret
Of not conniving in its grief

La rose flotte au fil de l'eau
Les masques ont passé par bandes
Il tremble en moi un grelot
Ce lourd secret que tu quémandes

Le soir tombe et dans le jardin
Elles racontent des histoires
A la nuit qui non sans dédain
Répand leurs chevelures noires

Petits enfants petits enfants
Vos ailes se sont envolées
Mais rose toi qui te défends
Perds tes odeurs inégalées

Car voici l'heure du larcin
De plumes de fleurs et de tresses
Cueillez le jet d'eau du bassin
Dont les roses sont les maîtresses

Tu descendais dans l'eau si claire
Je me noyais dans ton regard
Le soldat passe elle se penche
Se détourne et casse une branche

Tu flottes sur l'onde nocturne
La flamme est mon coeur renversé
Couleur de l'écaille de peigne
Que reflète l'eau qui te baigne

The rose floats in the water's spell
And masks have passed in lonely bands
Within me chimes a little bell
The heavy secret you demand

The garden darkens in the dusk
Where women tell their stories to
The quiet night which scornfully
Spreads out the darkness of their hair

Children children while still young
Your tender wings took flight from you
In trying to defend itself
The rose loses its peerless scent

For now is come the hour of theft
Of tresses and of plumes and flowers
Pick from the font the water jet
The roses are its mistresses

The water gleamed where you went down
And I was drowning in your look
The soldier passes she leans out
Turns round and calmly breaks a branch

You float upon the wave of night
Flame is my heart turned upside down
The color of light tortoise-shell
Reflected in the cooling sea

O ma jeunesse abandonnée
Comme une guirlande fanée
Voici que s'en vient la saison
Et des dédains et du soupçon

Le paysage est fait de toiles
Il coule un faux fleuve de sang
Et sous l'arbre fleuri d'étoiles
Un clown est l'unique passant

Un froid rayon poudroie et joue
Sur les décors et sur ta joue
Un coup de revolver un cri
Dans l'ombre un portrait a souri

La vitre du cadre est brisée
Un air qu'on ne peut définir
Hésite entre son et pensée
Entre avenir et souvenir

O ma jeunesse abandonnée
Comme une guirlande fanée
Voici que s'en vient la saison
Des regrets et de la raison

O my fond youth abandoned as
A faded wreath is cast away
Here is the season coming back
Of dark suspicion and disdain

Canvasses compose the scene
Traversed by a false stream of blood
Stars blossom underneath the tree
Only a clown would wander here

A cold light scatters powder on
The décor and your rosy cheek
A gun shot afterwards a shout
And in the dark a portrait smiled

The glass broke in the picture frame
An air which one cannot define
Hovers between thought and sound
Part future and part memory

O my fond youth abandoned as
A faded wreath is cast away
Here is the season coming back
Of reason and of sad regret

# L'AMOUR, LE DEDAIN
## ET L'ESPERANCE

Je t'ai prise contre ma poitrine comme une colombe
    qu'une petite fille étouffe sans le savoir
Je t'ai prise avec toute ta beauté ta beauté plus
    riche que tous les placers de la Californie
    ne le furent au temps de la fièvre de l'or
J'ai empli mon avidité sensuelle de ton sourire
    de tes regards de tes frémissements
J'ai eu à moi à ma disposition ton orgueil même
Quand je te tenais courbée et que tu subissais
    ma puissance et ma domination
J'ai cru prendre tout cela ce n'était qu'un prestige
Et je demeure semblable à Ixion après qu'il
    eût fait l'amour avec le fantôme
    de nuées fait à la semblance
    de celle qu'on appelle Hera ou
    bien Junon l'invincible
Et qui peut prendre qui peut saisir des
    nuages qui peut mettre la main
    sur un mirage et qu'il se trompe
    celui-là qui croit emplir ses
    bras de l'azur céleste
J'ai cru prendre toute ta
    beauté et je n'ai eu que ton
    corps
Le corps hélas n'a pas l'éternité
Le corps a la fonction de jouir mais
    il n'a pas l'amour
Et c'est en vain maintenant
    que j'essaye d'étreindre
    ton esprit

# LOVE, DISDAIN AND HOPE

I folded you to my breast like a dove
    which a little girl smothers without knowing it
I took you with all your beauty a beauty
    richer than all the gold fields of California
    at the time of the Gold Rush
I have satisfied my sensual desire from your smile
    from your looks from your tremblings
I have had to myself and at my disposition your very pride
When I kept you bowed and when you bore
    my power and my domination
I thought I could take all that but it was an illusion
And I remain like Ixion after he
    had made love to the phantom
    of the clouds made to resemble
    the woman called Hera
    or else the invincible Juno
And who can take who can seize
    clouds who can get his hands
    on a mirage and may he be deceived
    who thinks to fill his
    arms with heavenly azure
I thought I was taking all your
    beauty and I had only your
    body
Alas the body has no eternity
The body has the function of giving pleasure
    but it has no love
And it is vain for me now
    to try to grasp
    your spirit

Il fuit il me fuit de toutes parts
   comme un nœud de
   couleuvres qui se dénoue
Et tes beaux bras sur l'horizon
   lointain sont les serpents
   couleur d'aurore qui se lovent
   en signe d'adieu
Je reste confus je reste confondu
   je me sens las de cet amour
   que tu dédaignes
Je suis honteux de cet amour
   que tu méprises tant
Le corps ne va pas sans l'âme
Et comment pourrais-je espérer
   rejoindre ton corps de naguère
   puisque ton âme était si éloignée
   de moi
Et que le corps rejoint l'âme
Comme font tous les corps vivants
O toi que je n'ai possédée que morte

Et malgré tout cependant que parfois
   je regarde au loin si vient le vaguemestre
Et que j'attends comme un délice
   ta lettre quotidienne mon
   coeur bondit comme un chevreuil
   lorsque je vois venir le messager
Et j'imagine que nous allons nous
   embarquer tous deux tout seuls
   peut-être trois et que jamais
   personne au monde ne saurait
   rien de notre cher voyage vers
   rien mais vers ailleurs et pour
   toujours

It flees it flees me everywhere
    like a nest of
    adders which untangle themselves
And your lovely arms on the distant
    horizon are serpents
    colored like the dawn which coil
    into a sign of farewell
I remain confused and confounded
    I feel tired of this love
    which you disdain
I am ashamed of this love
    which you despise so
The body does not get along without a soul
And how could I hope
    to rejoin your former body
    since your soul was so distant
    from me
And since the body rejoins the soul
As do all living bodies
O you whom I possessed only in death

And in spite of all however how anxiously at times
    I look about to see if the courier is coming
And how I await the delight of
    your daily letter my heart
    bounds up like a roe
    when I see the messenger coming
And I imagine that we are going
    to set out the two of us alone
    perhaps three and that no one
    in the world will ever know
    anything of our precious voyage toward
    nothing but simply toward somewhere else and
    forever

Sur cette mer plus bleue encore plus bleue
    que tout le bleu du monde
Sur cette mer où jamais l'on ne crierait:
    " terre "
Pour ton attentive beauté mes chants
       plus purs que toutes les
       paroles monteraient plus
       libres encore que les flots
Est-il trop tard mon coeur pour
    ce mystérieux voyage
La barque nous attend c'est
    notre imagination
Et la réalité nous rejoindra un jour
    si les âmes se sont rejointes
Pour le trop beau pèlerinage

Allons mon cœur d'homme la lampe va s'éteindre
    Verses-y ton sang
Allons ma vie alimente cette lampe d'amour
Allons canons ouvrez la route
Et qu'il arrive enfin le temps victorieux
    Le cher temps du retour

Je donne à mon espoir mes yeux ces pierreries
Je donne à mon espoir mes mains palmes de victoire
Je donne à mon espoir mes pieds chars de triomphe
Je donne à mon espoir ma bouche ce baiser
Je donne à mon espoir mes narines qu'embaument
    les fleurs de la mi-mai
Je donne à mon espoir mon cœur en ex-voto
Je donne à mon espoir tout l'avenir
    qui tremble comme une petite lueur
    au loin dans la forêt

On this sea bluer still bluer
        than any blue on earth
On this sea where no one would ever shout:
        " Land ! "
For your attentive beauty my songs
        purer than all words
        would turn out to be
        freer even than the waves
It is too late my heart for
        this mysterious voyage
The ship awaits us it is
        our imagination
And reality will reunite us one day
        if souls do reunite
For this too beautiful pilgrimage

Come my man's heart the lamp is going out
        Fill it with your blood
Come my life feed this lamp of love
And you canon clear the way
And finally may there come the day of victory
        The precious day of return

I give to my hope my eyes these pebbles
I give to my hope my hands palms of victory
I give to my hope my feet chariots of triumph
I give to my hope my mouth its kiss
I give to my hope my nostrils which
        the flowers of mid-May embalm
I give to my hope my ex voto heart
I give to my hope all the future
        which trembles like a tiny light
        far away in the forest

# A LOU HOMMAGE
## respectueusement passionné

Mourir et savoir enfin l'irrésistible Eternité
Oliviers vous battiez ainsi que font parfois ses paupières
Par ce livre dur et précis dans la joie
apprenez ô Lou à me connaître afin de ne plus m'oublier
Votre chevelure pareille au sang répandu
Je vous salue Lou comme fait votre arbre préféré le palmier
penché du grand jardin marin soulevé comme un sein
mais perché sur l'abîme je domine la mer comme un maître

et je place ici même malgré vous votre pensée la plus secrète

<div align="right">Guillaume Apollinaire</div>

# TO LOU  a respectfully passionate
# HOMAGE

To die and at last to know the luring of Eternity
Olive trees at times you blinked the way her eyelids do
Through this book which is firm and precise in its joy
learn O Lou to know me so as never to forget me
Your hair like spilled blood
I salute you Lou like your favourite tree the palm
leaning out of the wide seaside garden lifted like a breast
but perched above the abyss I dominate the ocean like a master

and even in spite of you I am putting down here your most
secret thoughts

<div align="right">Guillaume Apollinaire</div>

A LOU HOMMAGE RESPECTUEUSEMENT PASSIONE

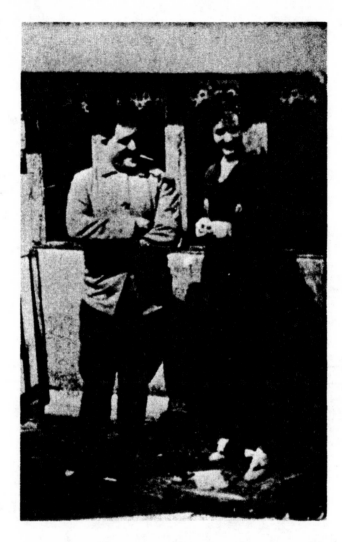

APOLLINAIRE AND HIS WIFE ON THE TERRACE OF THEIR APARTMENT IN
THE BOULEVARD ST GERMAIN 1917

# SELECTED PROSE WRITINGS

# THE NEW SPIRIT AND
# THE POETS

The new spirit which will dominate the poetry of the entire world has nowhere come to light as it has in France. The strong intellectual discipline which the French have always imposed on themselves permits them, as well as their spiritual kin, to have a conception of life, of the arts and of letters, which, without being simply the recollection of antiquity, is also not the counterpart of romantic prettiness.

The new spirit which is making itself heard strives above all to inherit from the classics a sound good sense, a sure critical spirit, perspectives on the universe and on the soul of man, and the sense of duty which lays bare our feelings and limits or rather contains their manifestations.

It strives further to inherit from the romantics a curiosity which will incite it to explore all the domains suitable for furnishing literary subject matter which will permit life to be exalted in whatever form it occurs.

To explore truth, to search for it, as much in the ethnic domain, for example, as in that of the imagination—those are the principal characteristics of the new spirit.

This tendency, moreover, has always had its bold proponents, although they were unaware of it; for a long time it has been taking shape and making progress.

However, this is the first time that it has appeared fully conscious of itself. Up to now the literary field has been kept within narrow limits. One wrote in prose or one wrote in verse. In prose, rules of grammar established the form.

As for poetry, rimed versification was the only rule, which underwent periodical attacks, but which was never shaken.

Free verse gave wings to lyricism; but it was only one stage of the exploration that can be made in the domain of form.

The investigations of form have subsequently assumed a great importance. Is it not understandable?

How could the poet not be interested in these investigations which can lead to new discoveries in thought and lyricism?

Assonance, alliteration as well as rime are conventions, each of which has its merits.

Typographical artifices worked out with great audacity have the advantage of bringing to life a visual lyricism which was almost unknown before our age. These artifices can still go much further and achieve the synthesis of the arts, of music, painting, and literature.

That is only one search for attaining new and perfectly legitimate expressions.

Who would dare to say that rhetorical exercises, the variations on the theme of: *I die of thirst beside the fountain* did not have a determining influence on Villon? Who would dare to say the investigations of form of the rhetoricians and of the Marotic* school did not serve to purify the French style up to its flowering in the seventeenth century?

It would have been strange if in an epoch when the popular art *par excellence*, the cinema, is a book of pictures, the poets had not tried to compose pictures for meditative and refined minds which are not content with the crude imaginings of the makers of films. These last will become more perceptive, and one can predict the day when, the photograph and the cinema having become the only form of publication in use, the poet will have a freedom heretofor unknown.

One should not be astonished if, with only the means they have now at their disposal, they set themselves to preparing this new art (vaster than the plain art of words) in which, like conductors of an orchestra of unbelievable scope, they will have at their disposition the entire world, its noises and its appearances, the thought and language of man, song, dance, all the arts and all the artifices, still more mirages than Morgane could summon up on the hill of Gibel, with which to compose the visible and unfolded book of the future.

But generally you will not find in France the " words at liberty " which have been reached by the excesses of the Italian and Russian futurists, the extravagant offspring of the new spirit, for France abhors disorder. She readily questions fundamentals, but she has a horror of chaos.

We can hope, then, in regard to what constitutes the material and the manner of art, for a liberty of unimaginable opulence. Today the poets

*From the French Poet Clement Marot (1495—1544).

are serving their apprenticeship to this encyclopaedic liberty. In the realm of inspiration, their liberty can not be less than that of a daily newspaper which on a single sheet treats the most diverse matters and ranges over the most distant countries. One wonders why the poet should not have at least an equal freedom, and should be restricted, in an era of the telephone, the wireless, and aviation, to a greater cautiousness in confronting space.

The rapidity and simplicity with which minds have become accustomed to designating by a single word such complex beings as a crowd, a nation, the universe, do not have their modern counterpart in poetry. Poets are filling the gap, and their synthetic poems are creating new entities which have a plastic value as carefully composed as that of collective terms.

Man has familiarised himself with those formidable beings which we know as machines, he has explored the domain of the infinitely small, and new domains open up for the activity of his imagination: that of the infinitely large and that of prophecy.

Do not believe that this new spirit is complicated, slack, artificial, and frozen. In keeping with the very order of nature, the poet puts aside any high-flown purpose. There is no longer any Wagnerianism in us, and the young authors have cast far away all the enchanted clothing of the mighty romanticism of Germany and Wagner, just as they have rejected the rustic tinsel of our early evaluations of Jean-Jacques Rousseau.

I do not believe that social developments will ever go so far that one will not be able to speak of national literature. On the contrary, however far one advances on the path of new freedoms, they will only reinforce most of the ancient disciplines and bring out new ones which will not be less demanding than the old. This is why I think that, whatever happens, art increasingly has a country. Furthermore, poets must always express a milieu, a nation; and artists, just as poets, just as philosophers, form a social estate which belongs doubtless to all humanity, but as the expression of a race, of one given environment.

Art will only cease being national the day that the whole universe, living in the same climate, in houses built in the same style, speaks the same language with the same accent—that is to say never. From ethnic

and national differences are born the variety of literary expressions, and it is that very variety which must be preserved.

A cosmopolitan lyric expression would only yield shapeless works without character or individual structure, which would have the value of the commonplaces of international parliamentary rhetoric. And notice that the cinema, which is the perfect cosmopolitan art, already shows ethnic differences immediately apparent to everyone, and film enthusiasts immediately distinguish between an American and an Italian film. Likewise the new spirit, which has the ambition of manifesting a universal spirit and which does not intend to limit its activity, is none the less, and claims to respect the fact, a particular and lyric expression of the French nation, just as the classic spirit is, *par excellence*, a sublime expression of the same nation.

It must not be forgotten that it is perhaps more dangerous for a nation to allow itself to be conquered intellectually than by arms. That is why the new spirit asserts above all an order and a duty which are the great classic qualities manifested by French genius; and to them it adds liberty. This liberty and this order, which combine in the new spirit, are its characteristic and its strength.

However, this synthesis of the arts which has been consummated in our time, must not degenerate into confusion. That is to say that it would be, if not dangerous, at least absurd, for example to reduce poetry to a sort of imitative harmony which would not have the excuse of exactness.

One is right to imagine that imitative harmony can play a rôle, but it will be the basis only of an art in which machinery plays a part; for example, a poem or a symphony composed on a phonograph might well consist of noises artistically chosen and lyrically blended or juxtaposed; whereas, for my part, I think it wrong that a poem should be composed simply of the imitation of a noise to which no lyric, tragic, or pathetic meaning can be attached. And if a few poets devote themselves to this game, it should be regarded only as an exercise, a sort of rough notation of what they will include in a finished work. The " brekeke koax " of Aristophanes' *Frogs* is nothing if one separates it from the work in which it takes on all its comic and satiric meaning. The prolonged " i i i i " sounds, lasting a whole line, of Francis Jammes' bird are a sorry

harmony if they are detached from the poem to whose total fantasy they give precision.

When a modern poet notes in several lines the throbbing sound of an airplane, it must be regarded above all as the desire of the poet to accustom his sensibility to reality. His passion for truth impels him to take almost scientific notes which, if he wishes to present them as poems, have the faults of being *trompe-oreilles* so to speak, to which actuality will always be superior.

On the other hand, if he wants for example to amplify the art of the dance and attempt a choreography whose buffoons would not restrict themselves to *entrechats* but would utter cries setting off the harmony with an imitative novelty, that is a search which is not absurd, whose popular origins are found in all peoples among whom war dances, for example, are almost always embellished with savage cries.

To come back to the concern with truth and the verisimilitude which rules all investigation, all attempts, all efforts of the new spirit, it must be added that there is no ground for astonishment if a certain number or even a great many of them remain sterile for the moment and sink into ridicule. The new spirit is full of dangers and snares.

All that, however, belongs to the spirit of today, and to condemn categorically these trials and efforts would be to make an error of the kind which, rightly or wrongly, is attributed to M. Thiers in declaring that the railroads were only a scientific game and that the world could not produce enough iron to build rails from Paris to Marseilles.

The new spirit, therefore, admits even hazardous literary experience, and those experiences are at times anything but lyric. This is why lyricism is only one domain of the new spirit in today's poetry, which often contents itself with experiments and investigations without concerning itself over giving them lyric significance. They are materials which the poet amasses, which the new spirit amasses, and these materials will form a basis of truth whose simplicity and modesty must never give pause, for their consequences can be very great things.

At a later date, those who study the literary history of our time will be amazed that, like the alchemists, the dreamers and poets devoted themselves, without even the pretext of a philosopher's stone, to inquiries

and to notations which exposed them to the ridicule of their contemporaries, of journalists and of snobs.

But their inquiries will be useful; they will be the foundation of a new realism which will perhaps not be inferior to that so poetic and learned realism of ancient Greece.

With Alfred Jarry, moreover, we have seen laughter rise from the lower region where it was writhing, to furnish the poet with a totally new lyricism. Where is the time when Desdemona's handkerchief seemed to be an inadmissible ridiculousness? Today even ridicule is sought after, it must be seized upon and it has its place in poetry because it is a part of life in the same way as heroism and all that formerly nourished a poet's enthusiasm.

The romantics have tried to give to things of rude appearance a horrible or tragic meaning. It would be better to say that they only worked for the benefit of what is horrible. They wanted to establish the horrible much more than the melancholy. The new spirit does not seek to transform ridicule; it conserves for it a rôle which is not without flavour.   Likewise it does not seem to give a sense of nobility to the horrible. It leaves it horrible and does not debase the noble. *It is not a decorative art. Nor is it an impressionist art.* It is every study of exterior and interior nature, it is all eagerness for truth.

Even if it is true that there is nothing new under the sun, *the new spirit does not refrain from discovering new profundities in all this that is not new under the sun.* Good sense is its guide, and this guide leads it into corners, if not new, at least unknown.

*But is there nothing new under the sun?* It remains to be seen.

What! My head has been X-rayed. I have seen, while I live, my own cranium, and that would be nothing new?

Solomon spoke for the Queen of Sheba, no doubt, and he liked novelty so well that his concubines were without number.

The air is filled with strangely human birds. Machines, the daughters of man and having no mother, live a life from which passion and feeling are absent, and would that be nothing new?

Wise men ceaselessly investigate new universes which are discovered at every crossroads of matter, and there is nothing new under the sun? For the sun perhaps. But for men!

There are a thousand natural combinations which have not yet been composed. Men will conceive them and use them to good purpose, composing thus with nature that supreme art which is life. These new combinations, these new works—they are the art of life, which is called progress. In this sense, progress exists. But if it is held to consist in an eternal becoming, a sort of messianism as appalling as the fable of Tantalus, Sisyphus, and the Danaidae, then Solomon was right over all the prophets of Israel.

What is new exists without being progress. Everything is in the effect of surprise. The new spirit depends equally on surprise, on what is most vital and new in it. *Surprise is the greatest source of what is new.* It is by surprise, by the important position that has been given to surprise, that the new spirit distinguishes itself from all the literary and artistic movements which have preceded it.

In this respect, it detaches itself from all of them and belongs only to our time.

We have established it on the solid basis of good sense and of experience which have induced us to accept things and feelings only according to truth, and it is according to truth that we admit them, not seeking at all to make sublime what is naturally ridiculous or *vice versa*. And from these truths surprise is most often the result, since they run counter to commonly held opinion. Many of these truths have not been examined; it is enough to unveil them to cause surprise.

One can likewise express a supposed truth so as to cause surprise, simply because no one has yet dared to present it thus. But a supposed truth is not opposed by good sense, without which it would no longer be truth, even supposed truth. That is why I imagine that, if women could bear no more children, men could make them, and why in showing it to be so I express a literary truth which could only be termed a fable outside of literature, and I thus cause surprise. But my supposed truth is no more extraordinary or unbelievable than those of the Greeks, which show Minerva coming armed out of the head of Jupiter.

Insofar as airplanes did not fill the sky, the fable of Icarus was only a supposed truth. Today, it is no longer a fable. And our inventors have accustomed us to greater prodigies than that which consists in delegating to men the function which women have of bearing children. I should

say further that, these fables having been even more than realized, it is up to the poet to imagine new ones which inventors can in turn realize.

The new spirit requires that these prophetic ventures be accepted. It is why you will find traces of prophecy in most works conceived in the new spirit. The divine games of life and imagination give free rein to a totally new poetic activity.

It is that poetry and creation are one and the same; only that man can be called poet who invents, who creates insofar as a man can create. The poet is he who discovers new joys, even if they are hard to bear. One can be a poet in any field: it is enough that one be adventuresome and pursue any new discovery.

The richest domain being the imagination, the least known, whose extent is infinite, it is not astonishing that the name of poet has been particularly reserved for those who look for the new joys which mark out the enormous spaces of the imagination.

The least fact is for a poet the postulate, the point of departure for an unknown immensity where the fires of joy flame up in multiple meanings.

There is no need, in undertaking discovery, to choose with the reassuring support of any rules, even those decreed by taste, a quality classified as sublime. One can begin with an everyday event: a dropped handkerchief can be for the poet the lever with which to move an entire universe. It is well known how much an apple's fall meant to Newton when he saw it, and that scholar can thus be called a poet. That is why the poet today scorns no movement in nature, and his mind pursues discovery just as much in the most vast and evasive syntheses: crowds, nebulae, oceans, nations, as in apparently simple facts: a hand which searches a pocket, a match which lights by scratching, the cries of animals, the odor of gardens after rain, a flame which is born on the hearth. Poets are not simply men devoted to the beautiful. They are also and especially devoted to truth, insofar as the unknown can be penetrated, so much that the unexpected, the surprising, is one of the principal sources of poetry today. And who would dare say that, for those who are worthy of joy, what is new is not beautiful? Others will soon busy themselves about discrediting this sublime novelty, after which it can enter the domain of reason, but only within those limits in which the

poets, the sole dispensers of the true and the beautiful, have advanced it.

The poet, by the very nature of his explorations, is isolated in the new world into which he enters the first, and the only consolation which is left to him is that, since men must live in the end by truths in spite of the falsehoods with which they pad them, the poet alone sustains the life whereby humanity finds these truths. This is why modern poets are above all singers of a constantly new truth. And their task is infinite; they have surprised you and will surprise you again. They are already imagining schemes more profound than those which created with Machiavellian astuteness the useful and frightful symbol of money.

Those who imagined the fable of Icarus, so marvellously realized today, will find others. They will carry you, living and awake, into a nocturnal world sealed with dreams. Into universes which tremble ineffably above our heads. Into those nearer and further universes which gravitate to the same point of infinity as what we carry within us. And more marvels than those which have been born since the birth of the most ancient among us, will make the contemporary inventions of which we are so proud seem pale and childish.

Poets will be charged finally with giving by means of lyric teleologies and arch-lyric alchemies a constantly purer meaning to the idea of divinity, which is so alive within us, which is perpetual renewal of ourselves, that eternal creation, that endless rebirth by which we live.

As far as we know, there are scarcely any poets today outside the French language.

All the other languages seem to keep silent so that the universe may hear the voices of the new French poets.

The entire world looks toward this light which alone illuminates the darkness which surrounds us.

Here, however, these voices which are being raised scarcely make themselves heard.

Modern poets, creators, inventors, prophets; they ask that what they say be examined in the light of the greatest good of the group to which they belong. They turn toward Plato and beg him, if he would banish them from the Republic, at least to hear them first.

France, the guardian of the whole secret of civilization, a secret only

because of the imperfection of those who strive to divine it, has for this very reason become for the greater part of the world a seminary of poets and artists who daily increase the patrimony of civilization.

And through the truth and the joy they spread, they will make this civilization, if not adaptable to any nation whatever, at least supremely agreeable to all.

The French bring poetry to all people:

To Italy, where the example of French poetry has given inspiration to a superb young nationalist school of boldness and patriotism.

To England, where lyricism is insipid, and practically exhausted.

To Spain and especially in Catalonia, where the whole of an ardent young generation, which has already produced painters who are an honor to two nations, follows with attention the productions of our poets.

To Russia, where the imitation of French lyrics has at times given way to an even greater effort, as will astonish no one.

To Latin America, where the young poets write impassioned commentaries on their French predecessors.

To North America, to which in recognition of Edgar Poe and Walt Whitman, French missionaries are carrying during the war the fertile elements destined to nourish a new production of which we have as yet no idea, but which will doubtless not be inferior to those two great pioneers of poetry.

France is full of schools which protect and carry on the lyric spirit, groups in which boldness is taught; however, one remark must be made: poetry derives first of all from the people in whose language it is expressed.

The poetic schools, before throwing themselves into heroic adventures or distant apostleships, must mould, strengthen, clarify, enlarge, immortalize, and sing the greatness of the country which gave birth to them, of the country which has nourished and instructed them, so to speak, with what is most healthy and with what is purest and best in her blood and substance.

Has modern French poetry done for France all that it could?

Has it always been, in France, as active, as zealous as it has been elsewhere?

Contemporary literary history is enough to suggest these questions, and to answer them one would have to be able to calculate what national and promising tendencies the new spirit carries within it.

The new spirit is above all the enemy of estheticism, of formulae, and of cultism. It attacks no school whatever, for it does not wish to be a school, but rather one of the great currents of literature encompassing all schools since symbolism and naturalism. It fights for the reestablishment of the spirit of initiative, for the clear understanding of its time, and for the opening of new vistas on the exterior and interior universes which are not inferior to those which scientists of all categories discover every day and from which they extract endless marvels.

Marvels impose on us the duty not to allow the poetic imagination and subtlety to lag behind that of workers who are improving the machine. Already, scientific language is out of tune with that of the poets. It is an intolerable state of affairs. Mathematicians have the right to say that their dreams, their preoccupations, often outdistance by a hundred cubits the crawling imaginations of poets. It is up to the poets to decide if they will not resolutely embrace the new spirit, outside of which only three doors remain open: that of pastiche, that of satire, and that of lamentation, however sublime it be.

Can poetry be forced to establish itself outside of what surrounds it, to ignore the magnificent exuberance of life which the activities of men are adding to nature and which allow the world to be mechanized in an incredible fashion?

The new spirit is of the very time in which we are living, a time rich in surprises. The poets wish to master prophecy, that spirited mare that has never been tamed.

And finally they want, one day, to mechanize poetry as the world has been mechanized. They want to be the first to provide a totally new lyricism for these new means of expression which are giving impetus to art—the phonograph and the cinema. They are still only at the stage of incunabula. But wait, the prodigies will speak for themselves and the new spirit which fills the universe with life will manifest itself formidably in literature, in the arts, and in everything that is known.

# THE FALSE MESSIAH, AMPHION

## or

## The Stories and Adventures of the Baron of Ormesan

### II. A Great Film

" Who doesn't have a crime on his conscience? " asked the Baron of Ormesan. " I don't count them any more myself. I have committed a few, and they have brought me a certain amount of money. And if I am not a millionaire today, my appetites are more at fault than my scruples.

" In 1901 I had set up with some friends the International Cinematographic Company, which we called for short the *ICC*. We obtained films of special interest and then gave cinema showings in the principal cities of Europe and America. Our program was very well organized. Thanks to the indiscretion of a *valet de chambre*, we had been able to obtain an interesting scene showing the President of the Republic getting up in the morning. We had similarly filmed the birth of the Prince of Albany. But as the greatest prize of all, however, we had, by corrupting a few of the Sultan's functionaries, recorded in all its movements and for all time the impressive tragedy in which the Grand Vizer, Melak-Pacha, after a heart-rending farewell to his wife and children, drank the drugged coffee, as his master had ordered, on the terrace of his house at Pera.

" We lacked only the performance of a crime. But the moment of a crime is never known in advance, and it is rare that criminals act openly.

" Despairing of procuring such a spectacle by lawful means, we decided to organize one in a villa which we rented in Auteuil. We had thought at first of engaging actors to act out the crime we needed, but beyond the fact that we would be deceiving our future spectators in offering them faked scenes, and accustomed as we were to filming only reality, we could not be satisfied by a simple theatrical game, however

238

perfect. We thus had the idea of drawing lots among ourselves to see who would have to resign himself to committing the crime which the camera would record. But this prospect pleased no one. We were, as it happened, a group of honest men, and no one wished to lose his honor even for a commercial purpose.

" One night we lay in wait at the corner of a deserted street near the villa we had rented. There were six of us, all armed with revolvers. A couple passed. They were a young man and a young woman whose strange manner of dress seemed to us to furnish the interesting elements of a sensational crime. Silently we descended on them, bound them and took them to the villa. We left them there guarded by one of our number. We went back into ambush, and a gentleman with white whiskers and evening clothes appeared. We stopped him and took him to the villa despite his resistance. The sight of our revolvers got the better of his courage and his shouts. Our cameraman set up his machine, arranged a suitable light, and prepared to record the scene. Four of us stood next to the photographer and covered our three captives with our revolvers. The young man and woman had fainted. I undressed them with touching attention. I opened the woman's skirt and bodice and left the man in his shirt-sleeves. Then I spoke to the man in evening clothes.

" ' Sir, my friends and I do not mean you any harm. But we require you at the price of death to kill with this dagger which I place at your feet, this man and woman. You must try, first of all, to revive them. Take care that they do not overpower you. Since they are not armed, there is no doubt that you can carry it off.'

" ' Sir, ' the future assassin said to me politely, ' one must yield to force. Your decision has been made, and I do not wish to try to make you give up a resolve whose explanation is not clear to me, but I ask you only one favor: allow me to wear a mask.'

" We agreed and realized that it would be better for him as well as for us that he be masked. I tied over his face a handkerchief in which I made holes for his eyes, and the fellow began his work.

" He slapped the hands of the young man. Our machine was going and recorded this dismal scene.

" The assassin, with the point of his dagger, pricked his victim in the

239

arm. The young man jumped to his feet and threw himself on the back of his attacker with a strength increased by his fright. There was a short struggle. The young woman also came to and rushed to help her friend. But she fell first, struck in the heart by a blow of the dagger. Then it was the turn of the young man. He subsided at last with his throat cut. The assassin had done well. The handkerchief had not been disarranged during the struggle. He kept it on as long as the machine functioned.

" ' Are you satisfied, gentlemen ? ' he asked. ' And may I neaten myself up now ? '

" We congratulated him; he washed his hands, combed his hair, and brushed himself off.

" Then the camera stopped.

" The assassin waited for us to obliterate the traces of our presence because of the police who would not fail to be there the next day. We left together. The assassin took leave of us like a man of the world. He returned in haste to his friends, for doubtless he would win that same evening, after such an adventure, a fabulous amount of money. We bid this gambler good-night and thanked him, and then went home to bed.

" We had our sensational crime.

" It had tremendous publicity. The victims were the wife of a minister of a little Balkan state and her lover, the son of the pretender to the throne of a north-German principality.

" We had rented the villa under a false name, and the agent, to avoid trouble, identified the young prince as his tenant. The police were up in the air for two months. The newspapers put out special editions and, since we had begun our showing, you can imagine our success. The police never believed for a moment that we were offering the real version of the murder of the day. We took care, however, to announce it prominently. And the public was not deceived. We had an enthusiastic welcome, and, as much in Europe as in America, we profited enough after six months to distribute to the members of our association 342,000 francs.

" Since the crime was too well known to go unpunished, the police finally arrested a man from the Levant who could not produce a valid alibi for the night of the crime. In spite of his protests he was sentenced

to death and executed. Once again we had luck. Our cameraman was able, by a rare chance, to be present at the execution, and we strengthened our program with a new scene well suited to draw a crowd.

" When, at the end of two years, our association dissolved for reasons I shall not go into, I had almost reached a cool million, which I lost again on the races the next year."

# INTRODUCTION TO THE
# POETICAL WORK
# OF CHARLES BAUDELAIRE

To express freely the true state of the world of mortals—there is no greater courage than this among writers. Choderlos de Laclos applied himself to this task with a precision that was for the first time almost mathematical.

1782 is the memorable date of publication of *Les Liaisons Dangereuses*, in which, as an artillery officer, he tried to apply to morals the laws of triangulation which serve soldiers, as is widely known, as well as astronomers.

And the astonishing contrast! The infinite life which gravitates to the firmament obeys the same laws as artillery, which is intended by men to distribute death.

From the angular measurements which Laclos calculated was born the modern literary spirit; it is there that one finds the first elements of Baudelaire, a reasonable and refined explorer of the old way of life, but all of whose views on modern life imply a certain folly. He had inhaled with delight the corrupt bubbles that rose from the rich literary mud of the Revolution where, next to Diderot, Laclos, the intellectual heir of Richardson and Rouseau, had the most remarkable of descendants: Sade, Restif, Nerciat, and all the story tellers of the end of the 18th century.

Most of them, in reality, contain the germ of the modern spirit which is today preparing its victory, creating a new era for arts and letters. With this nauseous but often congenial manna of the Revolution, Baudelaire mixed the spiritualist pus of a strange American, Edgar Poe, who had composed in the way of poetry a body of work which is the disquieting and marvellous counterpart of that of Laclos.

Baudelaire is thus the heir of Laclos and of Edgar Poe. One can easily

distinguish the influence which each has exercised on the prophetic and deeply original mind of this man who, from this year 1917 when his work becomes public property, can be placed not only among the great French poets but even next to the greatest of world poets.

The proof of the influence of the cynical, revolutionary authors on *Les Fleurs du Mal* is found everywhere in his correspondence and notes. That of Edgar Poe decided him to adapt the moral sentiments which he took from his forbidden readings to the strangely toned lyricism which the Baltimore drunkard had revealed to him.

In the novelists of the Revolution he had discovered the importance of the question of sex.

From the Anglo-Saxons of the same period, such as de Quincey and Poe, he had learned that there existed artificial paradises. The methodical exploration of them had allowed him to attain, with the help of Reason, the revolutionary goddess, the lyric summits toward which the crazy preachers of America had driven Poe, their contemporary. But Reason blinded him and abandoned his as soon as he reached the heights.

Baudelaire is then the heir of Laclos and Edgar Poe, but a blind and crazy heir who, nevertheless, before he climbed the peaks, had looked at life and the arts with a marvellous precision.

It is true also that in him the modern spirit is for the first time incarnated. It is with Baudelaire that something was born which simply vegetated while the naturalists, the Parnassians, and the symbolists were going along without seeing a thing; and the naturists, having turned away, did not have the boldness to examine the sublimity and monstrousness of something new.

To those who would be amazed at this outgrowth of the mud of the Revolution and the plague of America, one must reply with the wisdom of the Bible on the generation of man from the slime of the earth.

It is true that Novelty above all caught the fancy of Baudelaire, who was the first to breathe the modern spirit over Europe, but his prophetic brain did not know how to prophesy, and Baudelaire did not penetrate the new spirit with which he was himself penetrated, and whose seeds he discovered in a few who had come before him.

It would be well worth while to abandon him, just as lyric writers of

such talent as Jean-Baptiste Rousseau have been abandoned as soon as their lyric spirit, too often repeated and brought down to a vulgar level, grows old.

However, even as public property, Baudelaire has not yet reached that point, and can still teach us that an elegant manner is not at all incompatible with a great freedom of expression.

*Les Fleurs du Mal* is in this respect a document of the first order.

The liberty which rules this collection did not prevent him from dominating without a challenge the world's poetry at the end of the 19th century.

His influence is increasing at present, and there is no harm in the fact.

We have rejected the moral side of this work, which is wrong in forcing us to consider life and all things with a certain pessimistic dilettantism by which we are no longer duped.

Baudelaire regarded life with a disgusted passion which intended to transform trees, flowers, women, the entire universe into something pernicious.

It was his whim and not sane reality.

Nevertheless one must not cease admiring the courage Baudelaire showed in never violating the contours of his life.

Today this courage would be the same.

Prejudices in regard to art have not stopped growing, and those who dare to express themselves with as much liberty as Baudelaire in *Les Fleurs du Mal* would find opposed to them, if not judicial authority, at least the disapproval of their fellows and the hypocrisy of the public.

The return to slavery, which is disguised in our time with the name of liberty, has already had as its first result in the world of letters (particularly in horror of that state of things which is self-determining) of suppressing the intellectual élite as well as almost every critic worthy of the name; the remaining few do not dare to speak today of *Les Fleurs du Mal*.

If he scarcely participates in that modern spirit which stems from him, Baudelaire still serves as an inspiration for us to claim a liberty that is left more and more to philosophers, scholars, and to artists of all the arts.

The social practice of the freedom of letters will become more and more rare and precious. The great democracies of the future will grant little liberty to writers; it is well to hang high the banner spirit of poets like Baudelaire.

From time to time it can be waved to arouse the small number of trembling slaves.

But let me repeat the *Hommage* of Stéphane Mallarmé...

> *Le temple enseveli divulge par la bouche*
> *Sépulcrale d'égout bavant boue et rubis*
> *Abominablement quelque idole Anubia*
> *Tout le museau flambé comme un aboi farouche*
>
> *Ou que le gaz récent torde la mèche louche*
> *Essuyeuse on le sait des opprobres subis*
> *Il allume hagard un immortel pubis*
> *Dont le vol selon le réverbère découche*
>
> *Quelle feuillage seché dans les cités sans soir*
> *Votif pourra bénir comme elle se rasseoir*
> *Contre le marbre vainement de Baudelaire*
>
> *Au voile qui la ceint absente avec frissons*
> *Celle son Ombre même un poison tutélaire*
> *Toujours à respirer si nous en périssons.*

# ONEIROCRITICISM

The coals of the sky were so near that I was afraid of their heat. They were on the point of burning me. But I was conscious of the different eternities of man and woman. Two animals of different species were coupling, and rose-vines covered the trellises which moons weighed down with grapes. From the monkey's throat came flames which made the world blossom like a lily. In the myrtle an ermine was turning white. We asked it the reason for the unnatural winter. I gulped down the tawny herds. Orkenise appeared on the horizon. We went toward that city, regretting to leave the valleys where the apple trees used to sing and whistle and roar. But the song of the cultivated fields was marvellous:

> By the gates of Orkenise
> A ploughman wishes to come in.
> By the gates of Orkenise
> A vagabond wishes to go out.
>
> The city sentries straightaway
> Fall upon the vagabond:
> " What are you taking out with you? "
> " I left all of my heart behind."
>
> The city sentries straightaway
> Halt the ploughman in his tracks:
> " What are you bringing in with you? "
> " My heart, for I shall marry here ".
>
> How many hearts in Orkenise!
> The sentries laughed and laughed.
> O vagabond, the road is dull,
> And ploughman, love is just as sad.
>
> The worthy sentries of the town
> Knitted on complacently;
> The heavy gates of Orkenise
> Then began closing gradually.

But I was conscious of the different eternities of man and woman. The sky suckled its young panthers. Then I noticed crimson spots on my hand. Toward morning some pirates carried off nine ships that were at anchor in the harbor. The kings were becoming cheerful. The women, as well, did not want to mourn anyone's death. They prefer old kings, stronger in their love than old dogs. A man making a sacrifice wished to be immolated himself in place of the victim. They cut his belly open. I saw there four I's, four O's, and four D's. We were served fresh meat, and I suddenly grew larger after having eaten it. Monkeys as big as their own trees violated ancient tombs. I called one of these beasts on which laurel leaves were growing. It brought me a head made out of a single pearl. I took it in my hands and questioned it after having threatened to throw it in the sea if it did not answer me. This pearl was ignorant and the sea swallowed it up.

But I was conscious of the different eternities of man and woman. Two animals of different species were making love to each other. However only the kings were not dying of laughter, and twenty blind tailors came to cut and sew a veil destined to cover the sardonyx. I directed them myself, backwards. Toward evening, the trees took flight, and monkeys became motionless, and I saw myself a hundred strong. This band which was I sat down beside the sea. Great ships of gold crossed the horizon. And when night had fallen, a hundred flames came to meet me. I procreated a hundred male children whose nurses were the moon and the hillside. They loved the flabby kings who were kept moving about on balconies. When I had come to the bank of a river, I took it in both hands and brandished it about. This sword refreshed me. The languid spring warned me that if I stopped the sun, I should see it as actually square. A hundred strong, I swam toward an archipelago. A hundred sailors received me and, having taken me to a palace, they killed me ninety-nine times. I burst out laughing at that moment and danced, whereas they were weeping. I danced on all fours. The sailors no longer dared to move, for I had the frightening appearance of a lion.

On all fours, on all fours.

My arms and my legs were alike, and my eyes which had multiplied

crowned me attentively. Then I rose up to dance like hands and like leaves.

I was gloved. The islanders took me to their orchards so that I might pick fruit like women. And the island, adrift, filled up a gulf where immediately red trees sprang up. A soft beast covered with white plumes was singing ineffably, and a whole population admired him without tiring. I found on the ground the head made out of a single pearl, which was crying. I brandished the river and the crowd dispersed. Some old men were eating smallage, and being immortal did not suffer more than the dead. I felt free, as free as a flower in its season. The sun was no freer than a ripe fruit. A flock of trees browsed among the invisible stars and the dawn gave its hand to the storm. In the myrtle one came under the influence of darkness. A whole people, heaped into a press, were bleeding and singing. Men were born from the liquid which flowed from the press. They brandished other rivers, which struck one another with a ringing sound. The shadows came out of the myrtle and went off to the gardens which a shoot watered with the eyes of men and animals. The handsomest of all the men seized me by the throat, but I succeeded in throwing him down. On his knees, he showed me his teeth. I touched them. Sounds came from them which changed into serpents the color of chestnuts, and their tongue was called Saint Fabeau. They dug up a transparent root and ate some of it. It was the size of a turnip.

And my quiet river covered them without drowning them.

The sky was full of feces and onions. I cursed the unworthy stars whose light flowed out over the earth. No living creature appeared any more. But songs arose on every side. I visited empty cities and abandoned cottages. I gathered up crowns of all the kings and made of them the immobile minister of the loquacious world. Ships of gold, unmanned, crossed the horizon. Gigantic shadows passed across the distant sails. Several centuries separated me from these shadows. I despaired. But I was conscious of the different eternities of men and women. Shadows of different kinds darkened with their love the scarlet of the sails, while my eyes multiplied in rivers, in cities, and on mountain snows.

*February 15, 1908*

# ANECDOTES

*March,* 1914

The Montparnasse, according to the inhabitants of the surrounding sections, is a quarter of crack-pots. The truth is that the Montparnasse is replacing the Montmartre, the Montmartre of the old days, of artists and songwriters, of windmills and cabarets, to say nothing of the hashisho-phages, the first opiomaniacs and the everlasting etherialists—all those (of the real Montmartre crowd) who were still alive and whom the general carousing was driving out of the old Montmartre, destroyed now by the owners and architects whom the Paris futurists so reviled, and out of which, moreover, all these now emigrated under the name of cubists, Redskins, or orphic poets. The outbursts of their voices disturbed the echoes at the corner of the rue de la Grande-Chaumière. In front of a café established in a house of licentious history, they made up a formid-able gathering, the Café de la Rotonde. Across the street, the Germans held forth. On this side, the Slavs were more numerous. The Jews went indifferently into either one.

The artists' paint stores in all the neighboring streets offered their multi-colored temptation to all those whom a glance at the avant-garde exhibitions had made cry out: *Anch'io son pittore.*

First of all, let us sketch out the appearance of the intersection. Prob-ably it will change before long. On one of the corners of the Boulevard du Montparnasse, a huge grocery store spreads before the eyes of a whole population of international artists its enigmatic name: HAZARD. Its goods are of the most varied and its customers of every breed. The American finds grapefruit here, which are to the lemon what the water-melon is to the cantaloup; the Russian finds his apples of paradise as common as whiteheart cherries ; the Hungarian finds his pork covered with red pepper, and so on. And here, on the other corner, the *Rotonde,* and an Indian in full costume with skins and feathers. André Salmon stops at times to sit on this distant terrace like a spectator at the back of the proscenium; Max Jacob is often there selling his *Côte* and his drawings; sometimes even the long serene silhouette of Charles Morice is outlined for a time against a wall inside.

At the corner of the Boulevard du Montparnasse and the Rue Delambre, it is the *Dôme* : a clientele of habitués, rich people, Massachussets esthetes or those from the banks of the Spree, a contemporary Pascin or Clinchtel; it is here that is decided how much admiration will be professed in Germany for such and such a French painter. The reputations of Géricault, Courbet, Seurat, and the Douanier have not had to undergo such esthetic discussions as these among the millionaire Germans of the *Dôme*.

On another corner there is *Baty*, the last wine-merchant. When he retires, that profession will have practically disappeared from Paris. There will still be public cellars and bistros, but the " 'chand de vin " will have seen his last. Meanwhile those whom sickness or rather doctors have not obliged to give up French wines entirely can have full enjoyment of this well-stocked cellar.

Further on, on the right on the Boulevard Raspail, the little café of *Vigourelles* gives shelter, on days when there is no dancing at Bullier's, to a petulant group of young men; a man with a severe expression is there often. He states with easy simplicity to anyone that wants to hear: " I am the shi . . . st man in the quarter, and I sh.t on all the municipal councillors ". He is called " the lion ". He has sh.t so much on the world that he makes a living by it. Obviously, most of the cafés and bistros of the quarter prefer giving him money to serving him. He only has to turn up in one of these places and immediately he receives, according to the prestige of the house, one, two, or even three francs. Each morning this man of genius makes his rounds in the quarter and that is enough for him to live on. He sh.ts on the whole world and owes no one a thing. Segonzac, Luc-Albert Moreau, André Derain, Edouard Férat, René Dalize, and an inscrutable person called the Finn—but who I think really comes from Limoges—all occasionally come to this little provincial café, *Vigourelles*. The distinguished proprietor of the house, Monsieur Vigoureux, earned an untarnishable popularity for himself in the arrondissement by publicly stating in a moment of rare eloquence: " Gentlemen, although a publican, I have a liking for the arts; Sundays, if I don't go to the movies, I go to the Louvre." Almost directly opposite is the little shop of Monsieur *Cocula*, who, by a singular feat of onomastic imitation, turned into his English near-homonym, Mr. Cook, and took care of

travellers; the English have their Cook's and the French their Cocula.

In the streets which surround the Montparnasse cemetery, where Monsieur de Max watches over Baudelaire's tomb, are the homes of the famed former residents of the Montmartre; many of them even, like Picasso, lived in the well-known house at 13, rue de Ravignan, which is today 13, Place Emile Gaudeau.

Now we can go back down the Rue de la Grande-Chaumière, the street of the academies, where just recently the only Patagonian in Paris, the Araucanian Oritz de Zacote, went about proclaiming that he had discovered the truth. There is still a famous little restaurant for models, *Chez Papa*; it is run by an ancient warrior of Garibaldi's who seasons spaghetti as well as they do in Roman *osterias*. It is a charming place where Anatole France, if he knew it, would come often. Meanwhile one meets very pleasant company there, among them Paul Morisse, André Billy and Paul Léautaud.

If it has a different tone from that of the old Montmartre, still the Montparnasse has no less gaiety, simplicity, and carelessness. The American-style dress of the artists of today is no less ample nor of a different corduroy than that of the young painters in those days; they are big in a different way, that's all, and sandals, after all, are no less Germanic than those frightful old elastic shoes. Soon, I can sense without wanting it to be so, the Montparnasse will have its nightclubs and songsters just as it has its painters and its poets. The day when Bruart has sung of the various corners of this quarter so full of fantasy, the dairy shops, the barracks-studio on the Rue Campagne-Première, the extraordinary Creamery-Grill Room on the Boulevard du Montparnasse, the Chinese restaurant, the Tuesdays in the Closerie des Lilas, then the Montparnasse will have had its day. Cook's Tours will bring in its hordes and Cocula will emigrate to some other quarter, taking with him the painters, the Chinese, the Patagons, the Comanche Indians, the Limousin Finns, the Vigourelles, and perhaps the sh . .. ingist man in the whole quarter, to another destination, another arrondissement, to another hill, another mountain—without doubt Buttes-Chaumont.

# THE POET ASSASSINATED

## 16. Persecution

In those days, poetry prizes were awarded daily. Thousands of societies were founded for that purpose, and their members lived in ease, distributing bounty to the poets on appointed days. But the 26th of January was the date when the most important societies, companies, administrative panels, academies, committees, juries, etc., etc., in the world made their awards. On that day they gave out 8,019 poetry prizes, which together amounted to a sum of 50 million 3,225 francs and 75 centimes. On the other hand, since the real love of poetry was not prevalent in any class of the people of any country, public opinion was highly aroused against the poets, who were called lazy, useless, and all the rest. January 26th of that year came and went without incident, but the following day the well know newspaper, *La Voix*, published in Adelaide (Australia) in French, carried an article by a scholarly chemist-agronomist, Horace Tograth (a German, born in Leipzig), whose discoveries and inventions had often seemed to border on the miraculous. The article, entitled *Laurel*, contained a sort of history of the cultivation of laurel in Judea, Greece, Italy, Africa, and Provence. The author gave advice for those who grow laurel in their gardens, and he mentioned the many uses of laurel as a food, in art and in poetry and its rôle as the symbol of poetic glory. He got around to speaking of mythology, alluding to Apollo and the fable of Daphne. Toward the end, Horace Tograth changed his tone abruptly and finished thus: " And then, though I say it myself, this useless tree is still too common, and we have less glorious symbols to which the people attribute the laurel scent. Laurel trees occupy too much space on our overpopulated planet; they are unworthy of existence. Each one of them takes the living space of two men. We should chop down the laurel trees and fear their leaves like poison. Whereas they were formerly the symbol of poetry and literary learning, they are today only the symbol of a past glory which is to true glory what death is to life, what a hand of glory is to the key it holds.

" True glory has abandoned poetry for science, philosophy, acrobatics,

philanthropy, sociology, etc. Today's poets are only good for coming into prize money, which they do not earn since they do not work at all and most of them (except singers and a few others) have no talent and therefore no excuse. As for those who have some kind of gift, they are even more harmful, for, if they get nothing, they all make more noise than a regiment and din our ears with their cursed stuff. All that kind has no reason to live. The prizes awarded to them are stolen from the workmen, inventors, scholars, philosophers, acrobats, philanthropists, sociologists, etc. The poets must go. Lycurgus banished them from the Republic, they must be banished from the earth. Without this, the poets, arrant shirkers that they are, will become our princes and, without having done a thing, will live off our work, oppress us, and ridicule the rest of us. In a word, we must get rid of the tyrrany of the poets as soon as possible.

" If all republics and kings and nations do not take care, the privileged race of poets will grow to such proportions and so rapidly that before long no one will want to work any more, nor to invent, learn, think, do dangerous things, remedy man's unhappiness nor improve his lot.

" Without delay, then, we must attend to the combating of this plague which is ravaging mankind."

This article had an enthusiastic reception. It was telegraphed and telephoned everywhere; the newspapers reproduced it. A few literary papers followed the article with jeering remarks about the scholar, doubting the soudness of his mind. They laughed at the fear he showed of the lyric laurel. The dailies and commercial papers, however, made much of his warnings. They said that the article in La Voix was a work of genius.

The article was a unique pretext, admirably suited to corroborate any hatred of poetry. And the pretext was itself poetic. The Adelaide scholar called upon the marvels of antiquity whose memory is buried in every well-born man, and upon the instinct of self-preservation which is in all the rest. It is why almost all Tograth's readers were moved and frightened and did not want to miss the opportunity of harming the poets who, because of the number of prizes they came in for, were envied by all classes. Most of the papers closed by asking that the government take measures at least toward abolishing poetry prizes.

That evening in a later edition of *La Voix*, the chemist-agronomist, Horace Tograth, published another article which, telegraphed and telephoned everywhere like the first, aroused to their full pitch the emotions of the people and their governments. The professor terminated thus:

" Chose, world, between your life and poetry. If no serious measures are taken against the latter, it is the end of civilization. You will not hesitate. The new era will begin tomorrow. Poetry will exist no more, and all lyres, too heavy now to produce any inspiration as of old, will be broken. The poets will be massacred."

During the night, events followed a similar course in all cities of the world. The article, telegraphed everywhere, had been reprinted in special editions of local papers which were sold out. All over, people agreed with Tograth. Rabble-rousers mixed with the crowds in the streets and stirred them up. That very night most governments made decisions which, when announced, provoked enthusiasm of indescribable proportions. Greece, Italy, Spain and Portugal were the first to decree that poets residing within their borders would be imprisoned at the earliest possible moment, pending a ruling on their disposition. Foreign poets who might try to enter these countries would face a death sentence. From the United States the decision was telegraphed to electrocute any man whose profession was notoriously that of a poet. From Germany was telegraphed the decree ordering the detention of resident verse—or prose—poets until they changed their ways. Actually during that night and the following day, all the states of the world, even those that only had a few inferior poets without talent, took steps against the very name of " poet ". Two countries only were exceptions; England and Russia. All these laws were put into force immediately. All poets on French, Italian, Spanish or Portugese territory were imprisoned the next day, and only a few literary papers appeared with black borders to lament the new terror. Midday dispatches announced that Aristent South-West, the famous Negro poet of Haiti, had been cut into pieces that very morning and devoured by a populace of blacks and mulattos drunk with sun and carnage. In Cologne, the Kaiserglocke had rung all night long, and in the morning Professor Stimmung, author of a medieval epic of forty-eight cantos, while on his way to take the train for Hanover, had been pursued

by a gang of fanatics who had beaten him with sticks, crying, " Kill the poet ! "

He took refuge in a cathedral and along with a few beadles was confined there by the incensed populations of Drikkes, Hannes, and Marizibill. These last, the most highly aroused, invoked the Virgin, St. Ursula, and the three Magi in low German, and were free with their fists in making their way through the crowd. Their pater-nosters and adjurations were interlarded with wonderfully crude insults to the professor-poet, whose reputation rested principally upon the unisexual character of his habits. With his forehead on the ground, he nearly died of fright in the shadow of a huge St. Christopher in wood. He heard the masons walling up the exits and prepared for death by starvation.

About two o'clock it was heard that a sacristan poet in Naples had seen St. January's blood boil in its vial. The sacristan went out to proclaim the miracle and hurried to the waterfront to match his luck with the sailors. He won all he wanted at their game, including a knife in the belly.

Wires announcing the arrests of poets followed one another all day long. The electrocution of the American poets was made known around four o'clock.

In Paris, a few young Left Bank poets, spared because of their small fame, organized a demonstration which left the Closerie des Lilas in the direction of the Conciergerie where the prince of poets was locked up.

Troops arrived to disperse the demonstrators. The cavalry charged. The poets produced arms and defended themselves, but on seeing this the people joined the fray. The poets were strangled along with anyone who appeared to be on their side.

Thus began the persecution which spread rapidly throughout the world. In America, after the electrocution of the prominent poets, all colored singers were lynched and even quite a few Negroes who had never sung a note; next the whites of the bohemian literary sets were disposed of. It was also learned that Tograth, after having personally directed the persecution in Australia, set out for Melbourne.

## 17.  Assassination

Like Orpheus, all poets were threatened with a tragic death. Publishing houses were pillaged and their volumes of verse burned. Massacres took place in every town. For the moment there was universal admiration for this Horace Tograth who from Adelaide (Australia) had unleashed the storm and seemed to have destroyed poetry forever. The knowledge of the man, it was said, was miraculous. He made clouds disappear or summoned storms where he wished. From the moment they laid eyes on him, women were his slaves. Besides, he never had been disdainful of virgins, female or male. As soon as he realized what enthusiasm he had aroused in the world, he announced that he would visit the principal cities of the globe after Australia had been purged of her erotic and elegiac poets. And indeed a little later it was learned with what acclaim the visit of the infamous German, Tograth, was received by the inhabitants of Tokio, Pekin, Yakoutsk, Calcutta, Cairo, Buenos Aires, San Francisco and Chicago. Everywhere he left an impression of supernatural power because of his miracles which he called scientific and his extraordinary healings which made his reputation as a scholar and wonderworker almost divine.

On the 30th of May, Tograth landed at Marseilles. The populace was packed onto the docks. Tograth came ashore in a launch. As soon as he was in sight, shouts, encouragements, and yells from innumerable throats blended with the sound of wind and waves and ships' sirens. Tograth was standing up in the launch, tall and thin. As the boat came nearer, his hero's features could be seen better. His face was hairless and bluish, his almost lipless mouth was like a gash or wound across it, forming what could be called a shark's face. His turned-up nose had flaring nostrils. His forehead rose perpendicularly, very wide and high. Tograth's clothing was white and tightly fitting; his shoes, also white, had high heels. He wore no hat. When he set foot on the soil of Marseilles, the enthusiasm was so great that, after the docks were cleared, three hundred persons were found to have been killed by suffocation, trampling, and crushing. Some men seized the hero and carried him, amid shouts and singing and while women threw flowers

to him, to the hotel where his suite was ready and at the door of which the manager, interpreters, and porters stood to receive him.

That same morning, Croniamantal arrived in Marseilles from Brünn to look for Tristouse who had been there since the night before with Paponat. All three of them were caught in the crowd which was cheering Tograth in front of his hotel.

"A happy demonstration", said Tristouse. "You're not a poet, Paponat. You've learned things worth a lot more than poetry. Isn't it true, Paponat, that you're not at all a poet?"

"Actually, my dear," answered Paponat, "I have turned a few verses to amuse myself, but I have never been a poet. I'm an upstanding business man, and no one is better than I for managing a fortune."

"Tonight, you'll send a letter to *La Voix* in Adelaide saying all that, and then you'll be safe."

"Without fail", said Paponat. "Have you ever seen such a thing? Poet! This will be good for Croniamantal."

"I hope they will kill him in Brünn where he was looking for us."

"But there he is now," said Paponat quietly, "he's hiding in the crowd and hasn't seen us."

"I want him to be massacred at once", said Tristouse with a sigh. "And I have an idea we won't wait long."

"Look," said Paponat, "here comes the hero."

The procession which was bringing Tograth arrived in front of the hotel and set the agronomist on the ground. Tograth turned to the crowd and spoke:

"People of Marseilles, I could, in thanks, use words bigger than your celebrated *sardine**. I could make a long speech. But these words could never match the magnificence of the reception you have given me. I know that among you there are afflictions which I can cure by my knowledge and the knowledge accumulated by scholars during thousands of years. May the sick be brought forward, for I would heal them."

A man with a cranium as bald as that of a Myconian cried out:

"Tograth! human divinity, all powerful savant, give me a full head of hair."

*The people of Marseille are reputed to exaggerate on occasion. This is a reference to their story that a single sardine once blocked their harbour.

Tograth smiled and asked the man to come forward; then he touched the naked skull saying: " Your sterile rock will be covered with abundant vegetation, but remember this good fortune and avoid laurel for the rest of your life."

At the same time as the bald man, a girl drew near. She implored Tograth:

" Wonderful man, wonderful man, look at my mouth. My lover broke my teeth with his fist. Return them to me."

The scholar smiled and put a finger in her mouth saying:

" Now you can bite again, you have excellent teeth. But, in return, show me what you have in your handbag."

Laughing, the girl opened her mouth where the beautiful new teeth gleamed, and then opened her bag with the apology:

" What a funny idea in front of everyone. Here are my keys and my lover's picture on enamel. He's better looking than that."

But Tograth's eyes shone; he had caught sight of a few rimed Parisian songs to Venitian melodies, folded up small. He took the sheets and having looked at them said:

" These are only songs. Don't you have any poems? "

" I have one pretty one", said the girl. " The porter for the Victoria Hotel did it for me before leaving for Switzerland. But I have never showed it to Sossi."

She handed to Tograth a small rose-colored sheet with this lamentable acrostic:

> My love before I go far afield
> And our love Maria thereby derailed
> Rattles and dies darling just one more time
> I'd take our forest ramble quietly
> And then I think I'll leave you happily

" It's not only poetry," said Tograth, " but, more than that, it's idiotic ".

He tore the paper and threw it in the gutter, while the girl's teeth chattered and she declared with a frightened air:

" Wonderful man, wonderful man, I didn't know it was wrong."

At that moment Croniamantal came up beside Tograth and shouted at the crowd:

" Scoundrels, assassins !"

Laughter broke out. There were cries of " In the water with him, the scum."

And Tograth, looking at him, said:

" My friend, don't let this crowd dazzle you. As for me, I love the people although I stay in hotels where they don't go much."

The poet let Tograth speak and then addressed the crowd again.

" Scoundrels, laugh at me; your joys are numbered and they will be torn out of you one by one. And do you know, you people, who your hero is?"

Tograth smiled and the crowd became attentive. The poet went on:

" Your hero, people, is Boredom bringing Misery."

A cry of astonishment rose from every mouth. A few women crossed themselves. Tograth wanted to speak, but Croniamantal seized him roughly by the throat, threw him to the ground, and held him down with a foot on his chest. Meanwhile he spoke on:

" This is your Boredom and Misery, man's most monstrous enemy, the unclean and slimy Leviathan, the Behemoth soiled with infamies and crimes and the blood of great poets. He is the vomit of the Antipodes, and his miracles deceive a sensible person no more than the miracles of Simon the Magician's deceived the Apostles. Citizens of Marseilles, you whose ancestors came from the most lyric of countries, why do you give support to the enemies of the poets, to the barbarians of all nations. Don't you recognize that strange German miracle turning up again now in Australia? It is that of having imposed on the world and of having been for an instant stronger than creation itself, than the poetry of eternity."

But Tograth, who had been able to free himself, stood up and, covered with dust and livid with rage, asked:

" Who are you?"

And the crowd shouted:

" Who are you?"

The poet turned toward the East and in an exalted voice said:

" I am Croniamantal, the greatest of living poets. I have often seen God face to face. I have lived through the blinding revelation of divinity tempered by my human eyes. I have lived an eternity. But since the time has come, I am now here standing in front of you."

Tograth received these last words with a terrifying burst of laughter. The first rows of the crowd joined in when they saw Tograth, and the laughter was soon communicated in bursts and ripplings and waves to the whole populace, and to Paponat and Tristouse Ballerinette. All these open mouths turned toward Croniamantal made him lose countenance. There was shouting amid the laughter.

"Into the water with the poet. Burn this Croniamantal. Give the laurel-lover to the dogs."

A man in the front row who carried a club gave Croniamantal a blow with it and his grimace of pain made the crowd's laughter redouble. An accurately thrown stone hit the poet's nose, and blood spurted from it. A female fishmonger pushed through the press and, confronting Croniamantal, said to him:

"Hello, old rascal. I know you. Poor bastard. You're just a policeman turned poet. All right, cop; all right, tale teller."

And she struck him a sharp blow and spat in his face. The man Tograth had cured of baldness came up and said:

"Look at my hair. Is that a fraud?"

Raising his cane, he brought it down so hard that he shattered Croniamantal's right eye. He fell over backward; the women threw themselves on him and struck him. Tristouse stamped her foot with joy while Paponat tried to calm her. But she was on her way to put out his other eye with the point of her umbrella. He saw her coming and cried out:

"I confess my love for Tristouse Ballerinette, the divine poetry which is my soul's consolation."

Then the crowd of men shouted.

"Shut up, carcass. Watch out, ladies."

The women got quickly out of the way, and a man who was balancing a knife on the flat of his hand tossed it so that it landed in Croniamantal's gaping mouth. Several men did likewise. Knives were thrown in his stomach and his chest, and soon all that was left on the ground was a corpse bristling with knives like the spines of a sea-porcupine.

## 18.  Apotheosis

After Croniamantal had died, Paponat had taken Tristouse Ballerinette back to their hotel, and she broke down as might have been expected. They were in an old apartment house, and by chance Paponat found in a closet a bottle of water belonging to the Queen of Hungary and going back to the 17th century. This remedy took quick effect. Tristouse returned to her senses and went without further delay to the hospital to claim Croniamantal's body. It was given to her without protest.

She had a decent funeral service said for him and placed on his grave a stone with this engraved epitaph:

WALK ON TIPTOE HERE

DO NOT DISTURB THIS SOUND SLEEP

Then she returned to Paris with Paponat, who abandoned her a few days later for a Champs-Elysées model.

Tristouse did not miss him for long. She went into mourning for Croniamantal and climbed up to the Montmartre to see the Benign Bird, who began by making a pass at her, and after he got what he wanted, they began to talk about Croniamantal.

" I must make a statue of him," said the Benign Bird, " for I am not only a painter, but a sculptor as well."

" That's just the thing," said Tristouse, " we must put up a statue."

" But where? " said the Benign Bird. " The government will never give us a spot. These are bad times for poets."

" So they say," replied Tristouse, " but perhaps it isn't true. What would you think of the woods in Meudon, Mister Benign Bird? "

" I had thought of it but I hadn't dared mention it. The woods in Meudon it is."

" A statue in what? " asked Tristouse. " Marble? Bronze? "

" No, that's too old," said the Benign Bird. " I must sculpt a deep statue in nothing—like poetry, like glory."

" Wonderful, wonderful," said Tristouse, clapping her hands. " A statue in nothing, in emptiness; it's magnificent. And when will you do it? "

" Tomorrow if you want. We'll have dinner and spend the night

261

together and go out to the woods in Meudon early in the morning and I'll sculpt this deep statue."

No sooner said than done. They dined out with the élite of the Montmartre, came back to bed around midnight, and the next morning at nine, armed with a pickaxe, a shovel, a spade, and some rough chisels, they set out for the pretty woods in Meudon where they met the prince of poets with his girl, happy after the fine days he had spent in the Conciergerie.

In a clearing the Benign Bird went to work. In a few hours he had dug a hole about half a yard wide and two yards deep.

Then they had lunch on the grass. The Benign Bird gave over the afternoon to sculpting the interior of the monument to look like Croniamantal. The next day, the sculptor came back with some workmen who lined the pit with a layer of reinforced concrete four inches thick, except for the bottom which was fifteen inches thick—all done so skilfully that this emptiness had Croniamantal's very shape and the hole was full of his spirit.

The day after that, the Benign Bird, Tristouse, the prince of poets, and his girl came back to the monument, which was filled with the earth that had been dug out of it, and there, after nightfall, they planted a beautiful laurel tree while Tristouse danced, singing:

> They didn't all love you you lie
> Palantila nila miman
> When he was the lover of the queen
> He was king since she was queen
> It's true it's true I love him too
> Croniamantal at the bottom of a pit
> Is it he
>
> Let us pick marjoram
> By night.

# THE HERETIC

The Anglo-Saxon world takes great interest in religious questions. Especially in America, new religions stemming from Christianity spring into existence every year and find great numbers of followers.

On the other hand reformers and prophets provoke only indifference in the Catholic Church. In reality, it does not care any longer about its religion. It is also quite rare that there occur those little theological dissensions which used to lead to the foundation of a heresy. Actually, it often happens that Catholic priests separate from the church. These flights are caused by loss of faith. Many of these priests go their own way because of their special opinions on points of moral doctrine or of discipline (marriage of priests, etc.). These unfrocked clerics are for the most part non-believers; a certain few however create a little schism. But there are no longer any real heretics—such as Arius for example. Some solitary Turlupin may come along, but it seems impossible that a real Elijaiate should stand forth.

For these reasons, the case of Benedetto Orfei, who at the end of the 19th century founded at Rome the heresy called the " Three Lives ", is in my opinion unique.

From 1878 on, the Reverend Father Benedetto Orfei was the representative to the State in Rome of his order. Father Benedetto Orfei was a theologian and a man of good appetite, a pious man and a gourmand. He stood very high in the pontifical court, and, had it not been for his subsequent acts, he would today be a cardinal—that is to say " popeable ". This man, so well suited to the calm of cardinal red, lost out through trying to found a heresy. Following his excommunication, he had withdrawn to a villa in Frascati. There he was free to pontificate, having his faithful servants, two devout ladies, and a few country youths to whom he gave rudimentary instruction. To his way of thinking, he was preparing thus a glorious sect destined to replace Catholicism. Like every heretic, he rejected the dogma of Papal Infallibility and swore that God had given him powers of reform for his Church. I imagine that if Benedetto Orfei had become Pope, and that if the idea of his

heresy had occurred to him only at that moment, he would on the contrary have made use of the dogma of Infallibility in order to oblige all Catholics to believe in his doctrine, so that none could then deny it without being a heretic.

I visited Benedetto Orfei one mild May afternoon. The heretic was seated in a deep armchair. On his table some papers were spread out—probably briefs or encyclicals. He received me very civilly and, to honor me, had some old flagons of *vino santo* brought and some Roman or Sicilian confections: candied nuts in honey, a sort of pâté made of fondant in the three flavors of rose, mint, and lemon, in which were buried pieces of preserved fruit (orange peel, citrons, pineapples), a very mild paste made of quince called *cotogniata*, another paste called *cocuzzata*, and a kind of pancake spread with peach which is called *persicata*. He insisted that I taste the *vino santo*, and he sipped it with me, not without evidences of true satisfaction: a nodding of the head, a syphoning about of the wine in his mouth with appropriate movements of his lips and cheeks, a light movement of his left hand on his stomach. I soon perceived that the worthy heretic was deaf. Since he knew that I had come to take notes for subsequent elaboration into an essay on his heresy, I let him talk without interruption.

Benedetto Orfei, who came originally from Alexandria, employed its dialect freely. His speech was laden with coarse, almost obscene words, but all astonishingly expressive. It is known that mystics use such words, for mysticism is very close to eroticism. In spite of the interest which certain expressions would have for philologists, I shall not insist upon this aspect of Orfei's mind. My very superficial knowledge of Italian dialects did not, in any case, enable me to understand everything, and I only caught the sense of a number of words because of the gestures which accompanied the heretic's speech.

Here is how Benedetto Orfei related to me what he called his illuminating conversion.

" I had been occupied all day with hypostasis. When evening came, having said my prayers, I went to bed and began a rosary. At the same time I was meditating on the mysteries of the Faith. I thought of the

goodness of the Son of God, who, in order to wipe out ancient sin, was made man and died on the cross between two theives, an infamous punishment. A sentence which took the form of a popular refrain began to sound in my mind:

> ' They were three men
> On Golgotha;
> Just as on High
> The Trinity '."

Here the heretic stopped, aroused, poured some wine in our glasses, and drank with a sad and fleeting expression the contents of his, not forgetting the stroking of his belly, the facial movements, and the exclamations on the velvet flavor of this old wine. He made me try some of the *cocuzzata* and continued thus:

" This divine refrain sang in my soul until I fell asleep. I slept soundly, and in the morning at the hour of truthful dreams, I saw the sky open. Among the choirs of the hierarchies of Presence, Empire, and Execution and higher than the choir of Seraphim, which is the most exalted, three crucified figures presented themselves for my adoration. Dazzled by the light which surrounded the figures, I lowered my eyes and saw the holy procession of Virgins, of Widows, of Confessors, Doctors, and Martyrs, worshipping the crucified figures. My patron saint, St. Benedict, came toward me followed by an angel, a lion, and a bull, while an eagle flew overhead. He said to me: ' Friend, remember.' At the same time he raised his right hand toward the figures. I noticed that the thumb, index and middle fingers of that hand were extended, whereas the other two fingers were folded. At the same time the cherubim swung their censers, and an odor sweeter than that of the purest slow-burning incense filled the air. I saw then that the angel escorting my patron saint was carrying a ciborium of gold, admirably wrought. St. Benedict opened the ciborium, took from it a host, broke it in three pieces, and I communicated thus three times from a single host whose taste must have been more exquisite than that of the manna which the Hebrews enjoyed in the desert. A ravishing music of lutes, harps, and other celestial instruments was heard, played by the Archangels, and the Saints chanted:

> ' They were three men
> On Golgotha;
> Just as on High
> The Trinity.'

" I woke up. I understood that this dream was a grave event in my life and for all men. The time at which it happened left no doubt as to the veracity of such a dream. Nevertheless, as it upsets the beliefs upon which Christianity is based, I hesitated to inform the Pope. The following night I saw, in an early morning dream, the Holy Virgin between two women, saying to them: ' You also are the mothers of God, but men do not know of your maternity.' I woke up in perspiration. I hesitated no longer. I recited the Doxology, I had the mass of St. Mary the Major celebrated; and then I went to the Vatican to ask for an audition with the Holy Father, who granted it. I told him what had happened. The Pope heard me in silence and meditated an instant after having heard me. His meditation finished, he told me severely to stop all theological study, to think no more of such ridiculous and impossible things that only a devil could have inspired in me. He enjoined me to visit him again in a month. I was hurt and ashamed. I returned to my deserted convent and wept. The sacred refrain: *They were three men*, came back singing in my soul. I resisted it with all my will as if it were a temptation. I humbled myself before God.

" For a month I observed a strict fast and practised the twelve mortifications recommended by the contemplative, Harphius, in the second book of his *Mystical Theology*. I mortified myself principally according to the last five: mortification of all curiosity and understanding, mortification of every scruple of the heart, mortification of all impatient disquiet of the soul, mortification of the will, and the practice of a resignation to undergoing, for the love of God, any abandonment. At the end of this month of penances, the conviction which had come to me so fortuitously had been reinforced in my soul, and I went to see the Holy Father who, very affectionately, asked me if I had abandoned the chimeras which the demon of heresy had inspired in me. To answer him, I could only find these words: *They were three men* . . . ' Alas,' cried the Pope, ' this man is possessed.' I fell to my knees then. I spoke of my mortifications and

266

besought the Pontiff to exorcise me. With tears in his eyes, he assured me that God would be thankful for this voluntary humiliation; then he exorcised me according to the rites. I left then without persisting, for I was convinced that my thoughts were not of diabolic but of divine inspiration, since no exorcism had prevailed against them.

" The next day I wrote to the Pope, telling him of my conviction and asking him, since he was the head of the religion, to proclaim the truth which I had miraculously learned. I added that there was no infallibility which could make a lie out of what was true, and that, in consequence, I would separate myself from the Church in case he preferred ancient errors to this new evidence. In reply, I was excommunicated. Then, having abandoned my Order, and being rich with the goods I carried away from it, I took refuge in this peaceful shelter where, cast out from the bosom of the Catholic Church, I am laying the foundations of a new religion. I initiated the true triple communion, a host which contains the three human bodies of a single God in Three Persons. For the truth is this: the Trinity was made men. There were three Incarnations. The Three Persons of a single God suffered, on the same day, the passion necessary for the saving of mankind. The thief on the right was God the Father. One can tell it easily from the words of comfort he spoke on the cross for His Only Beloved Son. His life was sad and uncomplaining. He suffered unjustly for having been taken for a thief, which he was not. Being all-powerful and of infinite majesty, he did not want any disciple. Christ, who died between the divine thieves, was the Word and, being so, was the Legislator. It was his words and his acts which had to be transmitted to the world to be an example to it. And that is what happened. The thief on the left was the Holy Spirit, the Paraclete, Eternal Love, who, having become man, wished to be equal to human love, which is infamous. He was a real thief and suffered justly. Here is the mystery in all its holiness: God became man. God the Father incarnate suffered for having used for himself his supreme power and humbled himself to the extent of remaining unknown and without history. God the Son incarnate suffered for insisting upon the truth of his teaching and for giving the example of martyrdom. He suffered unjustly but gloriously in order to impress the minds of men. God the Holy Spirit

wished to suffer justly. With the flesh he assumed the worst of human weaknesses and abandoned himself to every sin through compassion and love of humanity. This is the truth then:

> They were three men
> On Golgotha;
> Just as on High
> The Trinity."

It was thus that Benedetto Orfei told me the story of his heresy and elaborated its doctrine for me. Carried away by his speech, he had forgotten to drink. As soon as his story was finished, he stretched out his right hand without leaning forward in his chair, took a *persicata* pancake, rolled it carefully, and made a mouthful of it. Then, having poured out some *vino santo*, he drank it—but awkwardly; for the *persicata* and the *vino santo* went astray in his throat. He swallowed the wrong way, and there was an explosion from his mouth and nose. The heretic, now red as a beet, coughed for all of five minutes. He needed a handkerchief. Since he used no tobacco, in place of a large colored handkerchief, he brought out a tiny one of cambric, scarcely ecclesiastical. This elegance astonished me. Still panting noisily, he caught his breath, not without indicating to me by a finger the quince jam, inviting me to take some.

He next confessed to me that the Catholic religion was rotten, being too old, and that the Pope was afraid to touch it for fear that all would fall away. He was even more expressive, and, using his native dialect, added:

" *L'è cmè ra merda: pi a s'asmircia, pi ra spissa.*"

When I rose to take leave of him, the heretic wanted to accompany me to the door.

Just as he got up, his soutane, a sort of monastic garment of black baize, opened, and I saw that underneath the heretic was entirely naked. His hairy body was furrowed with the marks of flagellations. A rough belt bristling with iron points, which must have caused insufferable pain, was wrapped about his waist. I saw other things as well, but of such a nature that I cannot describe them. All this nudity, to tell the truth, was visible only for an instant. The heretic immediately closed his soutane,

knotted its cord, and, smiling, invited me to enter the next room which was the library. I was stupefied to see that the man gave such punishments to his flesh and satisfied at the same time his gourmand's appetite. I considered these contrasts while entering the library, where I saw, conveniently arranged on shelves, all kinds of books, which the heretic invited me to examine. There were, all mixed together, rare and ordinary books, theology, philosophy, literature, and the sciences. There were books and manuscripts, ancient and modern, on paper and on parchment. I noticed the works of Aristotle, of Galen, of Oribase, the *Syphilis* of Tracastor, the *Wisdom* of Charron, the book of the Jesuit Mariana, Boccacio's tales, and those of Bandello, of Lasca, St. Thomas, Vico, Kant, Marcilio, Ficino, *The Diadem of Monks* by Smaragdus, and others. Then I left the heretic and never saw him again.

Some time after that I learned that there had just appeared *The True Gospel*, of Benedetto Orfei, translated into the popular tongue, containing the life of God the Father, the first of the two gospels parallel to the canonical Gospels. I procured the book, which was very short. It contained little that was very precise on the first person of God. One learned from it that nothing was known of the birth of God the Father. Of his life, almost nothing was known except that it was just, obscure, and friendless. His existence was involved with that of the other two persons of the Trinity, and it was while trying to dissuade God the Holy Spirit from a crime that he was trying to commit that they were taken together, and God the Father condemned unjustly. Each of the words he spoke at the scene of their punishment with Jesus and the bad thief was the subject of a chapter in which it was commented upon. This was in effect the only well-known moment in his life, and still the heretic had to borrow the story of it from the synoptic gospels. After the death of God the Father all became a mystery again. Nothing more was known, not even of his resurection and ascension, which were probable but unknown. This work had been written in Latin, it seemed, translated into Italian, and then published. The Latin manuscript of parchment must be still in existence.

The following year, Benedetto Orfei brought out the second gospel parallel to the canonical Gospels, or the Gospel of the Holy Spirit. Like

that of God the Father, his life was obscure. But, whereas only the death of the Father was known, it was known of the Holy Spirit that he, at one time, violated a sleeping virgin. This vileness was the deed of the Holy Spirit of which Jesus was born. Once again, the words spoken on the cross were stressed; the mystery arose after the moment when the soldiers broke the legs of the two thieves. This volume, beautifully written as it happens, and with sections of inspired reasoning, contained passages of such crudity that the Italian authorities had it seized as an obscene book; thus it is unobtainable.

The copies of the first gospel, or the Life of God the Father, are moreover extremely rare themselves: anxious to destroy them, the pontifical court bought up the greater part.

The heresy of the Three Lives did not spread widely. Benedetto Orfei died on the threshold of the century. His few disciples scattered, and it is probable that the teaching of the heretic will have been in vain, that nothing will come of it, and that none will think of preaching it.

A priest who knew Benedetto Orfei well, and who had often tried to make him give up what the catholics called his errors, told me the end of the story. He died, as it appears, in consequence of indigestion, but his body was discovered to be covered with wounds resulting from the tortures which Orfei inflicted on himself; so much so in fact that the doctors hesitated over attributing his death to his gluttony or to his mortifications of the flesh. The truth is that the heretic was the same as all men, for all are at the same time sinners and saints,—if they are not criminals and martyrs.

# SELECTED BIBLIOGRAPHY

The most available and extensive bibliography in English is in Bates (below, B).

The two standard collections in French, the first of which contains a comprehensive bibliography, are the following:

*Oeuvres Poétiques,* ed. Marcel Adéma and Michel Décaudin, Gallimard, Ed. de la Pléiade, 1956 (complete poetry and theater)
*Oeuvres Complètes,* 4 vols, illus., Ballard and Lecat, 1965

Unless otherwise indicated, place of publication is Paris for texts in French and New York for texts in English.

## A. WORKS

Currently available editions in French and in English are given in parenthesis.

*Les Onze Mille Verges,* 1907 (banned in France; tr. anon., *The Debauched Hodspodar,* Los Angeles, Holloway, 1967)
*L'Enchanteur Pourrissant,* 1909
*L'Hérésiarque et Cie.,* 1910 (Stock, 1940; tr. Remy Inglis Hall, Doubleday, 1965)
*Le Bestiaire ou Cortège d'Orphée,* 1911 (see *Alcools*)
*Les Peintres Cubistes: Méditations Esthétiques,* 1913 (ed. L. C. Breunig and J. C. Chevalier, Hermann, 1965; tr. Lionel Abel, intro. Robert Motherwell, illus., Wittenborn, 1949)
*Alcools,* 1913 (suivi de " Le Bestiaire " illus. par Dufy et de "Vitam Impendere Amori, " Gallimard, Collection Poésie, 1969; tr. William

Meredith, Doubleday, 1964; tr. Anne Hyde Greet, Berkeley, California, 1965)

*Le Poète Assassiné*, 1916 (Gallimard, 1947)

*Vitam Impendere Amori*, 1917 (see *Alcools*)

*Les Mamelles de Tirésias*, 1918 (Bélier, 1946; tr. Louis Simpson, *Odyssey*, December, 1961)

*Calligrammes*, 1918 (préface de Michel Butor, Gallimard, Collection Poésie, 1967)

*La Femme Assise*, 1920

*Anecdotiques*, 1926 (ed. Marcel Adéma, Gallimard, 1955)

*Tendre comme le Souvenir* (Gallimard, 1952)

*Le Guetteur Mélancolique* (Gallimard, 1952)

*Poémes à Lou* (Geneva, Cailler, 1955)

*Chroniques d'Art* (ed. L. C. Breunig, Gallimard, 1961)

*Les Diables Amoureux* (ed. Michel Décaudin, Gallimard, 1964)

*Lettres à Lou* (Gallimard, 1969)

## B. Biography and Criticism

Adéma, Marcel. *Guillaume Apollinaire*, La Table Ronde, 1968 (an earlier edition, tr. Denise Follot, Grove, 1954)

Bates, Scott. *Guillaume Apollinaire*, Twayne, 1967

Bonnefoy, Claude. *Apollinaire*, Classiques du XX siècle, 1969

Breunig, L. C. "The Chronology of Apollinaire's *Alcools*," *PMLA*, Dec. 1952

——————. *Guillaume Apollinaire*, Columbia Essays on Modern Writers, 1969

Carmody, Francis J. *The Evolution of Apollinaire's Poetics, 1901–1914*, Berkeley, California, 1963

Davies, Margaret. *Apollinaire*, London, Oliver and Boyd, 1965

Décaudin, Michel. *Le Dossier d'Alcools*, Minard, 1960

Durry, Marie-Jeanne. *Guillaume Apollinaire, Alcools*, 3 vols. S. E. D. E. S. 1956–65

*Europe*, Nov.–Dec. 1966 (special number on Apollinaire)

Moulin, Jeanine. *Guillaume Apollinaire, Textes Inédits*, Geneva, Droz, 1952

Pia, Pascal. *Apollinaire par Lui-même*, Seuil, 1954

Rouveyre, André. *Amour et Poésie d'Apollinaire*, Seuil, 1955

Shattuck, Roger. *The Banquet Years*, Vintage Books, 1968

*Revue des Lettres Modernes* (annual numbers devoted to Apollinaire studies since 1962)